THOMAS HEARNE
and his landscape

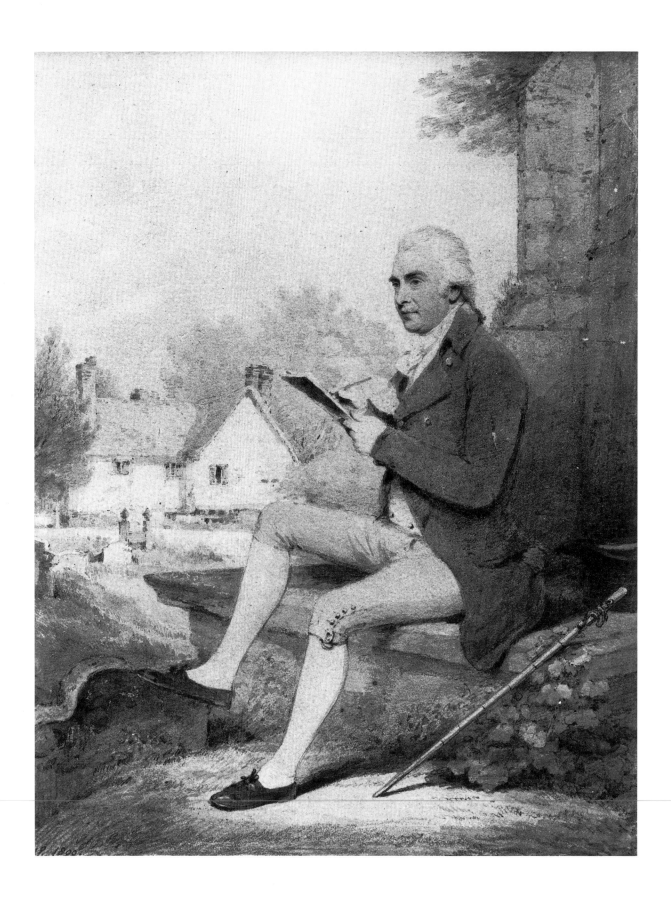

THOMAS HEARNE
and his landscape

DAVID MORRIS

REAKTION BOOKS

Published by Reaktion Books Ltd
1–5 Midford Place, Tottenham Court Road
London W1P 9HH, UK

First published 1989

Designed by Ron Costley

Photoset by Rowland Phototypesetting Ltd
Bury St Edmunds, Suffolk
Printed and bound in Great Britain by
BAS Printers Ltd
Over Wallop, Hampshire

British Library Cataloguing in Publication Data
Morris, David, *1954–*
Thomas Hearne and his landscape.
1. Paintings, landscapes, watercolour. English.
Hearne, Thomas 1744–1817
I. Title
759.2

ISBN 0-948462-05-1

Frontispiece: Henry Edridge: *Thomas Hearne in Ashstead
Churchyard, Surrey* 1800. Watercolour over pencil, 33 × 25.4.
The Trustees of the Victoria and Albert Museum.

Measurements are given in centimetres throughout.

Contents

Acknowledgements
page vi

Preface
page vii

CHAPTER ONE
Early Life and Apprenticeship
page 1

CHAPTER TWO
A Colonial Commission: Antigua and the Leeward Islands
page 9

CHAPTER THREE
The Antiquities of Great Britain
page 24

CHAPTER FOUR
Literary Illustration and Rustic Landscape
page 52

CHAPTER FIVE
British Landscape: Picturesque Tours and Patronage
page 67

CHAPTER SIX
Later Work
page 119

References
page 139

Select Bibliography
page 148

Index
page 151

Acknowledgements

Extracts from Joseph Farington's *Diary* and *Notebooks on Artists* are used by kind permission of Her Majesty the Queen and Yale University Press. Quotations from J. C. Brooke's correspondence with Thomas Hearne appear by permission of The Bodleian Library, Oxford.

PHOTOGRAPHIC ACKNOWLEDGEMENTS

The author and publishers are grateful to the owners, both private and public, who supplied photographs for this book. Sources of photographs not credited in the captions are listed here:

The Courtauld Institute of Art, Witt Library, 38, 39, 40, 42, 43, 44, 45, 46, 47, 73, 74, 75, 76, 87, 94, 97, 102, 104, 107; The Leger Gallery, London, 50, 7; The Martyn Gregory Gallery, London, 5; The Paul Mellon Centre, London, 2; Thomas Agnew & Sons Ltd, 50; William Drummond, 71.

Preface

Thomas Hearne was one of the most important topographical artists of the later eighteenth century. During his lifetime he was highly regarded by three leading connoisseurs of painting – Sir George Beaumont, Richard Payne Knight and Dr Thomas Monro – and all of them bought or commissioned work from him. His reputation remained high in critical circles until the mid nineteenth century. As taste in watercolour paintings moved away from eighteenth-century ideas of pictorial balance and restrained colour harmony, many writers disparaged the work of the early topographers, arguing that it lacked creative imagination. The most commonly expressed view was that, following Paul Sandby and Michael 'Angelo' Rooker, Hearne had only 'gradually advanced the art of painting in water-colours' (R. N. James, *Painters and their Works*, 1897). Cosmo Monkhouse felt, however, that Hearne was 'the most accomplished and complete' topographical watercolourist of the period, an artist 'whose position in the history of English watercolour art has scarcely been sufficiently recognised' (*The Earlier English Watercolour Painters*, 1890). Monkhouse admired Hearne's techniques for drawing architecture, trees and skies, his aerial perspective and his 'close and fresh . . . observation of nature'. Until the 1980s, despite increasing popular interest in watercolours and the publication of excellent large-scale histories, little more had been written which looked specifically at Hearne's work, and it was still described primarily in terms of the technical evolution of British watercolour painting.

In this book I have taken the opportunity to examine his watercolours, drawings and the prints made from his designs, in a broader historical and cultural context than was possible in the short essays of the catalogue published to coincide with the first exhibition of Hearne's work, shown at Bolton, Southampton and Bath in 1985–6. I have considered Hearne's motivation and intentions (in the light of his letterpress to the *Antiquities*), examined the Diary of his fellow-artist Joseph Farington (which contains many records of conversations with Hearne) and read the scattered letters and writings of close associates and patrons. I have also drawn upon a variety of topographical, historical and literary evidence in order to show the attitudes of Hearne's contemporaries to his typical subjects and to gauge the influence upon his career of the increasingly sophisticated market for watercolours, drawings and engravings. These are important considerations, as the topographers of Hearne's generation have all too often been discussed primarily within a technical context, as influences upon the next generation of landscape watercolourists. Per-

haps because of this narrow view of artistic practice, the full range and meaning of Hearne's work has never been properly considered, and the undoubted aesthetic quality of his images has been largely divorced from an understanding of the cultural assumptions which they so subtly and elegantly embody.

I would like to thank all those who have helped me in my research on Hearne, and those who have guided this book into print. I am grateful in particular to the following people: Ann Bermingham, Duncan Bull, Richard Chester-Master, Patrick Conner, Bill Drummond, Elizabeth Fairman, Maureen Gray, the late Francis Hawcroft, Anne Jackson, Dennis Lennox, Lowell Libson, Anne-Marie Logan, David Mackie, Barbara Milner, Gabriel Naughton, Patrick Noon, Vivien Onslow, Felicity Owen, Duncan Robinson, Bill Ruddick, Lindsay Stainton, John Sunderland, Robert Wark, Scott Wilcox, Robert Williams and Robert Woof.

In addition my thanks go to the staff of the following print rooms and libraries: Manchester Central Reference Library; John Rylands University Library of Manchester; Manchester Polytechnic Library; The British Library; British Museum Print Room; Victoria & Albert Museum Print Room; The Paul Mellon Centre for Studies in British Art; The Witt Library, Courtauld Institute; The Yale Center for British Art, New Haven; Yale University Library; Henry E. Huntington Library and Art Gallery; and The Royal Library, Windsor.

It is a pleasure to acknowledge the support of the Henry E. Huntington Library and Art Gallery, San Marino, and the Yale Center for British Art, New Haven, whose generous fellowship awards enabled me to work with their outstanding collections. I would like to thank the staff of both institutions for their warm hospitality. My research was also greatly assisted by grants from the British Academy and the Paul Mellon Centre for Studies in British Art. I am grateful to Dr John Gray, Brian Hughes and the Arts Sub-Committee of Bolton Metropolitan Borough for allowing me study leave in order to pursue my research in the United States, and for their permission to use photographs originally acquired for the 1985 exhibition catalogue on Thomas Hearne.

I would especially like to thank Professor Michael Kitson, who has been unfailingly encouraging throughout, and Reaktion Books, my publishers, for their enthusiasm, patience and attention to detail. Above all I owe a particular debt of gratitude to Michael Rosenthal. At an early stage he discussed with me various ways of approaching Hearne's work. Later, in commenting on the first draft, he suggested many improvements, made pertinent criticisms and did valuable editorial work. I am grateful to him for his assiduousness and insight.

Finally, I would like to thank my wife Rebecca for her inspiration, encouragement and constant support. This book is dedicated to her.

David Morris, Bolton, May 1989

Early life and apprenticeship

Thomas Hearne was born in the Gloucestershire village of Marshfield near Bath, on 22 September 1744; four days later he was baptized in the local parish church. Very little is known about his background. His parents, William and Prudence Hearne, had married in Marshfield in 1742, and their first child, Ann, was born a year later, but died within a month. Thomas, their next child, was only four years of age when his father died in 1749. Soon after this second family tragedy, Prudence Hearne and her son moved from Marshfield to the village of Brinkworth in Wiltshire, where Thomas Hearne was to spend most of his childhood.[1] In the 1750s Brinkworth was a small farming community; its houses were strung out along a spine of high ground overlooking a plain to the south. Five miles to the east lay the ancient town of Malmesbury. We have no evidence that Hearne had any inclination towards drawing in his youth, but his surviving adult works include many images of the buildings, landscape and rural way of life familiar to him from his early years. A drawing of Malmesbury Abbey (shown in 1766 at the Free Society of Artists) was his first exhibited work to carry a specific title.[2] Later, in the important series of engravings made from his drawings – *The Antiquities of Great Britain* – a view of Malmesbury Abbey was on the frontispiece to the first volume (illus. 21) with two more views of it among the plates (illus. 30). Two other drawings are also known (illus. 22, 99). The hamlet of Bradonside near Brinkworth (illus. 105), Bradenstoke Priory and Brackenborough Church were among other local sites to which Hearne was attracted on his regular visits to Wiltshire.[3]

Prudence Hearne continued to live in Wiltshire until at least 1797, but Thomas Hearne was sent to London, probably in the late 1750s when he would have been in his middle teens.[4] According to Farington's account, Hearne was

placed as an apprentice with his Uncle, a Pastry Cook, in Maiden Lane, Covent Garden. Miller, an Engraver, lived at an adjoining house and kept a Print Shop. To an acquaintance formed with young Miller, Son to this Engraver, may probably be ascribed the inclination which young Hearne felt to drawing, and his application became such, and his proficiency so great, as to enable him to obtain a premium from the Society established for the encouragement of Arts, Manufactures and Commerce.[5]

The Society of Arts, as it became generally known, was founded in 1754 and in the following year began to issue premiums as an encouragement to young aspiring artists. In 1763 Hearne was awarded one guinea for a still-life drawing and he

1. *William Woollett* 1770. Pencil, 9.5 × 6.7. The Trustees of the British Museum.

succeeded in following up this modest achievement by securing an eight-guinea premium in 1764, for an equestrian subject.[6]

The following year Hearne was apprenticed to the engraver William Woollett (1735–85; illus. 1), with whom he was to work from 1765 to 1771. These years were significant in directing Hearne's subsequent career. Woollett was already considered to be the finest landscape engraver of his generation when Hearne began his apprenticeship. Originally an apprentice to the Fleet Street printmaker John Tinney, Woollett had drawn and engraved a series of elegant if prim views of country houses, gardens and estates between 1757 and 1760. These landscapes were starkly symmetrical and peopled by genteel figures taking the air or admiring a prospect of their grounds. Although Woollett never again made engravings after his own drawings, he continued to sketch out-of-doors and to make landscapes. He encouraged Hearne to do the same.[7]

Woollett established his reputation as an engraver with a print after Richard Wilson's *Destruction of the Children of Niobe* (published by John Boydell in 1761). During the previous year Boydell had found that English collectors were clamouring for copies of prints after the fashionable storm scenes and shipwrecks of the French artist Claude-Joseph Vernet (1714–89). Boydell had to import these prints for cash; but by commissioning Woollett to engrave Wilson's *Niobe* – a dramatic subject similar to those by Vernet – he hoped to be able to use his engravings in exchange for French prints.[8] The strategy worked: Wilson sold the picture for eighty guineas, while Boydell paid Woollett £150 and made £2000 for himself through sales of the hugely successful engravings, which sold for five shillings each. Woollett was lauded as an English line-engraver at last capable of rivalling the technique of the French craftsmen who had been dominating the print market for many decades.[9]

Most of the effects in Woollett's prints were obtained by heavy preliminary

2. William Woollett after George Smith of Chichester: *The First Premium Landscape* 1762. Engraving with etching, 48.3 × 60.2. Paul Mellon Centre, London.

etching, with pure line engraving used only for emphasis and detail at the end of the process. The *First Premium Landscape* (illus. 2) by George Smith of Chichester, and engraved by Woollett in 1762, shows the intricacy of line and richness of tone and texture that could be achieved by combining the two techniques.[10] During his apprenticeship Hearne worked on many of Woollett's plates. He had the usual task of the assistant – etching the overall layout of the composition and general textural effects quickly, the master adding subtleties by subsequent engraving. Woollett's main assistant during these years was John Brown (1741–1801), and Farington reported that Hearne often complained that though Woollett 'admitted the name of *Brown* to be upon several of his plates in conjunction with his own, would never admit that of Hearne, although he etched a Landscape by Swaneveldt, a Snow-piece from Smith of Chichester, and a Shooting piece from Stubbs'.[11]

No doubt Hearne, twenty-seven years old on completing his apprenticeship in 1771, felt aggrieved at the sometimes humiliating role of the apprentice and wished for more independence. Engraving could be a lucrative career, but it did little to satisfy an artist's more creative aspirations. Later Hearne would disparage it as 'a *mechanical process*, ruling lines etc, it was not to be considered *as an effort of mind*, but a dexterity of hand … it required no sentiment, no elevation'.[12] As William Gilpin wrote in his *Essay on Prints* (1768), '*mere engravers*, in general, are little better than *mere mechanics*', a conventional view that was held by many within the Royal Academy, an organization founded in 1768 while Hearne was serving his apprenticeship.[13] Those in the Academy agreed that no matter how skilful the engraver, he was a craftsman rather than an artist, a copyist rather than a creator. Engravers were excluded from Academy membership and prints were not shown in Academy exhibitions. There followed decades of rancour and agitation during which the engravers demanded Academic recognition of the importance of their

3. *Joseph Banks* c.1765–71.
Pencil, 10.8 × 9.2.
The Trustees of the British
Museum.

role in widening the audience and the market for the works of painters.[14]

Hearne's ambition presumably fired him to eschew this mechanical occupation for the more financially precarious living of a draughtsman. During the whole of his apprenticeship, he continued to exhibit landscapes and architectural drawings.[15] His association with Woollett led to meetings with many of the leading artists and patrons in the London art world, which may have confirmed him in his decision. During the later 1760s Woollett was producing engravings after paintings by such leading artists as Richard Wilson, George Stubbs, George Smith of Chichester and John Inigo Richards, all of whom would presumably have visited his premises to discuss the plates.[16] Hearne was also acquainted with the naturalist and patron, Joseph Banks (1743–1820). Banks associated with artists all his life and accompanied Captain James Cook on the first of his expeditions to the South Seas, taking with him two professional draughtsmen. This was the first expedition to be adequately equipped for recording its scientific findings. Hearne drew Banks (illus. 3) as a young man in one of his earliest surviving works.[17] Informality and intimacy are suggested by the sitter's relaxed pose. Banks's head is delicately modelled and animated by the varying intensity of cross-hatched lines, in contrast to the torso which is sketched in a more summary manner. During this period Banks was building up his unrivalled collection of watercolours and bodycolours by the leading contemporary topographical draughtsman, Paul Sandby.[18] Sandby's series of Windsor views of the 1760s certainly lay behind Hearne's own *Windsor Castle – the South Front* (illus. 4). The compositional format of Hearne's *Windsor Castle*, with its solid block of buildings to the right leading the eye obliquely into the picture space, derives from Sandby's works, although the figure groupings, in contrast, are tentative and ill-proportioned.

The term 'topography' originated in the sixteenth century; from that time on it

4

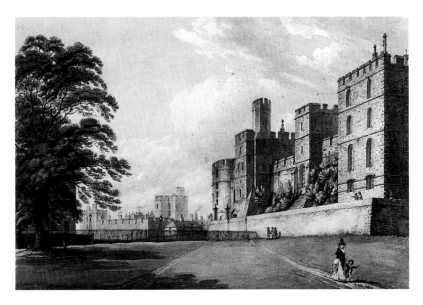

4. *Windsor Castle – The South Front c.1770.* Watercolour over pen and ink, 22.5 × 33.5. Windsor Castle, Royal Library. © 1988 H. M. the Queen.

meant the accurate delineation and description of a particular place or building. Its origins were bound up with scientific illustration, mapping, depictions of palaces, country houses and estates, and antiquarian enthusiasm for recording the remains of ancient buildings. In the early decades of the eighteenth century, a tremendous boom in country-house building and landscape gardening resulted in a burgeoning demand for estate portraits, and this aspect of the topographical tradition was then the dominant one.[19] From *c.*1750 antiquarian interest grew once more, and building on the work of Wenceslaus Hollar and Samuel and Nathaniel Buck, a lively tradition of draughtsmanship and engraving was developed to satisfy a growing demand for depictions of the material remains of British history and through these the British landscape itself.[20]

Horace Walpole, as well as visiting many important Gothic sites, began the conversion of his country house – Strawberry Hill, near Twickenham, on the River Thames – into a 'little Gothic castle' in 1750, copying medieval features from existing buildings and engravings.[21] His circle of friends and collaborators included the poet Thomas Gray, who wrote to Thomas Warton in 1758 about his developing interests in antiquarianism and in touring Britain:

The drift of my present studies is to know, wherever I am, what lies within my reach, that may be worth seeing whether it be Building, ruin, park, garden, prospect, picture or monument . . . and what has been the characteristick, and taste of different ages.[22]

Gray visited York Minster in 1762 with his friend William Mason, who recalled that in one chapel, the poet 'was much struck by the beautiful proportions of the window which induced me to get Mr Paul Sandby to make a drawing of it'.[23] Six years later Richard Gough, acknowledging 'the arts of design, ever cultivated by civilized nations, are the happiest vehicles of antiquarian knowledge', surveyed the field of contemporary landscape draughtsmanship and engraving:

Our modern artists, who have chosen this walk, throw themselves on the patronage of a curious public. The many views in the three kingdoms, annually exposed to criticism are evidences how favourably such performances are received. Gravelot, Smith, Vivares, Bellers have painted or engraved many prospects in different parts of England. Mr. Samuel Buck and his brother completed a noble design of giving the public above 400 views of religious and other ruins, and 80 prospects of cities and towns.[24]

As Gough indicated, this market was stimulated by the inception of annual exhibitions in London, which offered artists the chance to exhibit in a forum where they could obtain criticism and the approbation of their fellows, as well as bring their work to public notice. It was in this environment that Hearne had to operate after abandoning his idea of becoming an engraver.

Hearne seems to have worked almost exclusively in watercolour – he added occasional highlights in bodycolour, and Woollett had encouraged his talent for landscape drawings tinted with watercolour. Hearne (with a typically shrewd modesty) may have felt that a solid career as a draughtsman was preferable to the experience of Michael 'Angelo' Rooker, who struggled unsuccessfully in the 1770s to make his mark as a topographer in oils at the Royal Academy exhibitions.[25] Hearne therefore paid little attention to the fashionable bodycolour pictures exhibited by Sandby, George Barret the elder, and Francesco Zuccarelli. Indeed, Sandby used this technique mainly for imagined, classical landscapes, loosely following Claude Lorraine, Nicolas Poussin and Gaspard Dughet. Hearne, in his developing preoccupation with medieval architecture, naturally found the most useful available model to be the realistic topographical style. This ultimately derived from the Dutch school of landscape draughtsmanship, of which he would have seen many examples at Woollett's studio and in the London sale-rooms and print-shops.

In the spring of 1771, during Hearne's apprenticeship, the young aristocrat and keen amateur painter Sir George Beaumont (1753–1827) was taken by his tutor, the Revd Charles Davy (1722–97), to see Woollett in his London garret at 11 Green Street, Leicester Square. Beaumont later remembered that 'my fondness for art made me desirous of seeing the most celebrated professors in every line', and in a letter to Dr Thomas Monro in 1816 he vividly recalled the visit:

We mounted up to his garret and there sat Hearne, most assiduously employed in etching from a picture by Swanevelt, now in my possession. We passed about six weeks in London and there were few days in which we did not spend some hours in the company of Woollett and Hearne. We talked incessantly of pictures and plates, and my love of painting was completely confirmed. Mr. Woollett was prevailed upon to promise a visit to Mr. Davy in the course of the summer and bring Hearne with him; accordingly in August they arrived at his house at Henstead in Suffolk. There we passed six weeks together, I may almost say as far as I was concerned, in perfect happiness. We sketched all day.[26]

Farington reported a conversation with Hearne in 1809 on the same subject: 'Sir George who was then pupil to Mr Davy then sketched Heads only, but being pleased with the sketches of Landscape made by Woollett and Hearne, he became

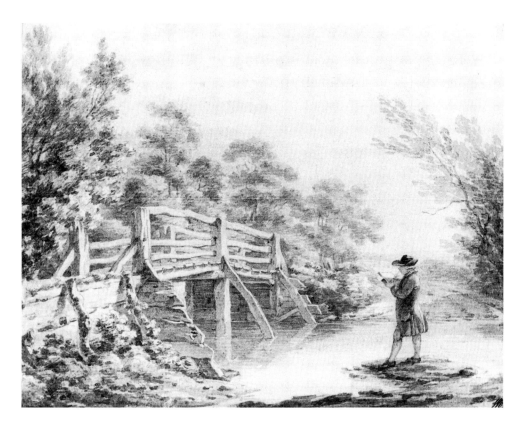

5. *A Bridge at Henstead, Suffolk* 1771. Blue and grey wash over pencil, 18.4 × 24.2. Private collection.

their imitator'.[27] Davy also left a record of this visit; his recollections were addressed to his former pupil, Beaumont, and included thoughts on their evening readings from Chaucer:

And let me now turn my thoughts to you, my dear Sir George, with the friends of Taste, whom your goodness hath made mine, in the neighbourhood of these enchanting scenes, which he [ie Chaucer] hath described with the preciseness of a painting; and recall some passages of this Poet to your memory, whom you formerly admired, when we read a part of his works together, in the sequestered humble situation you then loved; a time I now delight to live over again in my imagination, which is aided by Mr. Woollett's and Mr. Hearne's delightful drawings, together with those of the worthy Pouncey and Smith; they place me upon the very spot where we used to pass our chearful summer's evenings.[28]

Davy's comments, written in the mid 1780s when Beaumont had already made the Grand Tour (in 1782–3) and by then was enjoying a lively social life in London, are heavy with nostalgia for what appeared to Davy to have been a simpler time spent in a 'sequestered humble situation'. Three of Hearne's drawings survive from this visit. *A Bridge at Henstead, Suffolk* (illus. 5) is a small watercolour depicting Woollett sketching. The bridge would have appealed to Woollett as it was akin to the high wooden bridges found in the Dutch polder, familiar to English artists through numerous prints by Dutch landscape painters and etchers of the previous century.[29]

Two watercolours from a trip into Norfolk to see Castle Acre Priory during their

6. *The Prior's House, Castle Acre, Norfolk* 1771. Watercolour over pencil, 15.7 × 22.2. Whitworth Art Gallery, University of Manchester.

East Anglian visit, reveal Hearne's early dependence on Woollett's style as well as providing early evidence of Hearne's own interest in medieval architecture. *The Prior's House, Castle Acre, Norfolk* (illus. 6) features the west front of the Cluniac Priory and part of the north side of the Prior's apartment, which had been converted into a farmhouse.[30] The treatment of the architecture, with broken washes and touches of colour on the sunlit masonry disclosing a fascination with the eroded appearance of ancient buildings and the play of light across stonework, anticipates Hearne's later techniques. An engraving of this watercolour, very close in composition, was one of the first plates to be issued for *The Antiquities of Great Britain* in 1778.[31]

Hearne must have found these six weeks in the summer of 1771 socially flattering. Beaumont, in his letter to Monro, gently mocked the youthful enthusiasm he himself experienced that summer:

The remembrance of this happy year never fails, when I think of it, to cross my mind like a gleam of bright sunshine. I was young and ardent, and admiration – the most pleasing of sensations – I enjoyed in the highest degree. I thought Woollett and Hearne the greatest artists that ever existed, and if any one had presumed to say that Claude or Gaspar knew half so much of the matter, I should have considered it as ignorance or prejudice.[32]

But Hearne's own career was about to change dramatically. Within three months of his visit to Castle Acre Priory with Woollett and Beaumont, he was on board a Royal Navy ship, and about to begin a ten-week voyage to the Leeward Islands in the West Indies.

8

A Colonial Commission: Antigua
and the Leeward Islands

Hearne had resolved to take up an offer to travel to the Leeward Islands in late 1771, when his apprenticeship to Woollett was coming to an end. He was employed as a draughtsman in the service of Sir Ralph Payne, who earlier that year had been appointed Captain-General and Governor-in-Chief of the Leewards, a group of sugar colonies comprising Antigua, St Kitts, Nevis and Montserrat. The effect upon Hearne of the alien environment and culture of the Leewards must have been considerable. Janet Schaw, another first-time visitor to Antigua in 1774, vividly described her approach to the island:

The beauty of the island rises every moment as we advance towards the bay; the first plantations we observed were very high and rocky, but as we came further on, they appeared more improved, and when we got into the Bay, which runs many miles up the Island, it is out of my power to paint the beauty and the Novelty of the scene. We had the island on both sides of us, yet its beauties were different, the one was hills, dales and groves, and not a tree, plant or shrub I had ever seen before; the ground is vastly uneven, but not very high; the sugar canes cover the hills almost to the top, and bear a resemblance in colour at least to a rich field of green wheat . . . The houses are generally placed in the Valleys between the hills, and all front to the sea. We saw many fine ones . . . The other side exhibits quite a different scene, as the ground is almost level, a long tongue of land runs into the Sea, covered with rich pasture, on which a number of cattle feed . . . we saw some very rich plantations all enclosed with hedges, but of what kind I know not.[1]

The Payne family had been large landowners on St Kitts for several generations, and Sir Ralph's father had been Chief Justice and later Governor there. The younger Payne, in common with many children of wealthy white planters, was educated in England; he spent several years during the 1760s on the obligatory Grand Tour of Europe, and then ascended several rungs of the political ladder in Parliament. In 1767 he had married Françoise Lambertine, daughter to Henry, Baron Kobel of Saxony. She had the ear of Queen Charlotte at court in London, and four years later her husband was created a Knight of the Bath and appointed to his two colonial posts. With his return to the Leewards, Payne inherited a large estate from his parents on St Kitts, although he took up his main residence on Antigua, the largest island in the group and the traditional centre of colonial government.

In the Leewards Payne was a highly-privileged member of an influential oligarchy of rich white families. They headed a social hierarchy that was built upon the all-pervasive institution of black slavery. First settled by the British in the 1620s,

7. *A View on the Island of Antigua: The English Barracks and St John's Church from the Hospital* 1775–6. Watercolour over pen and ink, 51.5 × 73.6. Paul Mellon Collection, Upperville, Virginia.

8. *Court House and Guard House in the Town of St John's, Antigua* 1775–6. Watercolour over pen and ink, 51.1 × 73.6. The Trustees of the Victoria & Albert Museum.

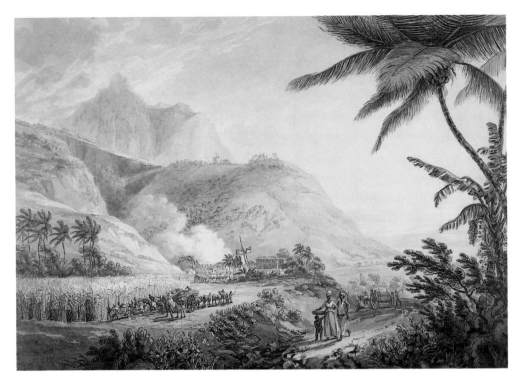

the Leewards had gradually become a vital part of an expanding, transatlantic commercial empire. Since the 1720s sugar-cane production, using the labour of black slaves from West Africa, had expanded and become so important to Britain, that it eventually transformed every aspect of Caribbean life. The British affection for tea and coffee drinking had grown dramatically after 1750, and with it sugar imports. By the time Hearne and Payne arrived in the Leewards, sugar consumption in Britain had risen to four times what it had been in 1700 and exceeded eightfold that of the French. Sugar imports were far higher in monetary value than any other single commodity brought into Britain in the 1770s.[2] Because of this, in the West Indies, and particularly in the older colonies such as the Leewards, larger proprietors producing only sugar were tending to buy out the smaller, more diversified landowners. The large planters in turn shipped in huge numbers of black slaves to solve the continuing shortage of labour, caused by proliferating sugar estates and the inability of the existing slave population to maintain its own numbers. Many blacks died on the voyage from West Africa (mortality rates averaged 15–20% during the eighteenth century); furthermore, around one third of those who survived the passage and reached the plantations died within three years.[3] The case of Barbados was typical: between 1708 and 1735 the islanders imported 85,000 new slaves in order to raise the black population from 42,000 to 46,000.[4]

In the 1720s there were 12,943 slaves and 5200 whites on Antigua; by 1774 there were 37,308 slaves and 2590 whites.[5] The white West Indians, a diminishing

11

percentage of the total population, were gripped by two ever-present fears: the first was the threat of a French sea-borne attack from nearby Martinique and Guadeloupe;[6] the second was that of an insurrection among the expanding slave population.[7] It was held that the West Indian rural economy was fundamental to prosperity at home; besides supplying the sugar, its processing required British made 'coppers, mill cases, ladles, skimmers, mill stills and almost numberless other articles'. It was therefore necessary to provide considerable naval and military support for the Leewards, and particularly for Antigua.[8]

As Captain-General, Payne had joint authority over the four companies of regular British troops stationed in the Leewards. As a planter, he owned more than five hundred slaves. The leader of the British colonial administration, Payne also had numerous influential contacts in London; nevertheless, he was very popular as Governor-in-Chief, an almost unique circumstance for someone in his position. As one contemporary, John Luffman, wrote: 'If a Governor is an active man and looks with perspicuity into public affairs, as becomes the good magistrate and the true representative of Royalty, he is hated ... he will ... check smuggling, which is carried on in a great degree between this island, and those of the French, Dutch and Danes'. Luffman then went on to explain the undoubted popularity of Payne and another of his predecessors, by arguing that both were 'West Indians, who knew the dispositions of the people they had to govern, and by prudently keeping the arrogant at as great a distance as the more modest would naturally keep themselves, they had the good fortune to be approved'.[9] Indeed, when Payne was recalled from his post as Governor-in-Chief in 1775, it was much against the will of the inhabitants of the Leewards, who petitioned for his continuance in office; a unanimous vote in the assembly approved the presentation of a sword set in diamonds.[10]

Payne commissioned Hearne to celebrate and commemorate his stewardship of the Leewards, and during his three and a half years there Hearne recorded the towns, harbours, scenery, agricultural life and people. He retained almost one hundred and forty of the drawings which he made in the course of preparing a series of twenty large watercolours for Payne between 1775 and 1776.[11] Only three of this set have so far been traced but from them, together with a handful of related drawings and a consideration of contemporary writings by others, we can begin to examine how he tackled the commission and set about depicting the topography of the Leewards and its social character.[12] To do this, it is important to consider the ideological context of these images and to re-examine what is meant by 'topographical draughtsmanship', especially that done on commission.

Behind the compositional arrangements and techniques of the three large water-colours known to have been commissioned by Payne, lie the traditions of architectural and military draughtsmanship. The Court House and other buildings in the main street of St John's (illus. 8) recall Paul and Thomas Sandby's architectural

10. *A View on the Island of Antigua: The Front of the English Barracks, St John's from the Parsonage* 1775–6. Watercolour over pen and ink, 51 × 73.5. Jacob Underhill Collection, Antigua.

views (illus. 20), with the foreground arranged to lead the eye deep into pictorial space. The two views of the Barracks at St John's (illus. 7, 10) rely more on the watercolours made by Thomas Sandby for the Duke of Cumberland, during the latter's military campaigns in Scotland (1745–6) and in Flanders (1747–8; illus. 11). Through his contacts with Woollett and Banks, Hearne may well have known of

11. Thomas Sandby: *A View of Diest from the Camp at Meldart* 1747. Pen and black ink and watercolour over pencil, 38.5 × 70.5. Windsor Castle, Royal Library. © 1988 H. M. the Queen.

Sandby's many replicas of these watercolours (made in the 1760s); Hearne after all was also surveying a British military presence, albeit in the West Indies. The compositional patterns common to both Hearne's views and Sandby's post-Culloden works imply that there was an accepted model for depicting colonial landscape, one which was derived from military draughtsmanship and related to notions of conquest and dominance. This model gave Hearne the means by which to show colonial buildings and personnel as signifying undisputed British authority

13

over an extensive terrain, a form of representation almost akin to making a mapped landscape.

In picturing the Barracks from the military Hospital (illus. 7), Hearne paid particular attention to architectural detail and also to the landscape elements. The Barracks and Hospital were constructed after the original barracks had been severely damaged during a hurricane in 1772. One observer thought the new buildings 'spacious and healthy and allowed to be the most complete in the islands'.[13] Hearne took his view from the Hospital, just beyond which was the plentiful water provision for the garrison – the exceptionally large reservoir that was necessary to compensate for Antigua's lack of rivers (only one small stream existed) and to exploit the rainfall.[14] A well, complete with water-bucket, rope and wheel, appears on the Hospital wall at the extreme left of the picture. In the far distance Hearne has included a glimpse of the harbour, one of the largest in the West Indies, served by a dockyard in which repairs could be undertaken without ships having to return to Britain. This was of the utmost importance for the success of the maritime wars with France which flared intermittently throughout the eighteenth century.[15]

The view thus gives us both the military buildings erected during Payne's governorship and the other improvements undertaken, with English Harbour and the Anglican parish church of St John's as a background. The impression conveyed is that Antigua is a well-defended, well-planned and stable British colony. A group of five black people and a free coloured militiaman is in the foreground.[16] The three older black men seem to be playing a game of chance. The two younger ones on the left appear to be dressed as domestic servants and the third in the loose garment of a field-slave.[17] With them are two young black children playing in an empty barrel, beside which is a large basket of fruit and produce. In the 1780s John Luffman observed that after the great Sunday market, the one day of the week when black slaves could do a small amount of trading for themselves, some 'play at dice (as they call it) with small shells, and frequently lose, not only every dog that they have been working for through the day, but so great is their love of play, that the very trifling clothes from their backs is a forfeit to their mischance'.[18] This prominent group of slaves gambling did more than simply provide appropriate foreground pictorial interest: it suggests that Payne would have approved of an image of three generations of blacks, at ease in a well-run and orderly society, yet carefully watched over by a military presence, composed in part of free-coloured militiamen. Such were the sentiments of Janet Schaw, a Scottish visitor to Antigua in 1774–6, recorded in her journal when she witnessed the Sunday market celebrations of black slaves on Boxing Day, 1774: 'We met the Negroes in joyful troops on the way to town with their Merchandize . . . Both men and women carried neat white wicker-baskets on their heads'. These were filled with vegetables and fruits for sale at the market.

14

At this season the crack of the inhuman whip must not be heard, and for some days it is Universal Jubilee; nothing but joy and pleasantry to be seen or heard, while every Negro infant can tell you, that he owes this happiness to the good Buccara God . . . It is necessary however to keep a look out during this season of unbounded freedom; and every man on the Island is in arms and patrols go all round the different plantations as well as keep guard in the town. They are an excellent disciplined Militia and make a very military appearance.[19]

When Payne became Colonel of the Militia's carabineers in 1773, he would have been personally involved in just such operations as those Janet Schaw described. Her inconsistent views on black slaves (she was archly patronizing – 'joyful troops', and also fearful of rebellion) were typical of patrician opinion both in Britain and the colonies. Similar ideas can be found in James Grainger's georgic poem, *The Sugar Cane* (1764), in which Grainger recommended that 'festal days' should be carefully managed lest they ended in blacks committing 'fell acts of blood, and vengeance'.[20] Underlying these views was the influential white ideology which, since the sixteenth century, had defined blacks as inferior human beings. Thus, Lord Chesterfield argued that Africans were 'the most ignorant and unpolished people in the world, little better than lions, tigers, leopards, and other wild beasts, which that country produces in great numbers'; it was therefore not immoral 'to buy a great many of them to sell again to advantage in the West Indies'.[21] One objector to this attitude was the Tory humanist, Samuel Johnson, who voiced the thoughts of many religious abolitionists when he opposed slavery as being contrary to the divinely ordained precept that 'no man is by nature the property of another'.[22] In reviewing *The Sugar Cane* in 1764 Johnson wrote that

The fourth and last book begins with a striking invocation to the genius of Africa, and goes onto give proper instructions for the buying and choice of Negroes . . . The poet talks of this ungenerous commerce without the least appearance of detestation; but proceeds to direct these purchasers of their fellow-creatures with the same indifference that a groom would give instructions for chusing a horse.[23]

A celebrated legal case in 1772 brought the question of slavery to the forefront of British public life and established the important principle that black slaves could not be deported to the colonies if they had proclaimed their freedom while in England. When summing up, Lord Mansfield commented that the 'state of slavery . . . is so odious, that nothing can be suffered to support it, but positive law. . . . I cannot say this case is allowed or approved by the laws of England and therefore the black must be discharged'.[24]

Hearne's paintings were made against a background of rising disquiet about the institution of black slavery, but the content of his watercolours reflected the orthodoxy of his patron and the local authorities. Indeed, the view of the Court House and Guard House in St John's (illus. 8) features the arrival of Payne's impressive coach-and-six in the main street, and its welcome by a full military parade. On close inspection this rich image reveals much of Antiguan social life.

The Court House, the large classical building on the right, considered 'the best in the West Indies',[25] was built of stone brought from Pelican Island, about nine miles away; it was the political, judicial and administrative centre of colonial Antiguan government. Opposite was the Guard House, the military headquarters on St John's, and St John's parish church, built 1740–5, the main Anglican place of worship on the Island. Janet Schaw remarked on the opulence of the interior of the church and, in particular, 'The seat for the Governor-General is noble and magnificent, covered with Crimson velvet; the drapery round it edged with deep gold fringes; the Crown Cyphers and emblems of his office embossed and very rich'.[26]

The arrival of the Governor was an appropriate event to depict in this location, but Hearne also included other groups of figures in the foreground which accord with contemporary accounts. Janet Schaw recorded that the English women on the island drank only lime juice and water and that 'while the men are gay, luxurious and amorous, the women are modest, genteel, reserved and temperate'. They only wanted colour, she said,

to be termed beautiful . . . I am convinced this is owing to the way in which they live, entirely excluded from proper air and exercise. From childhood they never suffer the sun to have a peep at them, and to prevent him are covered with masks and bonnets, that absolutely make them look as if they were stewed.[27]

This was to prevent any confusion between them and other members of Antiguan society, such as the mixed-blood mulattos, quadroons and mestees. Colonial society was sensitive to the subtle levels of differentiation between black and white, slave and free-born. Hearne has depicted this racially motivated feeling of cloistered gentility in his group to the left foreground, where a black servant shields the white woman with a parasol while her dandified child plays with a dog; the other Englishwoman on the extreme right, casting a shadow on the wall, also shields herself from the sun. The several black figures which also occupy the foreground, all appear to be dressed as different types of domestic servant. John Luffman noted that black male servants never wore stockings and generally went without shoes. He found many servants in rags and felt that 'were the slaves to go quite naked it would have no more effect on the feelings of the major part of the inhabitants of this country than what is produced by the sight of a dog, cat or any other domesticated quadruped'.[28]

Sir Ralph Payne saw his own black servants rather as ornamental but unhygienic appendages:

He was attended by an army of servants, but he would not allow any of the black servitors about him to wear shoes or stockings, their legs being rubbed daily with butter so that they shone like jet; and he would not, if he could avoid it, handle a letter or parcel from their fingers. To escape the indignity, he designed a golden instrument, like tongs, with which he held any article which was given him by a black servant.[29]

Hearne's is a composite image of the pomp of British colonial power and enforced black deference and industry; the servant on the left adjusts the angle of his mistress's parasol; the black servant to their right pushes a hogshead of sugar, signifying Antigua's monocultural trade with Britain.

Only one of the many small sketches Hearne made on the Leewards has so far been traced. *Negroes on mules, Antigua* (illus. 12), appears to record a scene similar to one observed on Jamaica by Lady Nugent in the early nineteenth century. She described a race-meeting, where free blacks and mulattos 'dressed in the extreme caricature of English fashion', wore blue coats with large brass buttons with waistcoats of silk or satin in gaudy patterns, set off by white trousers.[30] Mules, as Janet Schaw observed, were normally used to pull the heavy wagons on the island and were seldom ridden.[31] Hearne's drawing has an element of caricature, though whether this was meant to satirize the fashions of the wealthy white planters by contrast with the blacks, or whether it was directed at the blacks themselves is uncertain. Hearne's working methods at this period display themselves here. Initially, the outline was drawn freely in pencil, as in the half-realized figure to the left. The resolved outline was then completed in pen and ink, before watercolour washes were applied. This common procedure followed Paul Sandby's practice in his figure studies.[32] Making the finished large-scale watercolours combined varied skills, beginning with careful and accurate architectural draughtsmanship. The buildings then had to be arranged in the kind of balanced composition that had been refined by Sandby, and embellished with judiciously placed and elegantly drawn figure-groups, chosen carefully from such sketches as those discussed above. Hearne's three large watercolours were drawn in pen and ink, unlike many of his smaller landscape drawings (whether made before or after his West Indies visit), which are in pencil. He tended to reserve bold ink outlines for works either

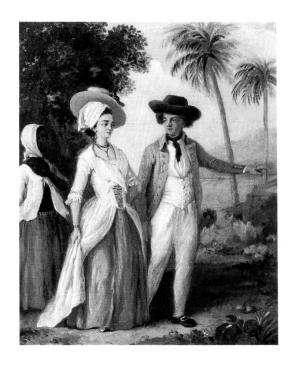

13. Augustin Brunais: *A Planter and his Wife attended by a Servant*. Oil on canvas, 30.5 × 24.75. Yale Center for British Art, Paul Mellon Collection.

commissioned or meant for exhibition; the less emphatic pencil drawings were often destined for private portfolios.

Hearne was not the only artist in the West Indies in the 1770s. Augustin Brunais (*fl.* 1752–79) was on Dominica in the Windward Islands probably from *c.*1769–73, under the patronage of the governor, Sir William Young.[33] Young also had estates elsewhere, including Tobago, St Vincent and Antigua, and Hearne and Brunais may therefore have met. Hearne's figure-groups are not unlike those in small oil paintings by Brunais (illus. 13), although the latter artist's main focus was on costume and custom: markets, village and harbour scenes, with groups of figures engaged in dancing, conversation and merrymaking. The influence may have been mutual, for in exhibition pieces of the late 1770s, which included more prospect-like landscapes, Brunais could have taken his cue from the large watercolours Hearne had made for Payne in 1775–6. A slightly later traveller to the West Indies, George Robertson (1749–88), accompanied William Beckford to Jamaica in 1774.[34] Beckford, an opulent plantation owner, published *A Descriptive Account of the Island of Jamaica* in 1790. His approach was above all picturesque: he admired the landscape of the Roman Campagna as popularly depicted by Claude and Gaspard Dughet, and he felt that Jamaica compared well with

the most wild and beautiful situations of Frascati, Tivoli and Albano . . . From many situations you have views so much diversified, that, wherever you turn, a new prospect delights the eye, and occasions surprise by the magnificence of the objects, by the depths of shadow or bursts of light, by the observation of gloomy dells or woody plains, of mountain torrents and of winding streams; of groups of negroes, herds of cattle, passing wains; and by the recurrence of every rural object that imagination can form, or attention discriminate.[35]

18

The Italian landscape as depicted by Claude was described in 1778 by the Revd Martin Sherlock in similar terms. Italy was Nature's 'favourite masterpiece', where

she seems to have made an effort to unite all her beauties in a single work . . . smiling ascents and fertile plains, majestic rivers and delightful lakes, rich hills and richer valleys . . . a chain of barren mountains . . . a vast and dreary marsh.[36]

Beckford's eccentric adaptation of the European picturesque tradition also conditioned his commission to Robertson. Of the many landscapes Robertson made in Jamaica for his patron, six were engraved in 1778.[37] His views (illus. 14) dutifully correspond to Beckford's verbal descriptions with such picturesque features as blasted trees, rural figure-groups, shaded river crossings and sunlit distances. Many were based on the River Cobre and Roaring River on Beckford's own plantation, yet there is no depiction of work in any of the prints because, as Beckford specified, black slaves were to be considered merely as neutral 'rural objects' in an ideal landscape. The picturesque mode enabled both Beckford and Robertson to present black slavery as a 'natural' part of the plantation landscape; this tallied with Beckford's belief that blacks were 'slaves by nature' and expressed one aspect of the planters' ideology.[38] Hearne's images of Antigua, on the other hand, seem closer to the viewpoint of a British governor-general, with their emphases on colonial buildings, military personnel and an integrated, hierarchic society.

After completing his watercolours for Payne, Hearne still sometimes chose to work from his stock of West Indies sketches. *Parham Hill House and Sugar Plantation, Antigua* (illus. 9) is a drawing which probably originated in a commission of 1779

19

in England from Clement Tudway of Wells, or perhaps another member of the same family. The Tudways were originally London merchants and had purchased Parham Hill plantation in the late seventeenth century. The affairs of the plantation were conducted in Antigua and London by the family until 1732, when the last Tudway heir resident in the island died. From then on the Tudways were absentee owners, with Parham Hill run by a manager and overseers.[39] Like many wealthy planter families they eventually abandoned the culturally confined Leeward Islands for a more elegant and comfortable life in Britain. Nevertheless, according to Janet Schaw,

Antigua has more proprietors on it however than any of the other Islands, which gives it a great Superiority. St. Christopher's, they tell me, is almost abandoned to Overseers and managers, owing to the amazing fortunes that belong to Individuals, who almost all reside in England.[40]

The Tudways absentee status is central to this commission. Hearne's relatively high viewpoint allowed him to map out an extensive view of the geography and activity at Parham Hill. The sugar plantation is shown being worked by slaves. Hearne chose to represent springtime, the busiest time of the year, with the ripened cane being cut, milled and processed. To the left a field gang is shown cutting ripe cane and loading the bundles onto a cart. The mounted white overseer gestures towards the mill and boiler-house; cane had to be milled as soon as possible to prevent deterioration. By the 1770s most mills in the Leewards were wind-powered (exploiting the reliable trade winds), replacing the more primitive machines that were driven by cattle. Steam is shown rising from the boiler-house, where the pressed cane-juice was evaporated in a series of coppers to produce raw muscovado sugar. The production cycle is shown completed by the scene in the right foreground where another cart transports two hogsheads of muscovado down to the coast at Parham harbour for shipment to England.[41] Behind the factory area on the right is Parham Hill House itself.

As absentee planters there seems good reason to think that the Tudways would have appreciated such a representation of their plantation. A strolling black group in the foreground, however, fits uneasily into the picture space and also seems at odds with the almost narrative elements in the scene; the female figure here is a reworking of one used in *The English Barracks, Antigua* (illus. 10). The 'family' group appear to be slaves as an absentee planter might want to see them, at ease in the heart of an efficient economic and social system. Hearne emphasizes the connection of the local with the imperial economy, by constructing his composition along conventional lines: the overarching palm tree is a customary framing device and Antigua's low hills have become exaggerated into a backdrop of dramatic mountains.

It is significant that there was a well established literary and social convention

which maintained that the labour of the slave gangs was relatively easy and that the black men and women enjoyed their labour. This description of a working slave-gang is from Grainger's *The Sugar Cane*:

> The Negroe-train, with placid looks, survey
> Thy fields, which full protection have attain'd.
> And pant to wield the bill: (no surly watch
> Dare now deprive them of the luscious Cane:)
> Nor thou; my friend, their willing ardour check;
> Encourage rather; cheerful toil is light.
> So from no field, shall slow-paced oxen draw
> More frequent loaded wanes; which many a day,
> And many a night shall feed thy crackling mills
> With richest offerings; while thy far seen flames,
> Bursting thro' many a chimney bright emblaze
> The Aethiop-brow of night.[42]

This echoes James Thomson's verse accounts in *Summer* (1727) and elsewhere, of the British agricultural labourer always content in 'Happy Britannia . . . Pleased and unwearied in his guarded toil'.[43]

Grainger's point of view was widely held: although slavery might theoretically be regrettable, many relished the notion of a comfortable estate prospering under slave cultivation. A similar line was taken by the leading and most senior planter in Antigua in the 1770s, Samuel Martin. His *Essay upon Plantership*, in its fourth edition by 1765, was the authoritative work for 'progressive' slaveholders. He stressed that 'a liberal education is undoubtedly the principal ingredient necessary, to form a good planter'. The gentlemanly virtues were needed in deciding 'what is the right or rational method of treating negroes, for rational beings they are, and ought to be treated accordingly; that is with humanity and benevolence, as our fellow creatures, created by the same Almighty hand'. Yet Martin's motives were primarily economic: 'as it is the interest of every planter to preserve his negroes in health and strength; so every act of cruelty is not less repugnant to the master's real profit, than it is contrary to the laws of humanity'. In his sections on the practical running of an estate, Martin asserted that 'negroes, cattle, mules and horses are the *nerves* of a sugar plantation'. The whole success of the enterprise depended on these *nerves*, 'as in a well-constructed machine, upon the energy and right disposition of the main springs or primary parts'. And again: 'a plantation ought to be considered as a well-constructed machine, compounded of various wheels, turning in different ways, and yet all contributing to the great end proposed'.[44]

Janet Schaw saw a scene very similar to that described by Grainger and depicted by Hearne:

The Negroes who are all in troops are sorted so as to match each other in size and strength. Every ten Negroes have a driver, who walks behind them, holding in his hand a short whip and a long one. You will too easily guess the use of these weapons; a circumstance of all others the most horrid. They are naked, male and female, down to the girdle, and you

constantly observe where the application has been made. But however dreadful this must appear to a humane European, I will do the Creoles the justice to say, they would be as averse to it as we are, could it be avoided, which has often been tried to no purpose. When one comes to be better acquainted with the nature of the Negroes, the horrour of it must wear off . . . It is the suffering of the human mind that constitutes the greatest misery of punishment, but with them it is merely corporeal. As to the brutes it inflicts no wound on their mind, whose Natures seem made to bear it, and whose sufferings are not attended with shame and pain beyond the present moment. When they are regularly Ranged, each has a little basket, which he carries up the hill filled with the manure and returns with a load of canes to the Mill. They go up at a trot, and return at a gallop, and did you not know the cruel necessity of this alertness, you would believe them the merriest people in the world.[45]

This of course was the reality of Grainger's 'cheerful toil'. Janet Schaw could justify slavery and the appalling cruelty it involved only by remembering the economic utility of the produce and by denying the humanity of the slaves.

In 1804 Hearne worked up one final watercolour from his West Indian sketches (illus. 15); it has the pencil underdrawing and freer watercolour washes characteristic of his later work. The scene is a calm period on the quarter deck of the *Deal Castle* during Hearne's passage home from the Leewards in 1775. It is notable for its attention to the details of shipboard life, as discussed in a recent account of the Georgian navy:

The view is taken from outside the captain's cabin door, looking forward along the port side. Note the untethered goat, and the fowls in coops stacked behind the man at the wheel. Behind the two officers talking in the foreground some work is being done on the main rigging. At the starboard gangway (in the right background) the midshipmen have assembled with their quadrants to practise taking their noon sights. This was the most spacious and least cluttered area of deck in the ship.[46]

When Hearne returned to England in the early months of 1775 he may have felt that he was returning to what appeared to be an island of liberty in a world of slavery. In 1772 Arthur Young, in one of his characteristically pithy if simplistic social calculations, estimated that in the whole population of the world, some 775 millions, only about 33 million people lived in what he called liberty; nineteen out of every twenty were unfree.[47] Adam Smith was to express a similar view in *The Wealth of Nations* in 1776:

The pride of man makes him love to domineer, and nothing mortifies him so much as to be obliged to condescend to persuade his inferiors. Wherever the law allows it, and the nature of the work can afford it, therefore, he will generally prefer the services of slaves to that of freemen.[48]

Slavery was the norm; the state of liberty was the anomaly, according to this well-established view.[49] We can only speculate upon Hearne's reactions to his three and a half years in the West Indies. He would have enjoyed great social privileges

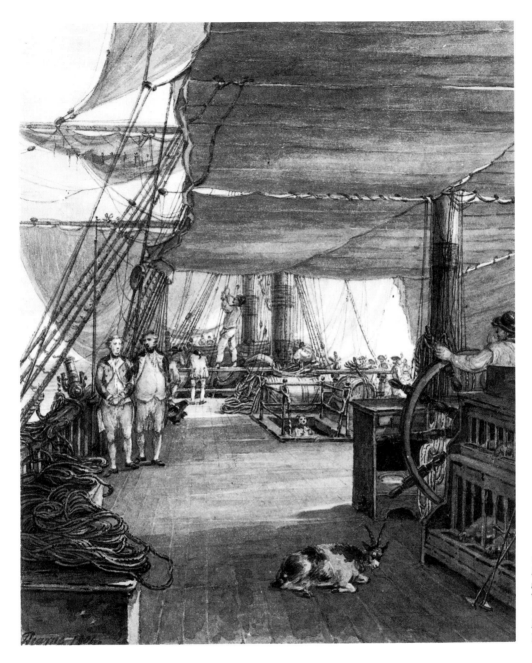

15. *A Scene on board HMS Deal Castle on a voyage from the West Indies*, 1775 1804. Watercolour over pencil, 19.1 × 15.6. The National Maritime Museum, London.

in Antigua, simply by being English and white. The wealthy planters with whom he socialized lived opulent lives, yet Janet Schaw did not feel they should be blamed: 'since nature holds out her lap, filled with everything that is in her power to bestow, it were sinful in them not to be luxurious'.[50] Hearne's watercolours show that he was able to discharge his commission effectively. It would be fascinating to know more about his experiences, but sadly his many letters sent from Antigua to Woollett have not been traced.[51]

23

The Antiquities of Great Britain

In 1776, having completed his commission for Sir Ralph Payne, Hearne again turned his attention to the British antiquarian and landscape subjects that had occupied him as an apprentice. Drawings exhibited at the Society of Artists in 1777 show that he had recently visited Wiltshire, Worcestershire, Suffolk and Kent in search of suitable subjects.[1] John Britton recalled Hearne at this period when he was

profitably and successfully employed as a topographical artist. The commanding ruins of Malmesbury Abbey naturally excited his curiosity and gave occupation for his faithful pencil. With some truthful and beautiful views of them he induced Mr. William Byrne to join him in publishing a series of engravings under the title of *The Antiquities of Great Britain*.[2]

Although trained as an engraver, Hearne had now entered the thriving world of print publishing as a draughtsman, owning a half-share in the plates and impressions made from his drawings and watercolours. Hearne and Byrne's *Antiquities* began publishing in May 1778, when a set of four engravings and accompanying texts were issued. Prints continued to be published for Volume I, usually in groups of four, at fairly regular intervals of between three to six months, until the spring of 1786 when the volume closed at fifty-two engravings and the collection was issued as a bound book. After 1786 the publication lapsed until 1796, when Byrne was persuaded by two members of the Society of Antiquaries, Joseph Windham and a Mr Peachy, to begin a second volume.[3] Thirty-two prints were published for this, beginning in May 1796; a set of four was issued each year until 1800, when Hearne's ill-health and disinclination to travel in order to make new drawings, led to the prints being issued biennially until the volume was completed in 1806. A year later the two volumes were re-issued together.

Hearne and Byrne joined other artists, engravers and publishers in responding to a rising demand for visual images and information relating to British history. The native antiquarian impulse had originally been stimulated by the sense of loss felt after the dissolution of the monasteries in the 1530s and the ravages of the Civil War in the 1640s; such religious and social dislocation prompted many scholars, including William Dugdale (1605–86) and John Aubrey (1626–97), to seek out and record the nation's medieval remains. This resulted in the burgeoning demand for topographical drawings and for prints of monasteries, castles and other sites.[4] By the mid-eighteenth century, many influential patricians were avidly studying the architecture and literature of British antiquity. One of the most remarkable of them

was Richard Gough (1735–1809); Gough had studied classics at Cambridge but, like many students of the time, left without taking a degree. He became captivated by medieval buildings while on an East Anglian tour in 1756, and his *Anecdotes of British Topography* (1768) was the fruit of twelve years of original research and wide reading. In 1771 he was appointed Director of the Society of Antiquaries, remaining in the post until 1797. He summed up his early aspirations in the Preface to the *Anecdotes*:

Curiosity to visit as much of my native country as I had opportunity, excited a desire to know all that related to its topographical antiquities ... These Anecdotes have informed and amused the collector: – if they only amuse the readers I shall not be absolutely condemned; – if they inform them, my passion for British antiquities becomes a zeal to serve the public.[5]

Gough's 'passion' was revealed in his strictures on the long-standing and overwhelming popularity of classical studies, and what he saw as the pernicious effects of the Grand Tour through Europe and the Near East, undertaken as the culmination of an aristocratic education:

We penetrate the wilds of Europe, and the desarts of Asia and Africa, for the remains of Grecian, Roman and earlier architecture, while no artist offers himself a candidate for fame in preserving those of our forefathers in their own country ... Temples and palaces of the polite nations of antiquity engross our attention, while the works and memorials of our own priests and heroes have no effect on our curiosity.[6]

These views were widely held among British antiquarians. P. V. Borlase, the Cornish parson who published the *Antiquities . . . of the County of Cornwall* in 1769, declared:

It is the usual observation of foreigners, that the English Travellers are too little acquainted with their own Country; and so far this may be true; that Englishmen (otherwise well qualified to appear in the world) go abroad in quest of the rarities of other countries, before they know sufficiently what their own contains; it must be likewise acknowledged that, when these foreign tours have been completed, and Gentlemen return captivated with the Medals, Statues, Pictures, and Architecture of Greece and Italy, they have seldom any relish for the ruder products of Ancient Britain.[7]

Gough was concerned about the detrimental effects such an education might have on the serious study of British medieval buildings:

One cannot enough regret the little regard paid to Gothic architecture of which so many beautiful models are daily crumbling to pieces before our eyes ... Had the remains of antient buildings been more attended to we should before now have seen a system of Gothic architecture in its various areas; we should have had all its parts reduced to rules; their variations and their dates fixed together.[8]

Some, who had paid attention to Gothic architecture, attempted to adapt it to comply with classical rules. The canonical example of this was Batty Langley, who

published his *Ancient Architecture Restored and Improved* in 1742. Langley held Gothic to be a debased Roman style, and therefore capable of improvement by the application of classical principles derived from Vitruvius and Palladio. His book influenced such committed Gothic enthusiasts as Sanderson Miller and William Shenstone.[9] Even Horace Walpole, whose central role in the revival of interest in all things medieval is well documented, tempered his enthusiasm for the use of Gothic in domestic architecture (best seen at Walpole's home, Strawberry Hill), by an unqualified belief that classical architecture was innately superior and more correct; Gothic was akin to 'bad Latin'.[10] Other authors, however, had stressed the independence of the Gothic style and dwelt on its ability to engender feelings of religious awe. In 1751 William Warburton praised Gothic as a 'new species of architecture, unknown to Greece and Rome; [founded] upon original principles and ideas much nobler than what had given birth even to classical magnificence'.[11] Seven years later, the architect John Gwynn contrasted the 'magnificence . . . of true, pure, and antient Gothick' found in Westminster Abbey, with the 'cold rules' of 'antient Rome and Greece'; he lauded the ability of Gothic buildings to give 'religious impressions . . . of the Deity'.[12] Stimulated by the continued dominance of classical models and the early progress of the Greek Revival, the overt nationalism in the work of antiquarians like Gough and Borlase in the late 1760s was reiterated by other commentators in the following decade; they similarly regarded the style as capable of reinforcing religious beliefs. John Carter, draughtsman and joint author of *The Builder's Magazine* between 1775 and 1778, deplored the fact that Gothic had 'for these few years past fallen greatly under the censure of immodest admirers of Grecian architecture'. He argued that 'Grecian and Roman architecture should be confined to mansions and other structures of ease and pleasure . . . affirming with confidence, nothing can be more in character, and better adapted, to a place of worship, than that awful (i.e. gothic) style of building'. Carter believed that students of the subject needed to know that 'Gothic architecture has been ages back the taste of Englishmen, and not entirely to be led away with Grecian architecture alone, because it is the invention of foreigners'.[13]

More generally, such research and writing, together with comparable artistic activity which included Hearne and Byrne's *Antiquities*, was central to the unprecedented movement, beginning in the 1740s, to collect, study and promote everything pertaining to the national past. Contemporaries believed that the most obvious threats to British culture were from France and Spain, especially during times of war. Less clear, but as important, was the growing sense of an internal betrayal of the national spirit and of moral decline, brought about through abuse of wealth, the growth of 'luxury' and the affectation of foreign, particularly French, habits, manners and attitudes.[14] Outbursts against corrupt patrician attitudes were often articulated in the 1770s, extending and amplifying the complaints of writers such as Gough and Borlase. In 1773 Horace Walpole wrote:

What is England now? ... A sink of Indian wealth, filled by nabobs and emptied by Macaronies! A senate sold and despised! ... A gaming, robbing, wrangling, railing nation, without principles, genius, character or allies; the overgrown shadow of what it was![15]

The monarchy and Church had been torn by crises during the 1760s. The Wilkes affair, together with unrest in the American colonies, had awakened misgivings which grew throughout the 1770s. The demoralizing British defeat at Saratoga in October 1777 and the entry of France into the war in February 1778, were followed in the summer of 1779 with a threat of invasion, after Spain also declared war against Britain. Conflicts mounted at home, culminating in the anti-Catholic and anti-Government Gordon Riots in June 1780. In November 1781 (the year before the final American victory), Walpole wrote to William Mason:

Our empire is falling to pieces; we are relapsing to a little island. In that state, men are apt to imagine how great their ancestors have been ... the few, that are studious, look into the memorials of past time; nations, like private persons, seek lustre from their progenitors.[16]

We know that Sir George Beaumont was pursuing his own family history, using Hearne's antiquarian contacts, by late 1778. In December of that year, Hearne received a reply from the herald, J. C. Brooke, to an enquiry he had made on Beaumont's behalf:

The family of Beaumont is of great antiquity, they were in England in the rank of Barons in Edw. I time, and are said to be lineally descended from the male line of the family of the present Kings of France; the fee for copying pedigrees from the Herald's Office is 5s. per descent, and upon a survey which Mr. Brooke has taken of the Beaumont pedigree, he finds, that Sir George may have a complete copy for about Six Guineas.[17]

It was precisely now that the Society of Antiquaries began experiencing a new influx of landed aristocratic members; the numbers had grown to 376 in 1784; by 1807 membership had risen to 849, swollen by the restrictions imposed on foreign travel by the Napoleonic Wars.[18]

The enthusiasm for touring in Britain itself had been developing within the fashionable élite, the gentry and the middling ranks since the 1750s. Large numbers flocked to the London attractions; spa towns such as Bath, Buxton, Tunbridge Wells, Cheltenham and Harrogate offered the tourist an abundance of 'delights', including medicinal waters, the marriage-market and gaming-tables. Keen antiquarians, such as William Stukeley, had often travelled to see ancient sites in the early eighteenth century, but medieval buildings and ruins were now increasingly visited, along with country houses and landscape gardens, as part of tours to 'picturesque' regions, such as the Derbyshire Peak, the Lake District and the Wye Valley. The new taste for landscape developed out of the cultural aspirations of the landed élite; they revered the idealized classical landscapes of Claude, Dughet and Salvator Rosa (familiar to them at least through engravings) and sought comparable views and prospects in the British countryside. Antiquarian remains were perceived

as constituent parts of the landscape, and given increased status by their association with those to be seen in paintings of idealized landscapes. From the 1780s the publication of the Revd William Gilpin's *Observations . . . relative to Picturesque Beauty* (which had been circulating in manuscript in the 1770s), and many similar works by others, interpreted the new taste; they popularized a set of rules for looking at nature, and helped to create a visually sophisticated audience to which all landscape artists, including Hearne, sought to address themselves. Gilpin had a particular love for antiquities in the landscape and summed up his views on them in 1792:

among all the objects of art, the picturesque eye is perhaps most inquisitive after the elegant relics of ancient architecture; the ruined tower, the Gothic arch, the remains of castles, and abbeys. These are the richest legacies of art. They are consecrated by time; and almost deserve the veneration we pay to the works of nature itself.[19]

In one sense, such a publication as the *Antiquities of Great Britain* promised subscribers and purchasers visual souvenirs of well-known sites, just as a tourist today might buy postcards or take a photograph. In order to make sketches for the engravings and exhibited watercolours, Hearne had to become a tourist himself. In the winter of 1776–7, Sir George Beaumont suggested that Hearne spend part of the following summer with him in the Lake District, and then accompany him as a sketching companion on a tour of the North of England. From the Lakes, Hearne and Beaumont travelled through Cumberland then, crossing to the east, they journeyed North to Warkworth in Northumberland before returning to London through Yorkshire and Nottinghamshire. The next year the antiquary, J. C. Brooke, reported another, more ambitious trip:

I called on Hearne this week, who showed me all the views he took in his late tour, which are numerous and very beautiful; chiefly of ruins in Scotland. I find he travels with Sir George Beaumont, a young Leicestershire Baronet, who has a great taste for drawing; last year they went with themselves, but this year Sir George took his lady; they travel in his post coach and four, her maid and one footman and were out two months.[20]

This time, after another visit to the Lakes, they went directly to Scotland, travelling to Glasgow, Stirling, Edinburgh, Midlothian and East Lothian, before heading south through the Borders, Northumberland, Durham and Yorkshire.[21] Thirty-seven of the fifty-two engravings in Volume I of the *Antiquities* derive from these two tours of the North and Scotland. Hearne was unusually privileged to be able to travel with so much speed and in such style; most artists when touring for topographical subjects walked great distances, often on appalling roads in typically British weather.

In the 1770s the North of England and Scotland were becoming popular with tourists (rather than artists) in search of landscape and antiquities, perhaps prompted by the publication of Thomas Pennant's first tour in 1771 and Paul Sandby's

popular Scottish views. Lord Breadalbane complained from his seat at Taymouth in 1773:

We have had a great deal of company here this summer, sixteen often at table for several days together; many of them from England, some of whom I knew before, and others recommended to me, being on a tour through the Highlands, which is becoming *Le bon ton*, but sometimes a little troublesome. Being always in a crowd is not agreeable.[22]

Despite this attention very little serious information was available, especially on Scottish churches and abbeys. Richard Gough observed:

Scotland has had a small share in topographical illustration . . . those given us by Mr. Paul Sandby served but to make us wish for a further acquaintance with the many wild prospects of this country from his pencil. Himself and others have since gratified the curiosity he awakened. The ecclesiastical topography of North Britain is likely to remain in darkness.[23]

Gough (here writing in his second edition of 1780) was no doubt thinking of the engravings published from 1778 by George Kearsley in the *Virtuosi's Museum*. But all Sandby's available Scottish subjects were based on studies made when he was engaged as a military draughtsman forty years earlier. Accordingly, they consisted almost exclusively of castles, only one Scottish ecclesiastical site appearing in the *Virtuosi's Museum* in December 1780.[24] Hearne, however, had been issuing engravings of Scottish abbeys and churches (based on drawings from the 1778 tour) since the middle of 1779. Fifteen of the engravings in Volume I were of Scottish subjects.[25] Hearne was also the first professional artist since Samuel and Nathaniel Buck to publish a large number of engravings of the antiquities of northern England. Taking the River Trent as the boundary, twenty-two of 52 engravings in the first volume were of northern antiquities. In stark contrast to this, the 108 plates of the *Virtuosi's Museum*, contained only two antiquities and three landscapes from northern England.[26]

Although Hearne and Byrne were joint-publishers of the first volume of the *Antiquities*, Hearne seems to have been the guiding intelligence behind its planning. He produced the drawings for all the plates and also compiled the historical texts that accompanied each print, besides exhibiting many of the drawings and watercolours from which the engravings were made at the Society of Artists in 1780 and 1783.[27] His financial stake, and his training under Woollett, gave him the authority and the skill to oversee the successful transformation from drawing to print, while his familiarity with the world of engraving probably assisted him in identifying Byrne as a suitable partner. Byrne trained first with an uncle who engraved heraldry on plate, but later he spent three years in Paris (from 1769 to 1772), 'at that time the chief seminary in Europe for the study of engraving, for improvement'.[28] Byrne's *Proposal* for Volume II records that he was sole proprietor for this series.[29] Joseph Farington reported Byrne as saying that he 'pays Hearne 10 guineas each for the drawings of the *Antiquities of Great Britain*, and he becomes

16. *Stonehenge* 1786. Watercolour over pencil, 16.5 × 28. Henry E. Huntington Library and Art Gallery, San Marino, California.

sole proprietor of the *2d volume* – He sells the drawings for 8 guineas'.[30] This kind of professional arrangement was characteristic of the 18th century, and enabled draughtsmen without patrons to earn a living.

Financially, both volumes had a chequered history. In 1794, after hostilities with revolutionary France had started to hit foreign sales of prints, Byrne proposed to sell one third of the property in the first volume of the *Antiquities* to Edwards, a bookseller. The *Antiquities* were valued at £1200, but the deal was turned down.[31] By 1797 Farington was reporting that 'Byrne complained much of the difficulties of the Times, and said the war had made £2000 difference to him'. He was once again trying to sell some shares of the *Antiquities*, but Farington also noted that 'Hearne does not choose to allow the *Antiquities* to be sold for less than £5 a set if taken in a quantity'.[32] When Byrne died in 1805, his son John took over as joint proprietor of the first volume. He and Hearne eventually sold off this work to the publishers Cadell and Davis, in addition to the thirty-two prints in the second volume, in which Hearne had no share. Both volumes together were valued at £1600.[33] Despite these difficulties from the mid- 1790s, the first volume was initially successful, and it secured considerable support from subscribers when issued as a bound work in 1786. These subscribers included antiquaries, artists and writers, such as Richard Gough, Sir Henry Englefield, Francis Grose, Farington, Paul Sandby, John Webber, Woollett and Edward Gibbon, which gives some idea of

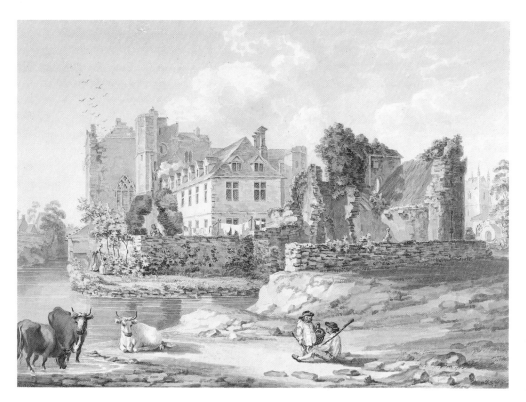

17. *Beverstone Castle, Gloucestershire* 1776. Watercolour and bodycolour over pen and ink, 18.5 × 25.5. Bolton Museum and Art Gallery.

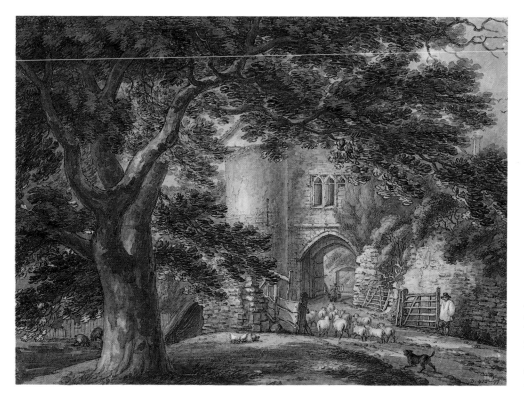

18. *Allington Castle, near Maidstone, Kent: the Outer Gateway* c.1782–3. Watercolour and pen and ink over pencil, 18.5 × 25.4. The Trustees of the Victoria & Albert Museum.

31

the breadth of appeal of this kind of work. It extended to many leading art connoisseurs and collectors: Joseph Banks, Beaumont, Oldfield Bowles, Richard Colt Hoare, Thomas Johnes, Richard Payne Knight, Dr John Monro and Sir Watkin Williams Wynn. The Royal Academy subscribed to both volumes for its library, the Council recording their particular admiration for the *Antiquities* when considering a number of different series of prints for purchase in 1804.[34]

When Hearne and Byrne issued the first *Antiquities* prints in 1778, they eschewed the cheaper end of a growing market. Each engraving and text for the first volume was sold for three shillings,[35] whereas Kearsley's engravings after Paul Sandby's drawings published in the *Virtuosi's Museum* cost only one shilling each. Kearsley knew his customers: 'What a cheap and rational amusement then will these Gentlemen possess monthly, for the same consideration that is given for one night's admittance to the pit of a theatre!'[36] The *Virtuosi's Museum* consisted of a miscellany of subject-matter – gentlemen's houses, landscapes and antiquities – along the same lines as the scenes gathered together by Josiah Wedgwood to decorate the creamware service commissioned by Catherine the Great of Russia:

the principle subjects are ruins, the most remarkable buildings, parks, gardens and natural curiosities . . . architecture of all ages and styles, from the rural cottages and farms, to the most superb Palaces, and from the huts of the Hebrides to the masterpieces of English architecture.[37]

Wedgwood in fact relied very heavily on previously published views, and all the images he used of ruins and antiquities traced so far derived from one source – *Buck's Antiquities*, which was re-issued by Robert Sayer in 1774. Sayer had bought up the 'worn out plates' originally made from the 1720s to the 1740s and retailed them in two volumes 'for less than half price' (illus. 31).[38]

Hearne's *Antiquities* were aimed at a specific section of the print market, those sympathetic to a more aesthetically cultivated approach to the depiction of medieval architecture. Sandby's engravings, the most popular of the period, were reworked and copied in countless histories and collections of views; the prospectus for the *Virtuosi's Museum* appealed to a broad audience and provides evidence of the rising interest in engraved British views, together with the increasingly commercial techniques employed by some publishers to keep their share of the market.[39] Hearne and Byrne's *Antiquities* embodied an alternative approach. John Britton noted that 'the sale of this very beautiful work did not tempt the artists to devote either much energy or capital to excite publicity'.[40] The *Antiquities* was not to be deliberately puffed up to maximize profit. It was neither cheap, nor aggressively marketed to a potentially new audience.

Hearne's early drawing style and approach to depicting antiquities is best observed in a watercolour such as *Beverstone Castle, Gloucestershire* (illus. 17), which is a particularly interesting and well-preserved example. The engraving was published in the *Antiquities* in 1778. In his image of the Castle Hearne sought to show the

continuity which existed between the medieval past and the industrious present. He remarked (in the letterpress) that Beverstone Castle had been built during the reign of Edward the Confessor; an accidental fire had destroyed three sides of it and since then, Hearne commented approvingly, 'a large commodious farm-house hath been erected within the area of the castle, and is now inhabited by Mr Tugwell, who has distinguished himself by many improvements in the machines necessary to agriculture'.[41] To the right of the Castle and farmhouse we can see the medieval village church, the spiritual centre of Beverstone's small community. This was quite different from the approach of Samuel and Nathaniel Buck; their view, engraved in 1732 and re-issued in 1774, concentrated simply on the ruinous Castle itself.[42] It was characteristic of Hearne to provide a context for the antiquities he depicted; this is apparent in his visual arrangement in each of the drawings and also in the social and religious topics often to be found in the letterpress accompanying each engraving.

In terms of composition and style, *Beverstone Castle*, and also *Micklegate Bar and the Hospital of St Thomas, York* (illus. 19),[43] were essays in the manner of Paul Sandby, the leader in architectural topography in the 1770s. Sandby had recently started issuing what was to become an influential series of aquatints based on tours made in Wales earlier that decade, first with Joseph Banks and later with his aristocratic patron, Sir Watkin Williams Wynn.[44] The composition and the size of Hearne's watercolours, the use of slight touches of bodycolour and the drawing of the trees in *Beverstone Castle*, together with his treatment of groups of figures in the urban setting of *Micklegate Bar*, all reveal his initial debt to Sandby's exhibited watercolours and the subsequent prints made from them. After his return from Scotland in 1751, Sandby combined the exacting study of buildings and perspective with a sensitive use of watercolour, conditioned by fashionable picturesque concerns, which until then had been the province of oil painting. Sandby was sensitive to the appearance of his watercolours and set a high standard for draughtsmen of the next generation. His status as a founder-member of the Royal Academy rendered his style all the more attractive. The *View of the Town through the Gateway from the Castle Hill, Windsor* (illus. 20) was typical of his careful observation and his use of contemporary figure-groups.

These elements are certainly present in such drawings by Hearne as *Micklegate Bar*, but Hearne's published text omitted picturesque description and raised antiquarian concerns. It considered the date of the Bar's construction, together with a moral question concerning the charitable function of the Hospital of St Thomas. Hearne dismissed earlier speculation on the age of the Bar (Drake's *History of York* suggested it was Roman, while Lord Burlington thought its style was Tuscan) and argued that the arch was Norman and superstructure Gothic. The Hospital of St Thomas, seen here in the right foreground, was the focus for most of the text. It noted that the Corporation of York kept the buildings in repair, and paid for prayers

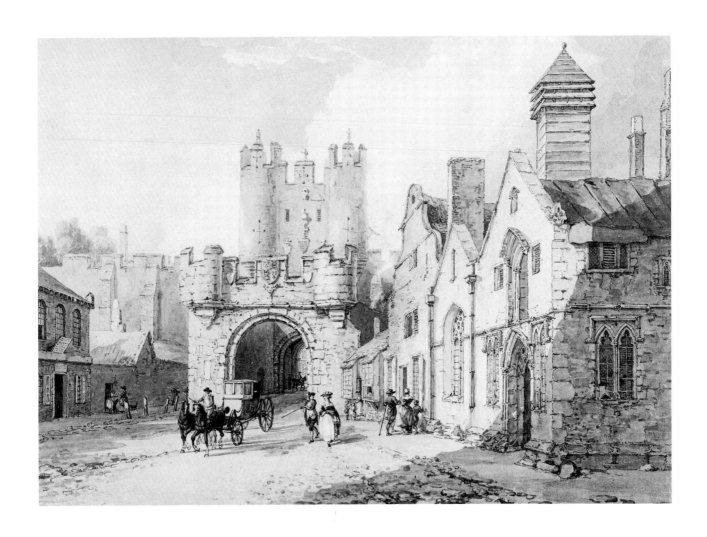

19. *Micklegate Bar and the Hospital of St Thomas, York* 1777. Watercolour over pen and ink, 18.4 × 25.7. Whitworth Art Gallery, University of Manchester.

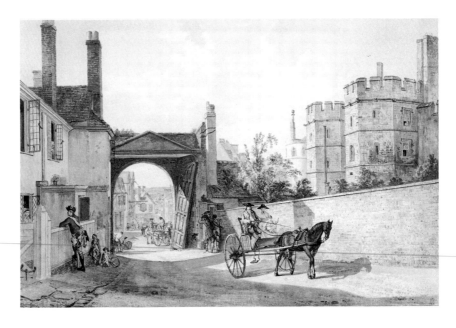

20. Paul Sandby: *View of the Town through the Gateway from the Castle Hill, Windsor* c.1770. Watercolour and pen and ink over pencil, 31.7 × 46.7. Windsor Castle, Royal Library. © 1988 H. M. the Queen.

34

to be read to the ten poor women living there, who subsisted only upon alms.[45] Continuity was again emphasized here, both in the physical maintenance of the building and in the charitable function of supporting the poor. Similar concerns are apparent throughout the *Antiquities*, where divergent attitudes to the physical maintenance and present functions of medieval, especially religious, buildings were examined and used as a rough measure of moral virtue. The whole publication is a

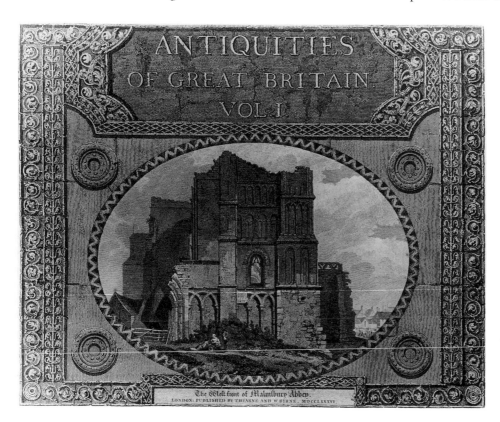

The West front of Malmsbury Abbey.
LONDON: PUBLISHED BY T.HEARNE AND W.BYRNE, MDCCLXXXVI.

21. *The West Front of Malmesbury Abbey*; Frontispiece to *The Antiquities of Great Britain*, vol. I, 1786. Engraving (W. Byrne and J. Landseer), 20.2 × 25.5. John Rylands University Library, Manchester.

series of relative studies concerning the survival and adaptation or destruction and decay of medieval buildings. Hearne brought a consistent moral and social vision to his work on the *Antiquities*, and its components can be pieced together from his choice of subjects, the way in which he realized them in visual terms and how they were described in the letterpress. The earnest antiquarian purpose of each volume was embodied in the frontispiece of the first volume (illus. 21). The letterpress described it as

a view of remains of the west front of the Abbey Church at Malmesbury, encompassed by an ornamental frame, composed of specimens of several decorations, which were profusely bestowed, and still remain in the South porch and on the West end of that building.[46]

Although Hearne's original drawing is lost, the engraving manifests his painstaking approach to the study and depiction of architectural details, his desire to place these medieval buildings within carefully arranged picturesque compositions, and also

35

his ability, as co-publisher, to influence the quality of the finished engraving. Other watercolours he made – the *South Porch of Malmesbury Abbey* (illus. 22) and the south west angle of *Malmesbury Abbey* (illus. 30) – illustrate the complex interlaced ornament and foliate scrolling used in his design for the imaginative frontispiece.[47]

While Hearne's work on Romanesque and Gothic architecture was meticulous and elegant, knowledgeable observers expressed dismay at the poor quality of the overwhelming bulk of antiquarian illustrations. Thus Richard Gough, in his *Anecdotes of British Topography* (1768) and the revised edition of 1780, observed:

If any architectural draughts of our [medieval] buildings are preserved, they are in private cabinets. Few of those engraved have been executed with sufficient care and skill. In most, the effect of the whole is more consulted than the proportions of the parts.

He exhorted artists to pay attention to the details of such architecture – the 'tracery of windows, the mouldings and turn of arches, the rich and light dressings of pinnacles and buttresses, the foliage of capitals, the clustering of pillars'.[48] Gough noted approvingly in the 1780 edition (published as *British Topography*) that 'the last year produced a monthly publication . . . from the pencil of P. Sandby and the burin of Rooker; and these have been followed by more finished and picturesque views on a larger scale by messrs Hearne and Byrne'.[49] By this time Gough had also greatly improved the quality and quantity of engravings published by the Society of Antiquaries in *Vetusta Monumenta*, which was issued again from 1780,

having been suspended in 1770.[50] In remarking on 'architectural draughts . . . in private cabinets' Gough may have had in mind the work of Walpole's circle of artists and architects at Strawberry Hill, including Richard Bentley, J. H. Muntz and John Chute, who had certainly worked in a detailed way on medieval buildings and produced many fine drawings.[51] In 1760 Muntz issued 'Proposals for publishing

23. Francis Grose: *Malmesbury Abbey* 1785. Engraving. John Rylands University Library, Manchester.

by Subscription a Course of Gothic Architecture'; the venture failed, however, as sufficient subscribers could not be found to support it. Their drawings largely remained in private hands and were rarely engraved; thus they were usually unseen by an increasingly 'curious public'.[52]

The drawings and engravings made by Francis Grose, an amateur draughtsman and antiquarian popularizer, were more typical of the contemporary engraved work criticized by Gough. The contrast with the picturesque compositions and meticulous craftsmanship of Hearne's work (illus. 21) is well caught in Grose's *Malmesbury Abbey* (illus. 23), which appeared in his well known part-work, *The Antiquities of England and Wales*.[53] The richly-carved decoration on the south porch is reduced to small uninflected engraved lines. The flying buttresses above the south aisle are limply drawn and the whole design lacks any understanding of the stylistic principles underlying Gothic architecture. Despite these aesthetic shortcomings, Grose's work enjoyed considerable success, and in 1795 it was plagiarized wholesale in Alexander Hogg's *Antiquities of England and Wales*, the first genuinely popular antiquarian publication.[54]

The interest stimulated by medieval buildings tended to focus on the historical events and personalities with which they were associated rather than on their intrinsic architectural qualities. Hence, engravings after Grose and other comparable antiquarian draughtsmen were intended to be locally identifiable: sufficient architectural features of each particular building were recorded in order to dis-

37

tinguish them from other medieval structures. The engravings were illustrations to the historical notes – hooks for the all-important associations and meanings which rendered such sites significant and worthy of attention. As Grose wrote in the preface to his *Antiquities*: 'In order to render every Article as clear as possible, the verbal Descriptions, where capable, are illustrated by Drawings'.[55] Hearne reversed this process. The engravings of Romanesque and Gothic buildings in *The Antiquities of Great Britain* were to be accompanied by explanatory texts. This fitted Gough's urgings that artists take a more aesthetically cultivated approach to medieval architecture, while still reflecting on its historical and moral significance.

Hearne and Gough found their paths crossing, perhaps due to J. C. Brooke (1748–94), an antiquary who was elected to the Society in 1775. Brooke became the Somerset Herald two years later and he was also Secretary to the Earl Marshal of England. In May 1778 Brooke wrote to Gough – 'I called upon Hearne today in company with Lord Surrey; his first number comes out tomorrow',[56] which suggests a lively awareness of Hearne's activities on their part. That December Brooke promised to work up an account of Lumley Castle for Hearne to publish with his forthcoming engraving; he also asked Hearne to send a 'proof of the Hermitage of Warkworth, and likewise the letterpress of one of his other views' to Thomas Percy, who was to help Hearne with the Warkworth text.[57] The collaboration continued, and in December 1779 Brooke again wrote to Gough:

The eight views for Hearne's two next numbers are, Hospital of St. Cross near Winchester, two of Malmesbury Abbey, two of Melrose Abbey, Lanercost Priory, Kelso Monastery and Edinburgh Castle. Lanercost I have drawn out for him. Can you point out to him authorities from whence he can extract little histories of the rest? It would be a kind act to an ingenious man.[58]

In February 1780 Gough replied that he had 'assisted Mr. Hearne, as far as I can, by the loan of the History of Winchester and Melrose Abbey, but, touching Malmesbury, I have nothing new to say'.[59] Two letters from Gough in March 1780 to the Revd Michael Tyson show that he quickly warmed to Hearne and realized their mutual interest:

I had a high treat at Hearne's lately . . . He is wonderfully happy in hitting off Gothic Architecture, which he much attends to. I saw a glorious large view of Durham, down the River; and was delighted with some drawings of Northern Ruins and Lakes. I have tempted him to draw round me this summer; as it is his wish to work near home, after having taken such distant excursions.[60]

Thus, during the crucial early years of his work on the *Antiquities*, Hearne had close contact with some of the key figures involved in the study and re-evaluation of medieval architecture. Their common purpose was to collect and disseminate visual records and historical information concerning a specifically national past, one which both Gough and Borlase had earlier understood to be threatened by the prevailing bias towards classical cultural history. This perceived threat had spurred

24. Thomas Hearne after Joseph Farington: *North aspect of Furness Abbey* 1779. Engraving (T. Hearne and W. Ellis). John Rylands University Library, Manchester.

their research and artistic activity, directed to alerting wayward members of the patrician class to the worth and value of an authentically British past, the 'works and memorials of our priests and heroes'.[61]

Hearne's drawings, prints and letterpress to *The Antiquities* contain evidence that allows us to see him becoming increasingly influenced by antiquarian attitudes and research. He was concerned, for example, that the different styles of medieval architecture be illustrated and his letterpress often explicitly engaged in the current debates concerning stylistic evolution, from pre-Conquest to Perpendicular. The letterpress to the *North aspect of Furness Abbey* (illus. 24) of 1779, for instance, opened with a reference to its architectural style as 'mixed'. Hearne noted:

the foundation of this religious house was laid whilst the Norman taste in building prevailed; and as it was carrying on (probably under the direction of different architects) the manner of its original design appears to have gradually deviated into that, which is distinguished by the appellation of Gothic. The progression from one style to the other is evident in this View, where the Door is in the former manner, whilst the larger Window over it, with that at the south end of the Transept, and those of the Choir, approach towards the latter.[62]

This sort of visual analysis, although comparatively simple in modern terms, was nevertheless rare in the 1770s. As late as the 1790s, the papers in *Archaeologia* (published by the Society of Antiquaries) relied almost exclusively upon documentary evidence as a means of dating medieval remains.[63] Hearne's approach was much closer to that of Thomas Gray, as recorded by William Mason: 'He did not

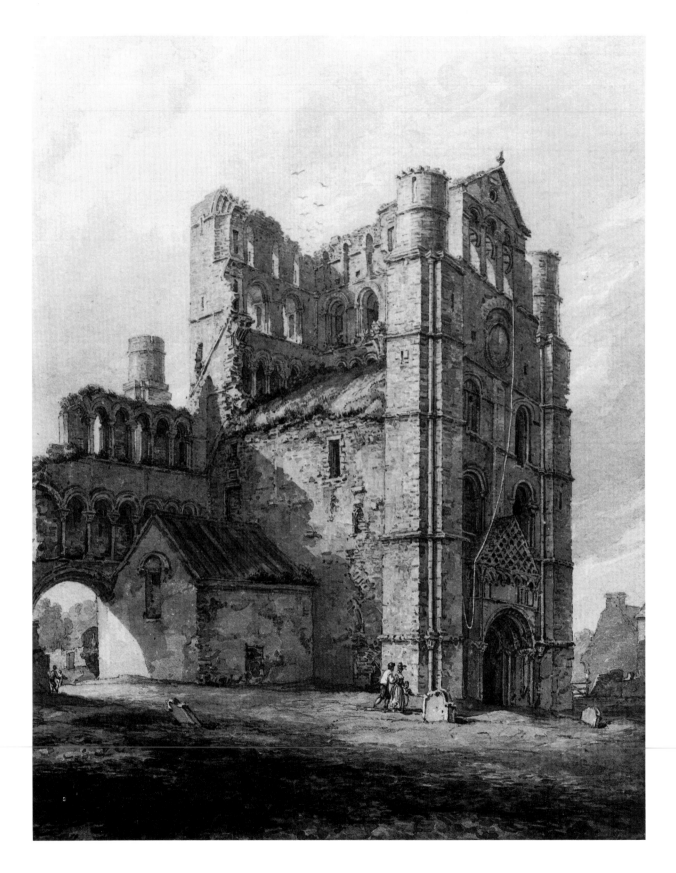

40

so much depend upon written accounts, as upon that internal evidence which the buildings themselves give of their respective antiquity'.[64] Hearne had become acquainted with Gray's principles of stylistic analysis through the latter's contributions to James Bentham's *History of Ely Cathedral* (1771), which was widely read in antiquarian circles.

From 1780 Hearne frequently employed these principles in the *Antiquities*. The *Monastery of Kelso* (illus. 26)[65] and the *Transept of Melrose Abbey* (illus. 25)[66] show

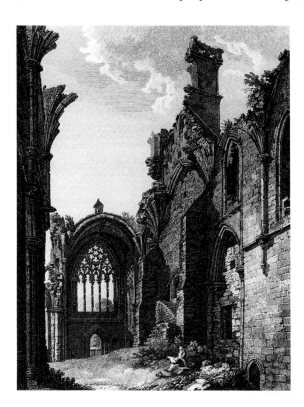

25. *The Transept of Melrose Abbey* 1780. Engraving (W. Byrne and S. Middiman). John Rylands University Library, Manchester.

how he combined image and text to emphasize a perceived stylistic progression from Romanesque to Gothic. Kelso – 'in all its parts of that plain and undecorated style of architecture, called Saxon, or Norman, which was generally used in this island at the time this Monastery was founded (1128)', contrasts with Melrose Abbey, which is in an

ornamented Gothic style . . . as much to be admired for an extreme delicacy and taste in the execution of its several Parts, as for its general character as a Whole. Pointed arches, buttresses, ornamented with niches, pinnacles curiously wrought, and clustered columns, whose capitals are variously decorated with fruit and plants, all exquisitely carved, are the distinguishing characteristics of this building.

Hearne noted that these features were not usual until the reign of Edward II (1284–1327). His letterpress for the *Cathedral Church of Ely* (published June 1783). developed the methodology he had adapted from Bentham.[67] Ely Cathedral

26. (*opposite*) *The Monastery, Kelso* 1778. Watercolour over pencil, 26.1 × 20.3. The Trustees of the Victoria & Albert Museum.

41

exhibits as large, as elegant, and as magnificent a display of what is called Gothic architecture, as any one fabric in this kingdom; and, from the different styles in which it is built, may serve better to illustrate the history of this kind of building in England than any structure now remaining.

The watercolour, *Monastery at Kelso* (illus. 26), also reveals an important advance in Hearne's technique, one which resulted from his increased confidence in depicting medieval architecture and growing knowledge of its stylistic development. At the end of the 1770s he had begun to apply separate flecks of watercolour wash to his pictures, in order to create the impression of decaying masonry. This technique is far more developed here than previously and was to become a characteristic of his work from then on. From 1778 Hearne increasingly emancipated himself from Sandby's approach to depicting antiquities; he dropped the lively figure groups, paid closer attention to architectural details and sought a visual equivalent for the sense of threat, embodied in physical ruination, he perceived in the buildings he drew.

Stirling Castle (illus. 27)[68] and *St Anthony's Chapel, Edinburgh* (illus. 28)[69] were variants of the popular genre of 'prospect' landscapes. By the mid- eighteenth century, a view from an elevated point embodied associations of command and dominance – a landowner surveying his property, for example, or in a more abstract sense, man overlooking and thus commanding the natural world that might otherwise dominate him.[70] The massive bulk of Stirling Castle, and the rock on which it was built, overlooks a prospect to the north-west. It dominates one of the main routes south from the Highlands, and in Hearne's image the Castle, with the Union Jack flying just behind it, is representative of a victorious and unifying monarchic power. Memories of the '45 Rebellion were still strong, and British patriots like Hearne sought to represent Scotland as at peace under firm, royal authority.

The imagery of *St Anthony's Chapel, Edinburgh*, (part of a ruined monastery originally founded by the Knights Templar of St Anthony) is more complex, and derives from its religious associations and position above the city of Edinburgh. Hearne's description began with a visual analysis:

From this elevated situation you command a very extensive and finely varied prospect, that is at once highly pleasing and terrific; having to the west the abbey and palace of Holyrood, with the city and castle of Edinburgh, and to the north and north-west the town and harbour of Leith, with the Firth of Forth and county of Fife; on the south and south-east are the summits of Arthur's Seat and Salisbury Craigs; and the perpendicular rocky sides of the hill in the park terminate the scene on the east.

Hearne continued with the 'moral observations on the very singular situations of this Chapel and Hermitage' (for Hearne 'a strong, plain Gothic building, well suited to the rugged sublimity of its situation'), a quotation from Arnot's *History of Edinburgh*. Arnot had noted that although the Hermitage was very close to the city,

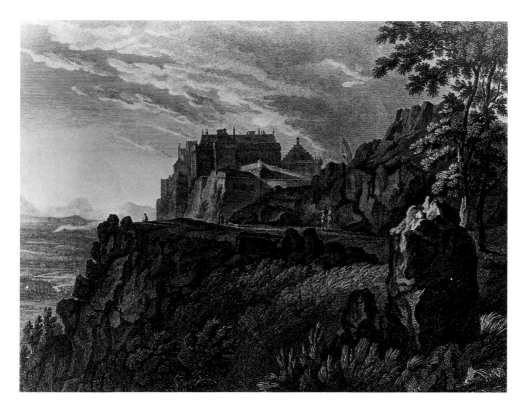

27. *Stirling Castle* 1779.
Engraving (W. Byrne and
S. Middiman). John
Rylands University Library,
Manchester.

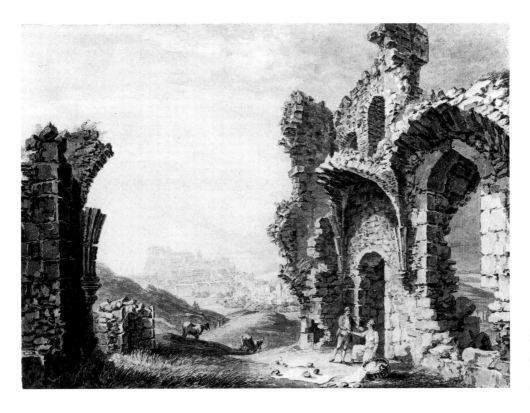

28. *St Anthony's Chapel,*
Edinburgh 1778.
Watercolour and pen and
ink over pencil,
18.4 × 25.5. Birmingham
Museum and Art Gallery.

its surroundings had the appearance and attributes of a 'desert'; isolated from mankind, it was ideal for a monastic site:

The barrenness of the rock might teach them humility and mortification; the lofty site, and extensive prospect, would dispose the mind to contemplation; and looking down upon the royal palace beneath, they might compare the tranquillity of their own situation . . . with the storms which assailed the court, amidst a tumultuous and barbarous people.

Hearne thus depicted both an interesting site and a ruined spiritual refuge from social conflict – a place of religious retirement. He composed the ruins to provide a prospect of Edinburgh and its Castle on the left, and a glimpse of Holyrood House, the royal palace, through the arch on the right. In the foreground a young cowherd greets a woman engaged in spreading laundry out to dry or bleach on the grass; in this group, Hearne offered a rather theatrical view of a literary convention, the simplicity of the poor, and perhaps a contemporary echo of the supposedly uncorrupted monastic life. From an antiquarian perspective, Richard Gough had observed that

our enlightened age laughs at the rudeness of our ancestors, and overlooks the manners of that rank of men whose simplicity is the best guardian of antiquity. Innumerable lights may be drawn from local customs and usages, which are generally founded in some ancient fact, and serve to guide us back to truth – Aids to tradition they are its most faithful interpreters![71]

Ideas of retirement and contemplation, then associated with ruined monasteries, abbeys and other religious buildings, were central to the most unusual group of works in the *Antiquities of Great Britain. Lanercost Priory* (illus. 29),[72] the *Transept of Melrose Abbey* (illus. 25)[73] and *The Abbey Church at Malmesbury* (illus. 30)[74] were published within the space of five months, between August and December 1780. All three show a single figure lost in contemplation within towering ruins. The portly cleric in *Lanercost Priory* is known to have been the Revd Charles Davy, Sir George Beaumont's former tutor, with whom both Woollett and Hearne were on close terms.[75] Below the image some verses by Davy were included:

These lone walls
and storied arches have a character,
marking the Virtues of the times deceas'd,
Whilst E C H O from her hollow charnel Vaults,
speaks to the listening ear of C O N T E M P L A T I O N,
the Epilogue to Life's M O R T A L I T Y.
How soon its gaudy Pageantries are pass'd
and D E A T H without his mask shuts the last Scene!

This is a conventional enough call to meditate on the inevitability of death and to devote oneself to the morally correct behaviour signified by medieval ecclesiastical ruins. Bentley's illustrations to Gray's *Elegy* employed a comparable iconography and it would later be taken up by Gainsborough in a soft-ground etching of 1780.[76] Nevertheless, other texts by Davy throw light on more particular meanings in Hearne's images.

44

In 1785 Davy was incapacitated by a stroke. During his illness he gathered together scattered letters written by him during the 1770s, and prepared them for publication.[77] Many were to his son, also called Charles, who at that time was a student at Caius College, Cambridge, and many of the letters are admonitions directed at his son's life and opinions. In the course of one letter Davy criticized

our young men of fashion, with whom a vanity of being admired, seems to be the grand motive of their pursuits; and who, without attending to anything beyond the surface, which they consider as the very cream of science, would be thought ignorant of nothing; prompted by this poor ambition of popular applause, and encouraged by a general inattention to the principles of fine arts, they set up for connoisseurs in them all. Statuary, painting, poetry, gardening and architecture, suffer by turns under the influence of their skill.[78]

In another letter he took his son to task for writing in favour of instrumental music, Davy seeing it as 'subservient to wickedness and debauchery, by being made the accompaniment of such obscene ribaldry as would be the scorn even of the vulgar without it'.[79] Davy believed that 'the great end and design of music is to moderate and calm the passions, and to interest them in the cause of virtue'.[80] He also believed this was the case with painting and the other arts, since their principles derived from 'one grand principle in Nature'.[81] The arts have many correspondences with each other and all have similar purpose in supporting the cause of 'Virtue'. Furthermore, Davy explicitly acknowledged the political content of his thinking:

This you may be told is exaggerating trifles, but nothing surely is a trifle which tends to the corruption of men's morals; without a sacred regard to moral obligations, no society can subsist . . . tyranny naturally arises (according to the established course of Providence), to chastise a wicked and licentious people . . . the abuse of liberty is naturally punished with the loss of it.[82]

In a letter to the Revd Dr Gooch, Archdeacon of Salisbury, Davy described the importance he attached to Gothic architecture with regard to religious faith:

The greatness of Place alone, has a wonderful effect; but the sublimity of high embowed roofs, the long drawn aisles, and solemn light of a Gothic Cathedral . . . inspire a seriousness of thought, which may dispose men's attention to the doctrines of the Scriptures, and prepare the mind for a reception of religious Principles . . . That these edifices are much better adapted for the purposes of Religion than Temples of the noblest Graecian architecture, I should have no scruple to affirm, from the difference of my own feelings . . . upon entering St. Paul's Church and Westminster Abbey; Ideas of mere grandeur are excited by the former, but ideas of *grandeur* and *religious sublimity* by the latter.[83]

Davy's solitary contemplation, as Hearne depicted it in *Lanercost Priory*, was designed to shore up his religious faith and sense of simple moral virtue, which he felt to be under threat from those full of 'vanity', who attended only to the 'surface' of the arts, those who lauded the 'Temples of the noblest Graecian architecture' (a criticism also made by Gough and Borlase, as noted above). These were the fashionable *beau monde* with their 'gaudy Pageantries'. *Their* paternal instructor, in

contrast to the stringent moralist Davy, was Lord Chesterfield, whose *Letters to His Son*, published in 1774, achieved tremendous popularity. Chesterfield insisted 'manner is all, in everything; it is by manner only that you can please, and consequently rise'.[84]

The solitary figure in the *Transept of Melrose Abbey* (illus. 25) either represents Hearne himself or Davy's former pupil, Sir George Beaumont. In *Malmesbury Abbey*

46

30. *The South West Angle of Malmesbury Abbey* 1780. Watercolour over pencil, 25.7 × 20. National Gallery of Ireland, Dublin.

(illus. 30) the figure is almost certainly Davy's student son, as the plate is dedicated to him 'by his much obliged friend. Th. Hearne'. Another single figure, of uncertain identity, sits in the doorway of the *South Porch of Malmesbury Abbey* (illus. 22).

In these four works the contemplative figure celebrates Hearne's circle of friends in a particular way. There is an urgent and also very personal purpose at work in these scenes: the reformation of morals and the reaffirmation of religious principles

47

through contemplating the splendours of native Gothic architecture. In a real sense, this group of works relocates the ideas embodied in the classical notion of retirement within a contemporary religious and national context.[85] Each of these concepts was well-known: Woollett (who engraved the figure of Davy for Hearne in *Lanercost Priory*) had also issued a plate after Richard Wilson's *Solitude* (1778), which depicted the ideal of moral and religious renewal through rural retirement; this print was dedicated to Sir George Beaumont.[86]

We may now return to those watercolours and engravings of Malmesbury Abbey, which are so central to reaching an understanding of Hearne's approach to British antiquities and his role in the continuing debate about the stylistic evolution of medieval architecture (illus. 21,22,30). The text to the Malmesbury engravings addressed the problem of sorting out the chronology of medieval buildings when 'alterations and improvements' had been made over the course of many centuries, in the progress from one style of architecture to another. Without some written documents of absolute authority,

it is not possible to fix the date of any building of the intermediate times precisely from the form of its parts, because we naturally may suppose such edifices had somewhat of the former manner, which was not grown obsolete, and somewhat of the latter, which was not established.

All this made the precise dating of 'the several discordant parts of this or any other ancient building' extremely difficult. This recognition seems perhaps admirably circumspect and objective in the case of Malmesbury, but Hearne nevertheless then went on to take a stand, relying once again on visual analysis:

but however, it seems probable that the remains of the circular arch of the west entrance into this Church, as well as the great porch on the south side, whose members are so richly ornamented with small bas-reliefs, and supported by columns with capitals of the same kind, are remaining members of the original stone structure; the building of which, it may be presumed, was begun in the reign of King Edgar, soon after he granted his charter to this Monastery, in the year 974.[87]

Hearne clearly felt it imperative to establish a link between parts of the surviving structure of Malmesbury Abbey and the Anglo-Saxon period, despite his earlier doubts about the validity of such assertions without supporting documentary evidence; hence such phrases as 'it seems possible' and 'it may be presumed'.

The earliest parts of Malmesbury Abbey are now thought to date from the complete rebuilding of the monastery church in the middle of the twelfth century; but to know that Hearne was incorrect in his dating is less important than understanding what made Malmesbury's Anglo-Saxon past both compelling and of particular significance for his drawings. Here, the texts he wrote for the engravings in the *Antiquities* are enlightening. Hearne repeated the conventional account, which located Malmesbury's origins in the seventh century when a hermitage was

set up by an Irish-Scottish monk, Maidulphus. His main interest, however, was reserved for St Aldhelm and the numerous Anglo-Saxon kings, particularly Athelstan, who were associated with the Abbey. Throughout the eighteenth century, antiquarians and scholars knew of St Aldhelm (c.640–709) as the first Anglo-Saxon scholar of distinction. He studied under Maidulphus, before becoming abbot of Malmesbury in about 675. The early topographers, Samuel and Nathaniel Buck (whose work was republished in 1774), called him 'a Person of universal Esteem for his excellent Learning, generally said to be the first English Saxon who wrote in Latin and taught the English to make Latin verse'. Aldhelm was buried at Malmesbury and his tomb later became a place of pilgrimage.

Hearne's generation considered Athelstan (895–939) to have been the most brilliant of English kings. At a time of incessant Viking invasions Athelstan conquered the kingdom of Northumbria as well as Cornwall, and he also established important contacts with the Holy Roman Emperor, the Normans and the Scandinavians. Samuel and Nathaniel Buck noted that 'King Ethelstan . . . was a great Benefactor and such an Admirer of the Memory of St. Aldhelm that he chose him for his Tutelar Saint'.[88] In addition, Athelstan was buried at Malmesbury Abbey. Under King Edgar (959–75), a noted patron of the arts and supporter of the Church, the monastery at Malmesbury received its charter.

Malmesbury Abbey was thus associated with some of the most prestigious 'priests and heroes'[89] of a remote but, for many in the later eighteenth century, very important era, one commonly represented as a Golden Age. In the 1770s many historians asserted that the Anglo-Saxon constitution was the original fount of English liberties and that the Anglo-Saxon state was a model kingdom. David Hume typically held that 'the picture of a fierce and bold liberty, which is drawn by the masterly pencil of Tacitus will suit those founders of the English Government'.[90] Other writers – Obadiah Hulme, James Burgh and John Cartwright – were Dissenters and political radicals who also believed that the origins of English liberty, elective monarchy and freedom of religion, were established in the Anglo-Saxon era. During the 1770s and 1780s they used these ideas as ammunition to criticize the Anglican Church and to help agitate for parliamentary reform and constitutional

31. Samuel and Nathaniel Buck: *South West View of Malmesbury Abbey* 1732. Engraving. John Rylands University Library, Manchester.

49

change, as well as to express severely anti-aristocratic sentiments. Hulme castigated the patricians as 'all men of one interest . . . a downright rank aristocracy, of the rich in land', and he criticized the traffic in offices, pensions and contracts that resulted from their corrupt and unconstitutional hegemony. This he understood as having descended from a predatory Norman nobility which had imposed its alien culture upon Englishmen. To remedy these evils Hulme called for the establishment of a nationwide network of political associations through which to agitate for constitutional reform and annual elections, and thus to restore the original equality of the Anglo-Saxon polity.[91]

The many defenders of the establishment, including Hearne, used this and other periods of national history in a different way. Hearne was a staunch defender of both the Anglican Church and the monarchy, and a deferential supporter of aristocratic hegemony exercised within a paternalistic and virtuous moral context. Therefore in his letterpress to the Malmesbury engravings he emphasized the religious and monarchic aspects of Anglo-Saxon history. Indeed, he generally chose to illustrate in the *Antiquities* those sites which provoked such associations. His engraving, the *Cathedral Church of Glasgow* (1779), for example, was associated with an incident of 1579 when extreme Protestant reformers wished to destroy the Cathedral, but

the inhabitants of Glasgow, though indefatigable in their pursuit of the reformation, acted with more wisdom and moderation . . . for considering the Cathedral as the chief ornament of their town, they spiritedly opposed the destruction of it . . . [took] up arms, and protested they would instantly bury those workmen under the ruins, who should dare to pull down any part of it.

Here, careful to voice criticism of both extreme Protestantism and Catholicism, Hearne vindicated the moderation, the *via media* of the Anglican Church.[92] In a similar way, when describing castles besieged or destroyed during the Civil War, Hearne vindicated gallant defences by Royalist garrisons; he also dwelt on scenes of devastation and ruin that could be attributed to 'republicans'.[93]

In many cases Hearne dwelt on the role of the landowning aristocracy in the preservation (or neglect) of ancient buildings. *Melrose Abbey* (illus. 25) was 'at present in the possession of his Grace the Duke of Buccleugh, to whose respect and taste for these venerable remains of antiquity the public is indebted for its present existence'.[94] while *Leiston Abbey* in Suffolk had been purchased by Sir Joshua Van Neck, 'who left it to his family, with those virtues which alone can render the possession of a large estate a blessing and an honour'.[95] These encomiums are not surprising – the plates were dedicated to the landowners concerned – but they do show the complex social character of any creative work on medieval architecture undertaken during the late eighteenth century. The well-being of most medieval buildings was intimately bound up with the attitudes of local landlords, and an

important purpose of the *Antiquities of Great Britain* was to celebrate those patricians who valued British medieval buildings alongside classical architecture.

Towards the end of the first volume of the *Antiquities* there are signs that Hearne's growing facility for drawing and his concern with picturesque landscape were leading him in new directions. For instance, the watercolour of *Allington Castle, near Maidstone, Kent; the outer gateway* (illus. 18),[96] probably worked up in 1782–3 from drawings made in 1777, shows a new pattern of composition, with the landscape elements now predominant.[97] The branches of the tree in the darkened foreground arch over to frame the dilapidated but sunlit castle, here pushed back into the middle distance. Variegated tinting on the walls creates the impression of pitted, eroding masonry. The inclusion of rustic figures, first seen in *Beverstone Castle*, certainly relates to Hearne's contemporary series of engravings, *Rural Sports*.[98] We learn from the letterpress of *Allington Castle* that although the owner, Lord Romney, no longer lived in his Castle and it was neglected and ruinous, nevertheless the 'inside still affords a comfortable and convenient residence for the tenants of two adjoining farms'; continuity was maintained and the humble industry of the poor rewarded by the benevolence of the rich.

Many later watercolours and engravings made for the second volume of the *Antiquities* developed from a comparable pictorial pattern.[99] The foreground often became the focus of interest, with the details of individual buildings assuming greater importance within the overall composition. Hearne became increasingly interested in the visual (and picturesque) appeal of the surfaces and textures of decaying stonework and enveloping trees and vegetation. Nevertheless, he also included some prospects, especially of English cathedrals, which parallels the growing interest of the Society of Antiquaries in cathedral remains in the 1790s.[100] Volume II may owe its less personal emphasis to the different contractual arrangements made between Hearne and William Byrne. For this volume Hearne was the employed draughtsman, not its instigator and co-publisher.

The final plate of the first volume was *Stonehenge* (illus. 16),[101] one of Hearne's most important and influential antiquarian compositions. Like Malmesbury Abbey, Stonehenge was virtually a local landmark for him. He probably knew Thomas Jones's painting, *The Bard* (1774), in which a striking megalithic henge appears in the background.[102] Hearne's view, however, did not have such overt Druidic overtones. The letterpress followed Gough's advice on the popular but historically fanciful speculations of Stukeley: 'without entering into his hypothesis we may trust his descriptions of the monuments'.[103] Nevertheless, Hearne's dramatically close-up view, with its darkly shadowed monoliths, and trilithons silhouetted against a storm-filled sky, acknowledged the inherent sublimity of the subject, later to be more fully exploited by Constable, Turner and others.[104] *Stonehenge* was the best-known early British temple, and for Hearne it provided an awe-inspiring image from the remote past with which to conclude the first volume of the *Antiquities*.

CHAPTER FOUR

Literary illustration and rustic landscape

Hearne's career as a draughtsman was at its peak between the late 1770s and 1800. The core of his production throughout these years was defined by his work as a draughtsman allied closely with the engraving trade, but he also took on specific private commissions as well as painting watercolours for exhibition at the Free Society of Arts, the Society of Artists and, after 1781, at the Royal Academy.

In a series of watercolours for exhibition and engraving, produced between 1777 and 1784, Hearne illustrated six episodes taken from literary sources. Two watercolours deriving from incidents in Henry Fielding's novel, *Joseph Andrews* (illus. 33,34,35), exhibited at the Society of Artists in 1777 alongside some early examples of Hearne's antiquarian drawings, and 'four Views; studies after nature' (probably landscapes) began this sequence, although they were not engraved and published by William Byrne until 1781 and 1788.[1] Hearne had taken the initiative in producing and exhibiting these works, just as he was to do in his collaboration with Byrne on *The Antiquities* in 1778. Literary subjects added variety to Hearne's artistic repertory, displayed in his first public exhibition after returning from the West Indies. He followed *Joseph Andrews* with two scenes from Oliver Goldsmith's *The Vicar of Wakefield* (illus. 45,46), drawn and engraved (this time by Woollett and William Ellis) in 1780,[2] and he also took subjects from James Thomson's enormously popular georgic poem, *The Seasons*, both for a watercolour shown at the Society of Artists in 1783 and for two engravings issued in 1784 (illus. 49,50).[3]

The popular market for books had been growing steadily from the 1740s, following publication of the earliest major group of English novels.[4] *Joseph Andrews* (1742), had sold 6500 copies, while Samuel Richardson's *Pamela* (1740) went through five editions in its first year. The twenty or so new novels issued each year between 1740 and 1770 doubled to around forty per annum in the 1770s, a level which was maintained for the rest of the century. Booksellers, book-clubs and circulating libraries were established throughout the country in the 1770s, and an increasing number of illustrated editions of novels and poetry were produced.[5] Two key elements fuelled this development: by the 1770s increasing numbers of people had more disposable income – a phenomenon also evident in the rise in demand for many other 'leisure' commodities, notably prints and decorative arts;[6] moreover, a legal decision of 1774 to abolish perpetual copyright removed much earlier literature from the restrictive rights enjoyed by specific publishers. As a result new editions proliferated, along with collections of author's works and

convenient pocket editions at low prices. During this period of unprecedented expansion, print publishers and the book trade worked very closely together. For instance, the first illustrated edition of *The Vicar of Wakefield* was published in two parts in May and December of 1780; Hearne's prints, based on the book, appeared in March and November of the same year, apparently timed to profit from an anticipated upturn in sales of Goldsmith's novel.[7]

Hearne was only the second artist to exhibit subjects from *Joseph Andrews*; possibly he was prompted by Woollett's engravings after Philipp de Loutherbourg's exhibited drawings of episodes from *Tom Jones* in 1776.[8] Hearne was the first artist to treat *The Vicar of Wakefield* as a source for narrative incidents, rather than simply for portrait studies of characters, and in this he was followed in 1784 by George Morland and Thomas Stothard, whose works initiated a series of illustrations of the novel which was to peak in the mid-nineteenth century.[9]

Hearne designed his illustrations taken from *Joseph Andrews*, *The Vicar of Wakefield* and *The Seasons* in pairs, using an oval format, in keeping with many watercolours and prints on literary themes produced in the 1770s and 1780s. He was more unusual, however, in consistently using landscape settings for them. With the two novels in particular, he applied his skills as a topographical draughtsman to provide a landscape context for each illustrated episode, thus inviting the viewer to read broader narrative themes in his images. (illus. 33,34,35,36,37). Michael 'Angelo' Rooker was also a landscapist, but his illustrations to Fielding's *Works* (1783), for example, were more typical of contemporary practice, being interiors or restricted exterior scenes (this can perhaps be related to Rooker's experience as a scene painter); his prominent figure groups conveyed more of Fielding's boisterous

32. Michael 'Angelo' Rooker: *Frontispiece to 'The History of Tom Jones, A Foundling'* 1783. Pencil and watercolour, 13 × 7. The Trustees of the Victoria & Albert Museum.

humour, vivacity and stagey comic incidents than did Hearne's compositions (illus. 32).[10]

Hearne's first subject was a scene in *Joseph Andrews* in which three travellers, Joseph, Fanny Goodwill and Parson Adams, 'came to a Parish, and beheld a Sign of Invitation hanging out. A Gentleman sat smoaking a Pipe at the Door'. Joseph is shown inviting Fanny towards the door, as the squire motions the party into the inn (illus. 33). The latter, who owns the distant mansion, later promises Parson Adams the local living (the church appears to the right), and proposes to entertain all three at his house for a few days. But, as most customers would have known, all these promises come to nothing and Joseph, a man-servant and thus familiar with the foibles of his betters, comments with the benefit of experience:

whenever a Man of Fashion doth not care to fulfil his Promises, the Custom is, to order his Servants that he will never be at home to the Person so promised. In *London* they call it *denying him* . . . all I know is, it is a Maxim among the Gentlemen of our Cloth [i.e. servants] that those Masters who promise the most perform the least.

The innkeeper, here looking anxiously out of the window, later confirms the truth of Joseph's maxim and laments that 'I thought he would have offered you my House next'.

The episode focuses on the behaviour of the squire – 'I esteem Riches only as they give me an opportunity of doing Good', yet the squire's every action contradicts his words. This dissimulation contrasts sharply with the Christian simplicity of Adams and the down-to-earth honesty and scepticism of Joseph, which would more appropriately accord with the proper moral behaviour of a representative of landed wealth.[11] Fielding's own anxiety, that the traditional, paternalistic bonds of society were under threat by the drift of many aristocrats and gentry into ease and corruption, was reiterated in the 1770s, particularly in such poems as Goldsmith's *Deserted Village*. We have seen that Hearne was a conservative in his views; presumably he would have been sympathetic to these sentiments. Hearne's own imagery corresponds with Fielding's model of British society. The village community, including a shepherd and his sheep, its cottages and the inn, appear in the foreground; the squire's mansion can be seen in the far distance beyond the church. This is the setting for an undramatic incident which Fielding used in order to convey his sentiments concerning a preferred social order.

By contrast, the rescue of an archetypal innocent, Fanny Goodwill, from the Captain (illus. 34,35) is a scene of high drama. The Captain, 'an old Half-pay Officer' in the retinue of another disreputable gentleman, has been charged by his master with kidnapping Fanny: 'that beautiful and innocent Virgin . . . was to be offered up as a Sacrifice to the Lust of a Ravisher'. Hearne shows her freed and the Captain restrained. The squire, 'a man of very considerable fortune', who had commissioned the Captain had completed his own education with a three-year 'Tour of Europe, as they term it, and returned home well furnish'd with *French*

54

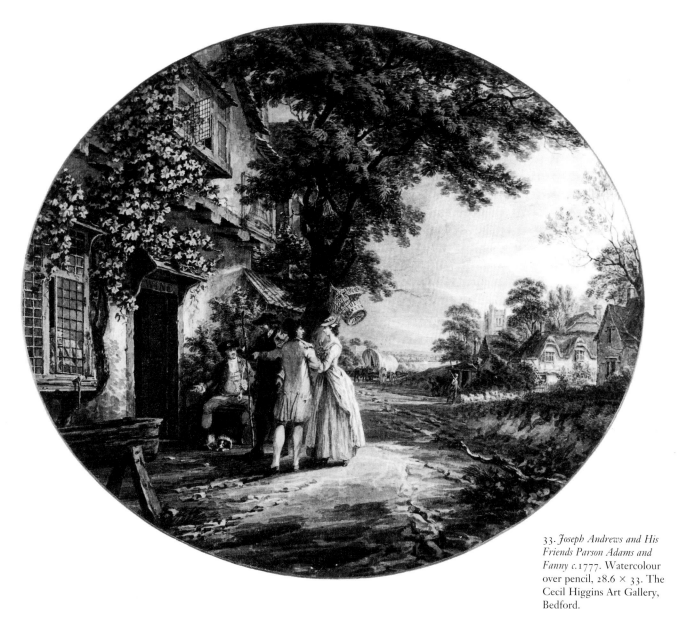

33. *Joseph Andrews and His
Friends Parson Adams and
Fanny c.*1777. Watercolour
over pencil, 28.6 × 33. The
Cecil Higgins Art Gallery,
Bedford.

Clothes, Phrases and Servants with a hearty Contempt for his own Country;
especially what had any Savour of the plain Spirit and Honesty of our Ancestors'.
Fanny's rescuer, 'Mr Peter Pounce . . . was a very gallant Person, and loved a pretty
Girl better than any thing, besides his own Money, or the Money of other People'.
As neither man was to be trusted, Fanny is not really safe until she is back with
Joseph and Parson Adams. As we have seen above, the negative stereotype of the
English gentleman who betrayed his country's culture and history after a sojourn
on the Continent, was as potent for Hearne's generation as it had been for
Fielding's.[12] Hearne's early sketch (illus. 34) deals with the figures in a matter-of-fact
way, akin to the first of his illustrations of *Joseph Andrews* (illus. 33); in the engraving
of 1788, however, Fanny's plight was dramatized (she is shown pleading with

34. *Joseph Andrews: Fanny Goodwill rescued from the Captain* c.1777. Pen and ink with wash, 25.7 × 33.6. The Trustees of the Victoria & Albert Museum.

35. *Joseph Andrews: Fanny Goodwill rescued from the Captain* 1788. Engraving (W. Byrne and B. T. Pouncey; figures by W. Sharp). The Trustees of the British Museum.

Pounce), reflecting the move towards a more sentimental aesthetic which took place in that decade (illus. 35).

The more general debate on the proper behaviour appropriate for a gentleman also informs Hearne's illustrations to Goldsmith's *The Vicar of Wakefield* (illus. 36, 37). The characters of Thornhill and Burchell provided two contrasting moral exemplars of the gentry, and although the novel's later popularity was to stem from its story of the elopement of Olivia, a wayward daughter, her disgrace and eventual return to her family, Hearne combined this with reflections on the action of the two leading male characters. He represented the rescue of Sophia Primrose by Burchell (illus. 36), as part of a carefully composed rural landscape (one which embodies many of the moral and social themes in the novel) rather than as a dramatic scene.[13] Goldsmith meant to celebrate an idealized and endangered country life, where the simplicity, honesty and independence of less wealthy farmers harmonized with a strong sense of justice and a system of law (tempered with mercy) administered by an hereditary aristocracy and gentry.[14] Goldsmith made it clear in *The Deserted Village* that this social ideal was threatened above all by the extravagance and moral decay of the local ruling elite:

57

Ill fares the land, to hastening ills a prey,
Where wealth accumulates, and men decay:
Princes and lords may flourish or may fade;
A breath can make them, as a breath has made;
But a bold peasantry, their country's pride,
When once destroyed, can never be supplied.[15]

Thus, the Primrose family live among a community of 'farmers, who tilled their own grounds, and were equal strangers to opulence and poverty'.[16] Hearne evoked this social context by including (in the left foreground) a watermill. Similar mills, derived from Dutch landscape prints, were to be found in the work of many English artists, such as George Lambert and Smith of Chichester, who employed them as symbols for common nature and the simple rustic life. The building visible on the horizon surely represents the 'magnificent house' belonging to the Thornhills, the local landowners.[17] Olivia, seen on a horse in mid-stream in the middle distance, is the only adult member of the Primrose family not involved in the main action. She turns both towards the large house and a figure who appears to be watching from a bridge in the distance. If this visual organization correlates with that followed in the first print of *Joseph Andrews* (illus. 33), then the distant figure is probably Mr Thornhill, Olivia's eventual seducer and Dr Primrose's persecutor. In the final dénouement of this almost fairy-tale plot, Burchell's true identity is revealed to be Sir William Thornhill, the rightful owner of the 'magnificent house'; the rakish younger Thornhill is his nephew, one 'entirely dependent on the will of his uncle'.[18] Hearne brings Burchell (Sir William) and Thornhill together in a way which alludes to their ultimate roles in Goldsmith's narrative, and depicts Olivia as literally turning away from the family, as she does metaphorically in the novel. His response to Goldsmith's tale demonstrates an understanding of and sympathy with its moral themes.

Hearne took his second subject, *The Breakfast on the Honeysuckle Bank* (illus. 37) from a later chapter (24), in which the younger Thornhill, thwarted in his attempts to corrupt Olivia, takes revenge on Primrose by causing him to be imprisoned for debt – the action of a gentleman swayed by 'falsehood, cowardice and oppression', as Sir William Thornhill eventually described it.[19] In Hearne's image of the family, reunited by Olivia's return, Mr Thornhill is once again a distant but pervasive presence: his coach is seen approaching by Olivia, who recoils in distress, and by Dr Primrose, who steels himself for the encounter. Pictorially, the coach *comes between* the family on the left and their cottage on the right, as Thornhill does in the narrative by having Dr Primrose arrested and the family evicted.

A few months after publication of *The Vicar of Wakefield* prints in 1780, Hearne began *Rural Sports*, a series of twelve engravings on country life (illus. 38–47).[20] The oval format, used in his literary illustrations, here served to emphasize the serial character of the prints, as they appear not to derive from a specific written source. Eight scenes depict agricultural activities in the context of small-scale

mixed farming: *Ploughing* (illus. 38), *Haymaking* (illus. 39), *The Cornfield* (illus. 40),
Threshing (illus. 41) and *The Windmill* (illus. 42) display the yearly production cycle
of cereals and animal fodder, while *The Dairy* (illus. 43), *The Hop Ground* (illus. 44)
and *The Apiary* (illus. 45) describe other appropriate tasks. The four scenes of
pastimes and sport are *Angling* (illus. 46), *the Talli-ho, or fox breaking cover, Shooting*
(illus. 47) and *Coursing*.

Hearne's first rustic landscape, *A View in Suffolk* (illus. 48), was a large watercolour
which won a premium at the Society of Arts in 1776. The subject probably
originated in visits to the Revd Charles Davy at Henstead, and the difference
between the 'original sketch from nature'[21] and this finished watercolour shows
Hearne's development of the method of picture-making he had earlier employed
in the West Indies. The sketch features a broad prospect of almost level terrain,
which Hearne in the watercolour gently elevated into hills. The sky has also been
given increased breadth and importance and the rather loose grouping of haystacks,
trees and buildings on the right has been tightened up. Here Hearne depicts a
largely unenclosed common, a village on the horizon and well-kept small farms in
the foreground; the large haystacks (to the right) and the wagon and pack-horse

59

opposite
38. (*top left*) *Ploughing* 1781.
Engraving, 18.3 × 21.

39. (*top right*) *Haymaking*
1782. Engraving, 18.3 × 21.

40. (*middle left*) *The
Cornfield* 1780. Engraving,
18.3 × 21.

41. (*middle right*) *Threshing*
c.1780–5 (re-issued 1810).
Engraving, 18.3 × 21.

42. (*bottom left*) *The
Windmill* 1781. Engraving,
18.3 × 21.

43. (*bottom right*) *The Dairy*
1780. Engraving, 18.3 ×
21.

above
44. (*top left*) *The Hop Ground*
1781. Engraving, 18.3 × 21.

45. (*top right*) *The Apiary*
1785. Engraving, 18.3 ×
21.

46. (*bottom left*) *Angling*
1781. Engraving, 18.8 ×
21.2

47. (*bottom right*) *Shooting*
1781. Engraving, 18.2 × 21.2.

61

indicate Suffolk's reputation as one of the leading agricultural counties, while the prominent church spire and large farmhouse (just to the left) mark the spiritual and worldly centres of the rural community.

With *Rural Sports* Hearne brought the tasks and recreations of country life into sharper focus; his careful delineation of buildings, land use and human activity reveals the topographical and agricultural roots of his images to be in south-east England and East Anglia. We know, for example, that *Angling* (illus. 46) was based on a 1771 drawing of a bridge at Henstead in Suffolk (illus. 5). The prominent buildings in *Threshing* (illus. 41) are typical of smaller farms in the south-east: the barn has a gabled porch so as to enlarge the threshing floor, and a plain tiled roof extends to make a shelter for animals.[22] *Haymaking* (illus. 39) includes, at centre left, the characteristic structure of a maltings, with its cowl on the roof of the kiln. Barley (the principal grain used for malt) was most commonly grown on farms in the south-east.[23] Hop-gardens (illus. 44) were particularly associated with Kent, while the weatherboarded construction common to the farmhouse in *The Cornfield* (illus. 40), the post-mill in *The Windmill* (illus. 42) and *The Dairy* (illus. 43) was also typical of the south-east and East Anglia, and can be seen in some of the farms in *A View in Suffolk* (illus. 48).[24] Hearne was well acquainted with Suffolk by the time he began *Rural Sports*. In addition to his six-week stay with Davy at Henstead in 1771, and his making the large view discussed above, he again worked in the county in 1780–1 at Heveningham, Leiston, Wingfield and Dunwich.[25] From his lodgings in London he was also within easy travelling distance of Kent and Essex.

Hearne's *Threshing* (illus. 41), conveys much information about this task. Two men, one with a hand flail, are working in a barn, while behind them is what appears to be a stack of threshed straw. The heavy wooden door, with its small pass-door, is wide open to admit light and provide ventilation, while a low cloth prevents the farmyard birds from entering and consuming the grain. To the right, haystacks (thatched against the rain) are shown raised above the ground on stone staddles, in order to minimize the danger of infestation by vermin or deterioration through damp. Used as a winter-fodder for both cattle and horses, plentiful hay ensured more manure for the arable fields, and this in turn improved yields of grass and grain, as shown in *Haymaking* (illus. 39) and *The Cornfield* (illus. 40). Much of Hearne's imagery, therefore, shared the traditional concerns of georgic poetry: accurate descriptions of rural tasks, celebration of the primacy of agriculture and the representation of the lower ranks of rural society as diligent workers, labouring for the good of the social hierarchy.

Hearne used a pictorial vocabulary, evolved from seventeenth-century Nether-landish art, that had already been recognized by George Lambert (1700–65), George Smith of Chichester and Thomas Gainsborough as providing an appropriate visual language for rustic subjects.[26] The low viewpoint and frame-filling compositional formula were alternatives to the Claudean prospect, and focused attention on the

fore- and middle-ground rather than the distance. Hearne was familiar with this tradition by 1776, as shown in *A View in Suffolk* (illus. 48). Furthermore, since in *Rural Sports* Hearne rejected the 'French' rustic genre fashion, which idealized and prettified (used by Francis Wheatley from the 1780s for his rural scenes),[27] it appears that he found this pictorial vocabulary appropriate for representing rural life as simple and laborious. 'The revolving labours of the year' are depicted in 'happy fields, unknown to noise and strife, The kind rewarders of industrious life'.[28]

Yet despite Hearne's adherence to an established view of rural life – perhaps most pronounced in the traditional image of the lone ploughman in the field (illus. 38) – the appearance of the agricultural landscape of Britain had been changing at increasing speed since the early eighteenth century, and by the 1780s the writing of georgic poetry had practically died out.[29] From the middle of the century, the process of field enclosure transformed huge areas of large open fields, common land and 'waste' on the Midland plain into regular fields divided by low hedges. Small freehold farmers began to lose their position in the rural hierarchy, many tenants lost their customary common rights and rural poverty increased; thus the social balance of the countryside began to change. At the same time, significant numbers of wealthy landed proprietors were loosening ties to their country estates and devoting more time to pursuing fashionable city life. The period saw a consolidation of aristocratic power, prestige and influence which was accompanied by a weakening of paternalist values in rural areas and a growing awareness of the increasing privations of rural pauperism.[30]

The unenclosed common land of the type seen in *A View in Suffolk* (illus. 48) was becoming increasingly rare, while the landscape Hearne depicted in *Rural Sports* was more typical of earlier, medieval types of enclosure, with its small and irregular plots of land, enveloping woodland, winding tracks and isolated farmsteads and cottages. Although this landscape was no more 'natural' than that of recently enclosed areas, the earlier changes had been piecemeal and on a scale thought appropriate for the needs of small freehold farmers. The older, more irregular pattern of medieval enclosure thus became increasingly appealing to conservative opinion as an exemplar of the 'natural' agricultural landscape, which had resisted change and where the perceived traditional order of rural society prevailed. This enduring quality was apprehended in the landscape's mature forest trees, thick hedges and vernacular buildings.

William Byrne's published prints made from Hearne's drawings demonstrate the popular appeal of such subjects; the series was re-issued in July 1810 at a time when artists, including Turner and Constable, were again engaged in painting agricultural landscape with an eye to the georgic tradition, in the midst of a renewed spate of enclosures undertaken during the Napoleonic Wars.[31]

The most popular rural poem of the eighteenth century, James Thomson's *The Seasons*, was published in its final form in 1744. Thomson had no truck with pastoral

nostalgia and believed that Georgian Britain, with its improving agriculture and expanding commercial empire, was a model of happiness and plenty. Hearne's illustrations to his poem differ from the earlier, more famous examples by William Kent and David Allan by being less 'rococo' and appearing to be more rooted in reality, albeit with an element of almost operatic artifice (illus. 49,50).[32] As the letterpress to the published engraving noted, *Summertime* (1784; illus. 49) illustrates the haymaking scene Thomson described in lines 350–70 of *Summer*:

> Now swarms the Village o'er the jovial mead . . .
> Wide flies the tedded grain; all in a row
> Advancing broad, or wheeling round the field,
> They spread the breathing harvest to the Sun,
> That throws refreshful, round a rural smell:
> Or, as they rake the green-appearing ground,
> And drive the dusky wave along the mead,
> The russet hay-cock rises thick behind,
> In order gay. While heard from dale to dale,
> Waking the breeze, resounds the blended voice
> Of happy Labour, Love and Social Glee.

To arrive at his elegant rustic composition Hearne drew upon a long tradition in British art of haymaking and pastoral scenes.[33] At the same time, because his figures could have been taken to represent actual, if well-groomed, labourers, he appears to have been responding to such a demand as that made by John Scott among others: that landscape painters people their scenes with appropriate inhabitants, showing 'simple elegance and ease'.[34] Hearne's figures in *Summertime* appear both 'simple' and 'elegant'. The costumes conform to those worn in *c.* 1783, showing that Hearne believed Thomson's sentiments to be as appropriate for the 1780s as they had been for the 1740s; the notion that 'happy Labour, Love and Social Glee' were the natural and enduring feelings of the whole rural community during haymaking, was an important one. *Summertime*, exhibited at the Society of Artists in 1783,[35] may have impressed George Stubbs, since he subsequently used the poses of the girl pausing in front of the haycart with her rake held upright, the woman on the left raking in hay and the man on top of the haycart, in early versions of his *Haymakers* and *Reapers*. Hearne made much of the triangular forms created by the rakes of the labourers, a device taken up, simplified and used to more forceful effect by Stubbs in his *Haymakers*, shown at the Royal Academy in 1786.[36] Hearne based his second illustration for *The Seasons* on lines from *Autumn* (230–310), this time depicting a harvesting scene (illus. 50). The verses describe how a wealthy young landowner, Palemon, becomes enamoured of Lavinia, a girl of means fallen on hard times and thus forced to labour in his fields. Hearne shows Palemon courting Lavinia, believing her to be a mere 'Gleaner in the field'. As it is subsequently revealed that Lavinia is in fact the daughter of Palemon's old patron, whose family became impoverished after the patron's death, a suitably respectable courtship and marriage can take place, and the social order remains intact.

48. *A View in Suffolk* 1776.
Watercolour over pen and
ink, 35.7 × 52.2. Leeds City
Art Galleries.

49. *Summertime* 1783.
Watercolour over pen and
ink, 27.7 × 32.7.
Whitworth Art Gallery,
University of Manchester.

65

50. *Autumn c.*1783–4.
Watercolour over pen and
ink, 26.3 × 31.7. Private
collection.

Hearne's literary illustrations and rustic landscapes show a consistent preoccu-
pation with agrarian society, but the completion of *Rural Sports* in 1785 ended this
prolific period, which had lasted only eight years.[37] These works parallel the first
volume of *The Antiquities of Great Britain.* In *The Antiquities* he had sought to raise
the aesthetic standard of antiquarian topography and to encourage moral reflection
among those who contemplated his representations of medieval architecture. In
these other works he had endeavoured to marry the traditions of landscape and
literary illustration and to inform the images this marriage produced with a moral
content which related to rural life. With the traditional contrast between town and
country implicit in his choice of subjects, Hearne focused attention on both the
edifying and the reprehensible; he emphasized the virtues of paternalism and
benevolence for the rich, industriousness and domestic content for the poor. But
by the late 1780s this attitude was becoming marginalized by sentimental rusticity,
a genre in which Francis Wheatley excelled, and from this time on Hearne
concentrated on antiquarian and landscape subjects.

66

CHAPTER FIVE

British landscape: picturesque tours and patronage

Hearne produced some of his finest landscape watercolours between 1777 and 1800. Some were private commissions for depictions of country houses and estates, like the set made for Richard Payne Knight of Downton in Herefordshire; others were based on sketches made while on tour in particular to the Lake District, the north of England and Scotland with Sir George Beaumont in 1777 and 1778. These watercolours, unrelated to any engraving project, were also more ambitious in size and scope than his drawings for *The Antiquities of Great Britain*. At their best they combined exact yet sensitive draughtsmanship and careful pictorial arrangement with an advanced use of broken colour-washes to convey atmosphere and the effects of light and shade.

Hearne's Lake District watercolours and drawings, made on the 1777 and 1778 tours in the company of Beaumont and Joseph Farington, are the first we should consider. Much of his work from these two summers was related to gathering material for possible inclusion in *The Antiquities*. Cumberland was liberally endowed with castles: Carlisle, Cockermouth, Greystoke, Naworth, Dacre, Penrith, Egremont and others. Hearne made studies at all these sites, and at the ruins of Lanercost Priory and Wetheral Priory in Cumberland and Furness Abbey in Lancashire, using pencil and wash or pencil, ink and wash. Many were quite conventional antiquarian designs, with the architectural subject set firmly in the centre of the composition. In others, notably Lanercost Priory (illus. 29) and Cockermouth Castle (illus. 54), he sought to place the spectator within the ruins, and invite a more personal, contemplative response to the image. We know that Hearne often copied Canaletto (and owned nine etchings by him), and this compositional ploy may have been adapted from Canaletto's bold architectural designs, in which the arch of a building often frames the main subject of the scene.[1]

Architectural studies apart, Hearne used the scenery around Derwentwater for a series of landscapes and figure studies. By the late 1770s the Lake District had become the particular focus for the fashionable in search of a native Arcadia – a local equivalent to those scenes depicted in the Roman landscapes of Claude, Salvator Rosa and Gaspard Dughet, all of whom were avidly collected by British patricians on the Grand Tour. Much of the early travel literature stressed the arcadian nature of the Lakes, including Thomas Gray's *Journal* (1775), in which the region was seen as an unspoiled paradise, one of sublime and astonishing mountain scenery.[2] In 1778 the first guide book to the Lakes was published, in

51. *View from Skiddaw over Derwentwater c.*1777. Watercolour over pencil, 18.7 × 27. Yale Center for British Art, Paul Mellon Collection.

52. *(opposite) Sir George Beaumont and Joseph Farington Sketching a Waterfall c.*1777. Watercolour wash over pen and ink, 44.5 × 29.2. The Wordsworth Trust, Cumbria.

which the author, Thomas West, argued that the region rivalled the Continent for its scenery:

In truth, a more pleasing tour than these Lakes hold out to men of leisure and curiosity cannot be devised. We penetrate the glaciers, traverse the Rhone and the Rhine, whilst our domestic lakes of Ullswater, Keswick and Windermere exhibit scenes in so sublime a stile, with such beautiful colourings of rock, wood, and water, backed with so tremendous a disposition of mountains, that if they do not fairly take the lead of all the views in Europe, yet they are indisputably such as no English traveller should leave behind him.[3]

West's language parallels Richard Gough's appeal of ten years earlier, that the polite should take notice of British medieval remains (the popular fashion for travel was a consequence of the growing interest in antiquities and landscape painting). West was in no doubt that a burgeoning taste for landscape painting

induces many to visit the Lakes of *Cumberland, Westmoreland* and *Lancashire*; there to contemplate, in Alpine scenery, finished in nature's highest tints, the pastoral and rural landscape, exhibited in all their stiles, the soft, the rude, the romantic and the sublime.[4]

68

69

53. *Sir George Beaumont and Joseph Farington Sketching in Oils c.*1777. Pencil, 17.8 × 19.1. The Wordsworth Trust, Cumbria.

The connoisseur of landscape painting and natural scenery found t^ celebrated landscapes of the Lake District at Derwentwater (or K̵ ̵e), ᴵn the rugged mountains of Borrowdale, or in the dominating twiᴵ ̵ummits of Skiddaw. When the Revd William Gilpin arrived at Derwentwater from Ambleside during his tour of 1772 he remarked that 'of all the lakes in these romantic regions, the lake we are now examining, seems to be most generally admired'.[5] The publication of Gray's *Journal* in 1775 drew Joseph Farington to Keswick later that year; by 1777 Farington was adept at making sketches which corresponded with Gray's descriptions.[6] Farington stayed with Hearne and Beaumont at an inn near Lodore, above Derwentwater, and Hearne recorded his companions sketching in oils out-of-doors by the nearby waterfall (illus. 52,53). Richard Wilson was reputed to have taken up this practice earlier in the century while in Italy, and his pupil, Thomas Jones, followed him. Farington was another of Wilson's pupils, while Beaumont had taken lessons in painting in oils from Jones in 1774. The practice was supposed to have originated with landscape painters based in Rome in the seventeenth century.[7]

Hearne appears to have stayed with watercolours, and *View from Skiddaw over Derwentwater* (illus. 51) deserves particular notice, both for its place in his own output and, more generally, in that of the development of British landscape painting in the 1770s. This extensive view from near the summit of Skiddaw includes prospects of Derwentwater and the far distance towards the mountains of Borrowdale in the south. There is no sense here of the methods usually followed for ordering an extensive landscape, methods that accorded with the influential models

70

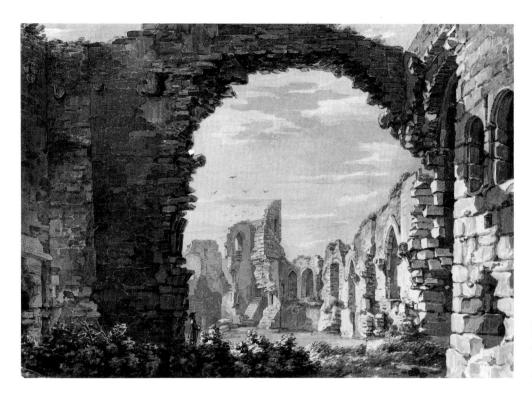

54. *A View of the Interior of Cockermouth Castle, Cumberland* 1777. Grey wash over pencil, 18.4 × 26.3. Private collection.

from 'classical' landscape painting. The dark foreground and great shoulder of mo. .the left, painted in intermingled washes and touches of brown, pink, ochre and green, emphasize the precipitate drop to the valley, lake and mountains beyond, all painted in varied blues and greys. This deliberate and convincing vertiginous composition is an example of Hearne working in the Burkean Sublime.[8] John Brown's *Description of the Lake at Keswick* (1767) included a passage on the sublimity of views around Derwentwater and Borrowdale, which illustrates the topographical conventions of expectation and experience within which Hearne worked:

I will now carry you to the top of a cliff, where if you dare approach the ridge, a new scene of astonishment presents itself, where the valley, lake and islands, seem lying at your feet, where this expanse of water appears diminished to a little pool amidst the vast immeasurable objects that surround it; for here the summits of more distant hills appear beyond those you had already seen; and rising behind each other in successive ranges, and azure groups of craggy and broken steeps, form an immense and awful picture, which can only be expressed by the image of a tempestuous sea of mountains.[9]

View from Skiddaw over Derwentwater (illus. 51) shows Hearne working to encompass the amphitheatre of mountains surrounding the lake, and even here, despite the Sublime nature of the scene, he used the pictorial vocabulary to contain and order his subject. The peaks of Borrowdale are softened and subordinated, the dramatic downward plunge of Skiddaw's flank is offset by the gently rising cloud shapes from left to right. The landscape opens out between these two forces of movement, the handling is sensitive to the play of light and shadow and the intermingling of gently

71

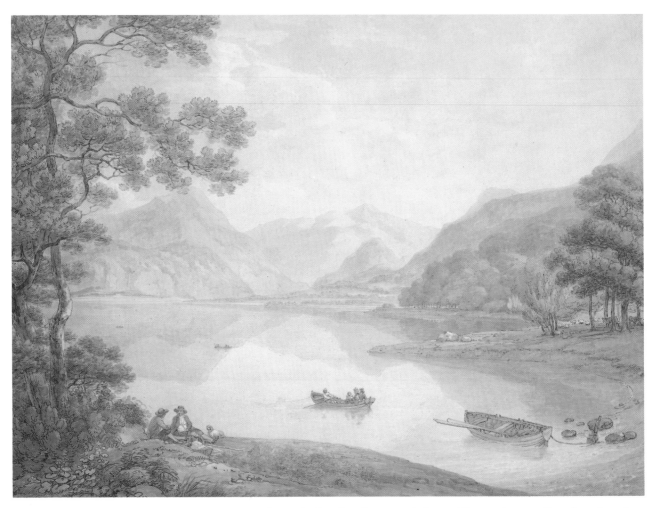

55. *Derwentwater from Brandelhow Woods* c.1777–8. Watercolour over pencil and pen and ink, 35 × 46.5. Rijksmuseum, Amsterdam.

tinted mountain peaks with the clouds around them. Hearne's pencil under-drawing is extremely delicate and harmonizes with the gentlest of washes in the distance to produce a drawing of great subtlety which exceeds the conventional bounds of topography. Just as *The Antiquities of Great Britain* embodied moral and social discourses, so the evidence of contemporary topographical literature suggests here a parallel concern in Hearne's picturing of the extensive view from near Skiddaw's summit.

From the 1750s there were two conventional attitudes informing writings about the area around Derwentwater. One saw the landscape in terms of seventeenth-century landscape paintings by Claude, Salvator Rosa and Gaspard Dughet. We find this in Brown's *Description of the Lake at Keswick*, written perhaps as early as 1753 but not published until 1767:[10]

The full perfection of Keswick consists of three circumstances, *beauty*, *horror* and *immensity* . . . to give you a complete idea of these three perfections, as they are joined in *Keswick*, would require the united powers of *Claude*, *Salvator* and *Poussin*. The first should throw his delicate sunshine over the cultivated vales, the scattered cots, the groves, the lake and

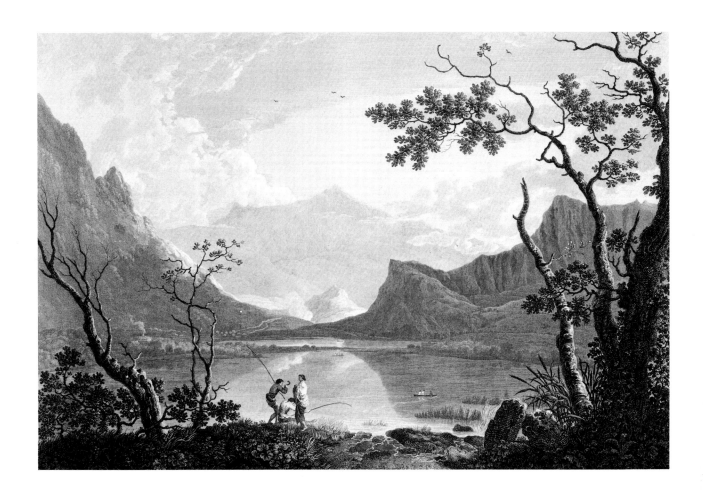

wooded islands. The second should dash out the horror of the rugged cliffs, the steeps, the hanging woods and foaming waterfalls; while the grand pencil of Poussin should crown the whole with the majesty of the impending mountains.[11]

Brown was the tutor of William Gilpin, who echoed these sentiments in his *Observations* on the Lake District, made on a tour in 1772. Derwentwater, 'was once admirably characterized by an ingenious person, who on his first seeing it, cryed out, Here is beauty indeed, Beauty lying in the lap of Horrour!'[12] An alternative convention – initiated with John Dalton's *Descriptive Poem* of 1755 – examined the Derwentwater landscape in more explicitly moral and social terms. Dalton wrote the poem for two female members of the Lowther family at Whitehaven, hence his setting of the Lake District in the context of local aristocratic life, and he praised the Lowthers' paternalistic devotion to the locality and its people. Scorning the lure of the Grand Tour or idle luxury at home the family

> Opens the hospitable door;
> Welcomes the friend, relieves the poor;
> Bids tenants share the liberal board,
> And early know and love their lord.

73

Such sentiments had been current in country-house poetry since the early seventeenth century and were reiterated by Pope in his epistles *Of the Use of Riches* to Allen, Lord Bathurst, and Richard Boyle, Earl of Burlington.[13] In accordance with this poetic convention, Dalton considers the landscape in a language redolent of social hierarchy and order:

> Supreme of mountains, Skiddaw, hail!
> To whom all Britain sinks a vale!
> Lo, his imperial brow I see
> From foul usurping vapours free![14]

In 1769 Thomas Gray used a protective, maternal metaphor to characterize Skiddaw: 'Passed by the side of Skiddaw and its cub called Lattrig; and saw from an eminence, at two miles distance the vale of Elysium in all its verdure; the sun then playing on the bosom of the Lake; and lighting up all the mountains with its lustre';[15] while the remarks made by the antiquarian Thomas Pennant, passing through the Lakes en route for a Scottish tour in 1772, support the notion that this landscape was commonly perceived as politically emblematic in a more abstract sense:

> *Skiddaw* shews its vast base, and bounding all that part of the vale, rises gently to a height that sinks the neighbouring hills; opens a pleasing front, smooth and verdant, smiling over the country like a gentle, generous lord, while the *fells of Borrowdale* frown on it like a hardened tyrant.[16]

Thomas West drew on both conventions in his *Guide to the Lakes* (1778). At one point he described the approach to Keswick from the south:

> The change of scenes is from what is pleasing, to what is surprising; from the delicate touches of *Claude*, verified on *Coniston Lake*, to the noble scenes of *Poussin*, exhibited on *Windermere-water*, and from these, to the stupendous romantic ideas of *Salvator Rosa*, realised on the lake of *Derwent*.

Further on, he described the view of Derwentwater from Brandelhow Woods on the western bank of the lake:

> The opposite shore is bounded by a range of hills, down to the entrance of Newland vale, where Causey-pike and Thornthwaite rise in Alpine pride, outdone only by their supreme lord, Skiddaw. Their skirts descend in gentle slopes, and end in cultivated grounds . . . the north end exhibits what is most gentle and pleasing in landscape. The southern extremity of the lake, is a violent contrast to all this. Falcon crag an immense rock hangs over your head, and upwards, a forest of broken pointed rocks in a semi-circular sweep, towering inwards, form the most horrid amphitheatre that ever eye beheld in the wild forms of convulsed nature.

Elsewhere he referred again to 'the skirts of Skiddaw' in maternal fashion, contrasting this once more with the fells of Borrowdale where 'rock riots over rock' in chaotic ruggedness.[17] Consequently, Hearne's extensive view from near the summit

of Skiddaw over Derwentwater towards the 'tamed' fells of Borrowdale may constitute a visual metaphor for a divinely ordained hierarchical social order, with the forces of potential disruption contained and constrained within an all-embracing visual harmony. Richard Wilson had similarly ordered the wildness of the mountains of North Wales in his *Cader Idris, Llyn-y-Cau*, engraved in 1775.[18]

Hearne's view of *Derwentwater from Brandelhow Woods* (illus. 55) is taken from the pastoral, wooded shores of the lake, praised by Gray and Gilpin, towards the mountains of Borrowdale. The two sweeping arcs, formed by the mountains and their reflections in the lake, are again reminiscent of a Wilson landscape, one engraved by Woollett in 1775: *Snowdon from Llyn Nantlle* (illus. 56).[19] This device, carefully adapting the topography to an idealized ordered view, is here aided by a more usual sequence of spatial recession, from the conventional framing tree on the left and the foreground promontory, across the lake, to the mountains in the background.

Hearne's remarkable panorama of the Derwentwater area, made for Sir George Beaumont in 1777, was described by the poet Robert Southey, who reported that while staying with Beaumont near Derwentwater, Hearne

made for him a sketch of the whole circle of his vale, from a field called Crow Park. Sir George intended to build a circular banqueting room, and have this painted round the walls. If the execution had not always been procrastinated, here would have been the first panorama. I have seen the sketch, now preserved on a roll more than twenty feet in length.[20]

Hearne's large panorama has not survived, but it clearly preceded Robert Barker's one of Edinburgh made a decade later, in 1787.[21] Thomas Gray had praised the view around Derwentwater from Crow Park, while lamenting the loss of the oak trees which had belonged to the Jacobite 3rd Earl of Derwentwater, executed after the rising of 1715; his confiscated estates passed to Greenwich Hospital, and the trees were felled and sold. Gray noted that Crow Park,

now a rough pasture [was] once a glade of ancient oaks, whose large roots still remain in the ground, but nothing has sprung from them. If one single tree had remained, this would have been an unparalleled spot; and *Smith* judged right when he took his print of the lake from hence, for it is a gentle eminence, not too high, on the very margin of the water, and commanding it from end to end, looking full into the gorge of Borrowdale.[22]

Thomas Smith's print of *Derwentwater from Crow Park* (1761), mentioned by Gray, was another precedent for Hearne.

A smaller *Panorama of Derwentwater from Crow Park* (illus. 60), datable to the mid 1770s on the evidence of the costume and the amount of tree-growth, does survive, and these six sheets may represent initial pencil and wash sketches by Hearne, which have been worked over in pen and ink and wash by a later hand.[23] The general pictorial conception, with the dark mass of the Skiddaw group dominant, the Borrowdale fells again subdued and the distances over Bassenthwaite

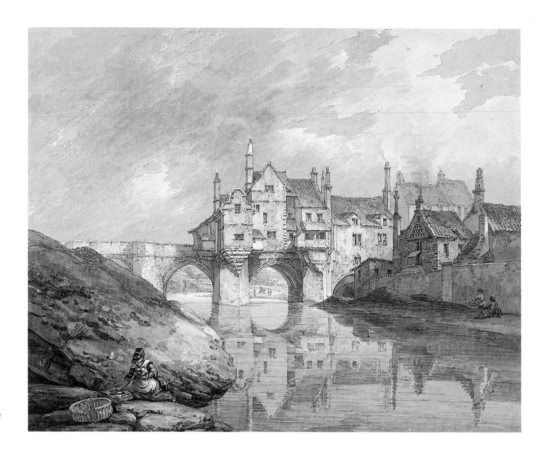

57. *Elvet Bridge, Durham*
mid- 1790s. Watercolour
over grey wash, 20.3 ×
25.4. The Trustees of the
British Museum.

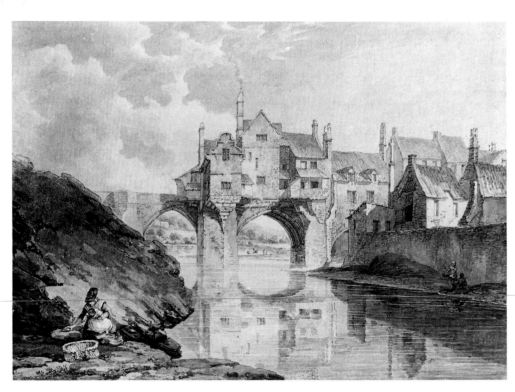

58. *Elvet Bridge, Durham*
1781. Watercolour with
touches of ink over pencil,
18.4 × 26.6. Ashmolean
Museum, Oxford.

76

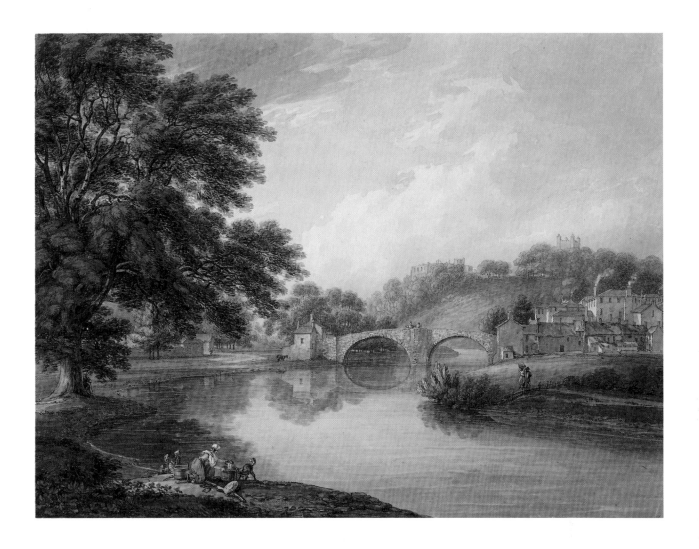

59. *Appleby c.*1783.
Watercolour with touches
of bodycolour over pen and
ink, 30.2 × 40.3. The Tate
Gallery, London.

Lake gently washed in, appears to fit well with Hearne's other views of the area. The elegant figures, admiring the prospect or sketching the scene, along with the rowing boats (for viewing the landscape from the lake) in *Derwentwater from Brandelhow Woods* (illus. 55), are reminders that this region was an important goal for those patricians, like Beaumont, in search of a visible 'British Arcadia'.[24] Thomas West spelt out the implications of living in such a region for the 'more humble' Lakeland inhabitants, at the end of his *Guide*:

You are placed in one of the most beautiful districts of the kingdom . . . And if you be not the happiest of people, the fault must be in yourselves; since nature has bountifully bestowed upon you every essential requisite of enjoyment. Be therefore content to pursue your innocent, though humble vocations, without letting a wish wander beyond your peaceful vales; and now and then turn your thoughts towards those particulars which annually bring among you so many wealthy and respectable visitors. Keep your highways in good order . . . Preserve your native modesty, and never let envy mar your civility. When you prune a fence joining to a public road, put the branches where they can be no annoyance; and then, as

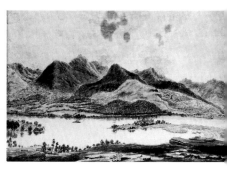

60. *Panorama of Derwentwater from Crow Park* c.1777. Pen and ink, and watercolour over pencil, 25.1 × 233.6 (six sheets joined). The Trustees of the Victoria & Albert Museum.

you are already exemplary in many moral virtues, you will set a pattern of rural decency worthy of the imitation of several politer parts of the kingdom.[25]

Both the social reality and, as we have seen, the pictorial representations of the Lake District, needed to be carefully ordered if the region was to fulfil the 'Arcadian' expectations of its visitors. Hearne used his Northern excursions as more than simply opportunities to study the landscape of the Lake District. On his tours to the ruined abbeys, castles, ancient towns and cities of northern England and Scotland he sketched in pencil and pen and ink, sometimes tinting with grey and sometimes blue-grey washes. From such sketches he made larger watercolours, including those of Appleby (illus. 59), Durham (illus. 57,58,61,62), Barnard Castle (illus. 66) and Edinburgh (illus. 64), integrating groups of buildings and townscapes into landscape settings. Professional draughtsmen such as Hearne were thought to have little prestige as artists, particularly in the light of the attitudes Sir Joshua Reynolds had been propounding in his *Discourses*, through which he aimed, impractically, to establish a British school of history painting.[26] Landscape, even when painted in oils, was an inferior 'department of painting', along with portraiture and still-life,[27] which could never impart the high moral ideals conveyed by history painting through the depiction of improving subjects taken from classical history, mythology and the Bible. The best to which landscape could aspire was represented by the works of Claude Lorrain.[28] Hearne, a draughtsman who did not paint in oils, could never have been admitted to the Academy Schools, yet might have found some comfort in reading Reynolds, whom he admired along with Claude. Reynolds had stated:

A man is not weak, though he may not be able to wield the club of Hercules; nor does a man always practise that which he esteems the best; but does that which he can best do. In moderate attempts, there are many walks open to the artist [and that] perfection in an inferior style may be reasonably preferred to mediocrity in the highest forms of art.[29]

It is likely that Hearne's artistic ambition made him determined to elevate the lowly art of architectural and landscape draughtsmanship into an expressive patriotic topography, informed by the principles of those masters of landscape painting most

78

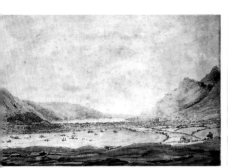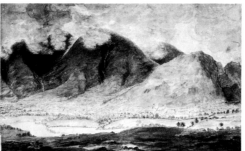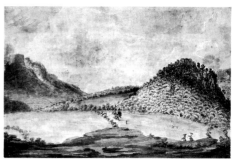

appropriate to his subjects. His training introduced him to the picturesque: he became acquainted with a wide range of Dutch, Flemish and Italian landscape prints, which he went on to collect himself. Dutch artists, such as Waterloo, Rembrandt and Ostade, and English painters working in their formal tradition, such as Gainsborough and George Smith of Chichester, enjoyed representing rugged, weathered textures and the play of light upon buildings and trees. Moreover, among their wide range of landscape subjects, were plenty which would be classified as 'common nature'. Hearne's Wiltshire childhood and memories of rural life probably added to the appeal of such images, much as Malmesbury Abbey had influenced his approach to medieval architecture. The contrasting 'classical' land-scapes of Claude, Dughet and particularly Richard Wilson, served as models of picture-making which, as recognizably 'ideal' landscapes would, if imitated, confer dignity and seriousness upon topographical paintings of native scenery.

The centrality of British antiquities and landscape to Hearne's work must be emphasized. Along with Paul Sandby, Michael Rooker and Edward Dayes, Hearne never made a continental Grand Tour – his extended period in the West Indies appears to have satisfied his appetite for foreign travel – and the commitment to touring in Britain from 1776 to 1781, indicates that his preference for British subject-matter was the result of determined conviction rather than a lack of ambition.

Hearne was not alone in seeking to charge landscape with elevated content. His close friendship with Charles Davy and Beaumont would have made him well acquainted with Alexander Cozens's theories.[30] Cozens had argued, in his teaching and books, that both landscape compositions and motifs supplied a formal system for communicating complex moral, political and emotional ideas, thus elevating landscape to a station properly occupied by history painting.[31] Gainsborough was also subverting academic dogma at precisely this period, by exhibiting drawings in imitation of oil paintings, or by quoting elevated sources in 'low-life' landscapes. Although Hearne always worked within the traditional technical boundaries of topographical practice (the stained drawing), seeking to elevate its content involved an inevitable contradiction. With popular support for topographical work so strong,

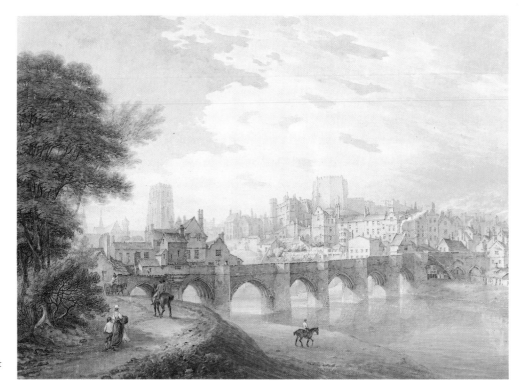

61. *North-east view of Durham* c.1781–4. Watercolour and touches of bodycolour over pencil, 32.7 × 45.4. Leeds City Art Galleries.

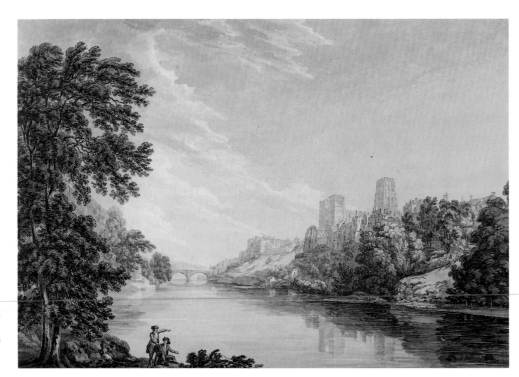

62. *Durham Cathedral from the opposite bank of the Wear* 1783. Watercolour and pen and ink over pencil, 37.2 × 53.9. The Trustees of the Victoria & Albert Museum.

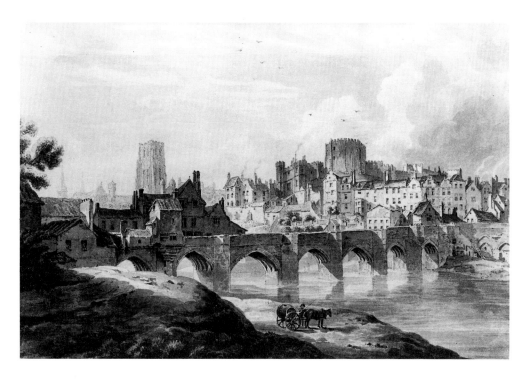

63. *North-east view of Durham c.*1777–8. Pencil and grey wash, 26.6 × 39.7. Norwich Castle Museum.

and increasing numbers of artists becoming landscape specialists (following Richard Wilson and Paul Sandby), the destabilization of academic hierarchies was only a matter of time. The detail of this development can be examined through the large watercolours derived from sketches and studies Hearne made during his tours of the North of England and Scotland in the late 1770s.

In 1778 he visited *Appleby* (illus. 59). The ambitious watercolour he made there features a broad view of the old bridge over the River Eden, including part of the town – its red tiled and grey slate roofs differentiated – and, half-hidden by trees on the crest of the hill, Appleby Castle. Here Hearne used the pictorial device of the bridge and its reflection in the river as the focus of a carefully ordered composition. The water surface is tinted subtly in soft grey, blue and green washes, while white bodycolour highlights the foreground figure, the texture of the stone bridge and the chimney-smoke. A framing tree on the left, and the sky echoing the forms of the landscape below, contribute to this balance and repose, yet nevertheless Hearne sought to render truthfully the fleeting effects of cloud and sunshine. At this period his work was characterized by this combination of pictorial sophistication and incipient naturalism. This is clearly shown by comparing two versions of the same view made at different times. Variants of *Elvet Bridge, Durham* (illus. 57,58) would have been worked up from sketches (either pencil and wash or pen and ink and wash) made on tour in 1777 and 1778. The 1781 drawing (now in the Ashmolean) exemplifies Hearne's increasing interest in depicting the varied colouring given to ancient stonework by moss and lichens, and by the play of light. There

81

64. *Edinburgh from Arthur's Seat* c.1778. Watercolour over pencil, 35.6 × 50.8. The Tate Gallery, London.

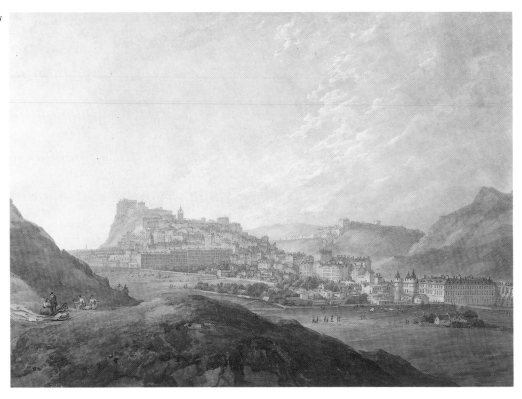

65. *Edinburgh from Arthur's Seat* 1778. Grey wash over pencil, 16.7 × 24.3. Yale Center for British Art, Paul Mellon Collection.

66. (*opposite*) *Barnard Castle* 1788. Watercolour over pencil, 25.4 × 38.8. The Bowes Museum, Barnard Castle, Co Durham.

67. (*opposite*) *The Windings of the Forth from Stirling Castle* c.1778. Watercolour over pencil, 18.7 × 27. Birmingham Museum and Art Gallery.

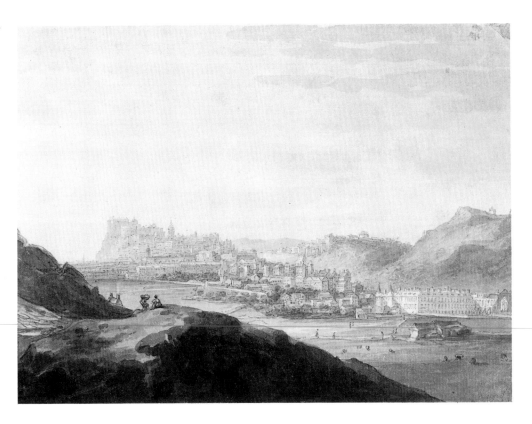

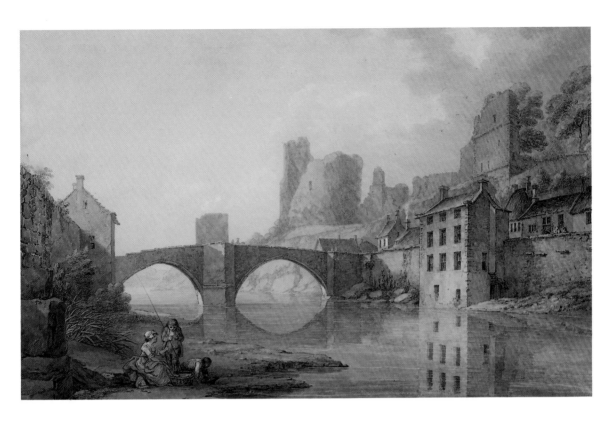

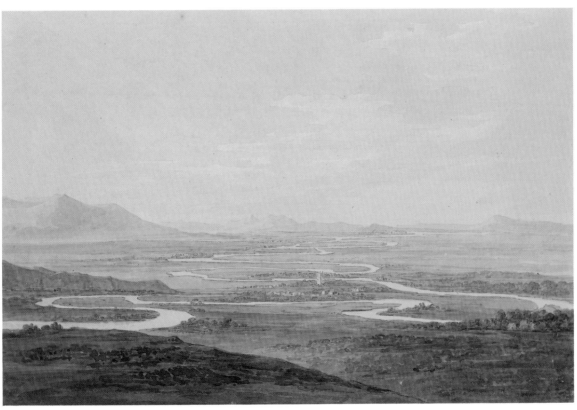

is an initial pencil outline, after which the bridge and buildings are painted in tones of grey, sepia and, behind the figures on the right, blue pigment. The other version (British Museum) was probably made far later, in the mid 1790s.[32] This is an altogether more imposing view. The increase in the height of the image now permits the reflection to be shown in full, together with a larger expanse of sky. The diagonal cloud formation opens out the image, lifting the eye away from the foreground rock, towards the opposite bank. Pencil underdrawing has been abandoned in favour of outlining with the point of the brush, which harmonizes more with the other washes; highlights are again picked out with touches of white bodycolour. The interest in light and texture is maintained but united with a shift towards greater pictorial balance.

The *North-east view of Durham* (illus. 61), dating to the 1780s, integrates topographical detail with atmospheric effects, subtly modulating colour and tone. It prospects the other side of Elvet Bridge with the Castle and Cathedral in the background. The grey wash and pencil study made on tour omitted the tree on the left (obviously a studio addition) and the figures on the track, while important antiquities like the Cathedral and Castle were given more emphasis (illus. 63). The architectural detail in *Durham Cathedral from the opposite bank of the Wear* (illus. 62) is drawn in pencil, but the lines of the foreground trees have been strengthened with pen and ink. The soft blues, greys, reds and greens barely tint this drawing beyond monochrome. Once again Hearne's ordering of the scene overrides topographical niceties. The reflections of the Cathedral towers have been shortened to keep them within the lower margin of the drawing. The vault of the sky links the trees on the left with the Cathedral and city on the right. Only two of these larger watercolours were exhibited at the Royal Academy. *Barnard Castle* (illus. 66), dated 1788 (ten years after Hearne's visit) and shown in that year, is almost certainly one of them. It shares, with the above watercolours, a studied arrangement of balancing forms (architecture and reflection); in addition the figure group is framed by the arch of the bridge in the manner of Wilson, and the restrained palette of warm pink and cooler blue-green harmonizes detail.

As we have seen, Hearne was fascinated by historical architecture, and it is noticeable that in most of these watercolours, a bridge in the middle distance is of central interest. Besides acknowledging Claude the image had other attractions. The strong architectural form of the bridge is an important pictorial accent, which also offers further glimpses of the landscape beyond. The juxtaposing of masonry arch and river reflection in the watercolours of Elvet Bridge, Durham, Barnard Castle and Appleby is the central balancing form in the composition, to which the eye is continually drawn. There is also a significant contrast between the solidity and permanence of the bridges and the ephemeral nature of the reflected images. The real fragility of such ancient structures was central to his artistic interests, and he would have known that the severe damage to Elvet Bridge in Durham in a flood

of 1771 necessitated rebuilding many of its arches. His contrasting imagery could thus evoke thoughts on the passage of time (for which a river was a traditional emblem) and impermanence in relation to ancient architecture.

Edinburgh from Arthur's Seat (illus. 64) was larger than *Barnard Castle*, but it was never exhibited by Hearne. The large shaded mass in the foreground shows part of the extinct volcano known as Arthur's Seat, while in the middle distance Edinburgh Castle and the city is bathed in early evening light. This section is painted with tonally-close washes over the pencil, contrasting with variegated brown and green tints in the foreground and the pale blue of the distant hills. The pen and wash study for this watercolour was probably made on the spot in 1778 during Hearne's tour with Beaumont (illus. 65). Dated drawings by Beaumont show they were in Dumbarton on 23 August and in Glasgow on 28 August. It is likely then that they arrived in Edinburgh in early September 1778. To create an imposing view Hearne 'improved' both nature and architecture. The distant hills are rounded, in contrast to the sketch, while some of the tenement buildings are physically heightened, or made to appear taller by reducing the surrounding foliage. The clarity of the prospect is further enhanced by moving the foreground figures in the sketch to the left, and by reducing the size of the farm buildings in relation to Holyrood House. Above the city the sunlit, broken clouds form a contrasting diagonal accent to the dark foreground mass.

On the 1778 tour Hearne and Beaumont appear to have gone as far north as Stirling, perhaps prompted by Thomas Pennant's praise of the views from the Castle as 'by far the finest . . . in Scotland' (illus. 67).[33] Drawings made that year formed the basis for two plates from Volume I of *The Antiquities*. The second, dedicated to Beaumont, carried a letterpress detailing Hearne's impressions of the visit:

The extraordinary Views from the scite [sic] of this Castle are not to be described in words; it must suffice to say, that towards the north, the south and the west, they are magnificent and sublime, and the windings of the Forth, through a plain towards the east, are so often and so suddenly deflected, that though the distance from the bridge at Stirling to the town of Alloa, does not exceed four miles, yet to pass to it by water is a navigation of more than twenty, and the eye is captivated in tracing its meanders through a rich and fertile country, finely diversified with plantations, granges and inclosures.[34]

This view looks east towards Alloa, with Cambuskenneth Abbey in the middle distance. The white of the paper (shining through the thin washes of the river) against a dark foreground attracts the eye from the left. Colour harmony as well as a subtle illusion of spatial recession are achieved through muted tones of brown, grey, green and blue.

Although Hearne never travelled to the Continent, many found its enticements overwhelming. Richard Payne Knight for instance, the son of a wealthy Shropshire ironmaster, was accompanied on a visit to Italy in 1776 by the young watercolour

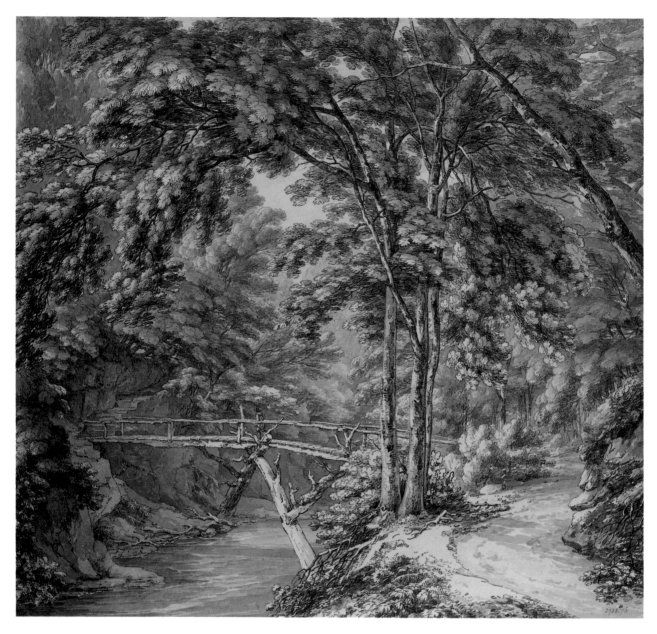

68. *The Alpine Bridge on the
Teme at Downton c.*1786.
Watercolour over pen and
black and sepia ink, 32 × 35.
The Trustees of the
Victoria & Albert
Museum.

69. (*opposite*) *An Oak Tree
c.*1786. Watercolour over
pen and ink, 50.6 × 34.3.
The Trustees of the
British Museum.

86

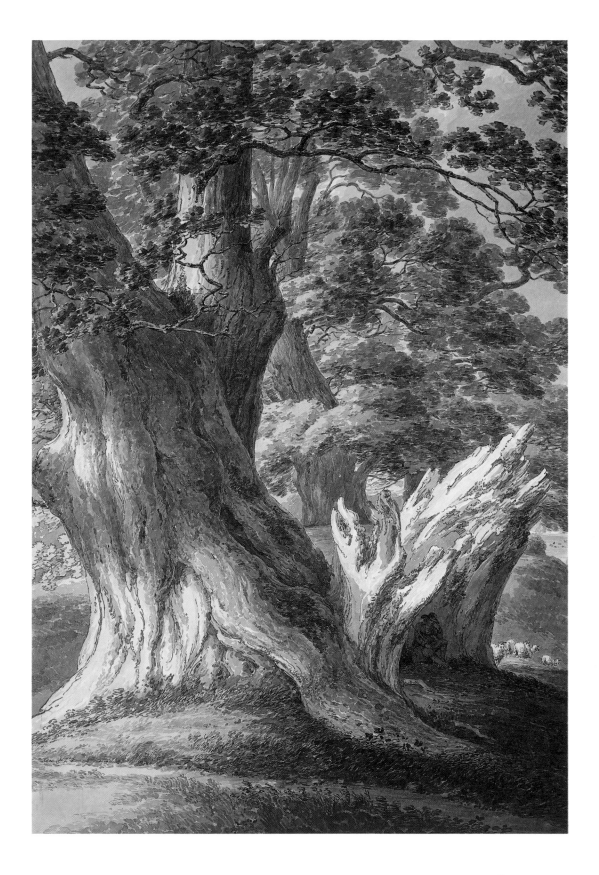

70. *The Sepulchre at Agrigentum, Sicily* c.1780. Watercolour with pen and ink over pencil, 27 × 44.7. The Trustees of the British Museum.

71. *(below) Heveningham Hall, Suffolk* 1781. Watercolour over pen and ink and pencil, 40.5 × 57.8. Private collection.

88

painter John Robert Cozens. After spending some months in the stimulating intellectual climate of Rome, Knight travelled through Southern Italy to Sicily with two new companions, Jacob Phillipp Hackert, a talented German draughtsman, then resident in Italy and popular with English patrons, and Charles Gore, a Yorkshire merchant of independent means who had passions for antiquarianism and amateur draughtsmanship. Their main purpose was to record the Greek temples on Sicily at Segesta, Selinunte, Agrigento and Syracuse. Many drawings were made by Hackert and Gore, and after Knight returned to England he engaged Hearne in 1780 to paint finished watercolours from them. This was apparently in preparation for Knight's intended publication of his tour, and Hearne thus rendered the often vividly coloured and over-elaborate sketches into more tonally balanced and simplified views which an engraver could use (illus. 70). Knight, an intellectually ambitious young man, was eager to make his mark in the liberal arts, and probably meant his publication to conform to the model supplied by the scholarly reports prepared by the Society of Dilettanti since the 1760s. Knight's plans for a book were scotched, however, when lavishly illustrated accounts of Sicily began to appear on the Continent in 1781.[35]

This commission alerts us to the low status that connoisseurs generally accorded to professional draughtsmen and the watercolours they produced. Draughtsmanship was considered to be a mechanical task which could be accomplished by a division of labour, with Hearne drafted in as a skilled technician rather than a creative artist. Although his watercolours were impressive enough in managing large compositions they do not show Hearne at his best, probably because he had to work from drawings by others. On the positive side, Payne Knight would prove to be a useful social contact and patron.

The East Anglian connections of Beaumont and Charles Davy probably secured Hearne the patronage of Sir Gerard Vanneck, who commissioned him to paint a number of views of his seat at Heveningham Hall, Suffolk, in 1780. The two watercolours that have been traced from this set are very different from one another in intention and effect. The larger (illus. 71) shows Sir Gerard and Lady Vanneck and a companion riding in their grounds, with the Hall in the distance. The proprietorial character of the image is not to be wondered at in the circumstances prevailing at Heveningham Hall in 1780–1. Sir Gerard's father, Sir Joshua Vanneck, a merchant banker of Dutch ancestry whose company engaged principally in the French tobacco trade and floating loans for the Whig government, bought the estate in 1759. The house was then a modest red-brick building dating from Queen Anne's reign, which the cautious Sir Joshua did not improve. When his son inherited the estate in 1777, however, things changed rapidly. He employed Sir Robert Taylor, a leading architect (best known for his work in the City of London), to transform the house into a convincing gentleman's 'seat'. The brick core remained but the exterior was emphatically remodelled, with the frontage extended to more

than three times its original length, 'with the maximum emphasis, in a colossal colonnade resting upon deep rusticated arches and carrying a massive, enriched podium'.[36] It is this exterior, finished by 1780, which Hearne depicted. Lancelot 'Capability' Brown had landscaped the pastoral valley, watered by a small stream, which the north front surveyed. The stream became a serpentine river and clumps of trees were planted over wide expanses of lawn, as was usual with Brown's improvements. Hearne's view shows this new estate landscape.

The size of this watercolour suggests that it is one of three Heveningham Hall subjects exhibited by Hearne on his first appearance at the Royal Academy in 1781. All his major drawings for public exhibition before this date had been antiquarian or landscape subjects shown at the Society of Artists. It is interesting that these particular country-house views were selected for his Academy debut, as the decision to exhibit there was a significant change in professional practice and allegiance, which we have seen reflected in his large-scale topographical work. Other estate views made for Payne Knight at Downton were shown at the Academy in 1785 and 1786, but it was not until 1787 that Hearne exhibited an uncommissioned landscape watercolour. As the Heveningham views included a *Landscape with portraits*, presumably of the Vannecks, Hearne appears to have been attempting to reinforce his own and his patron's ambition and standing in this public forum. In the late 1790s Joseph Farington laid out the bald financial facts of the case to a young artist:

Portrait painting undoubtedly offers more certain employ than any other branch, of course there is less risk ... Landscape painting is not so much encouraged as it has not the advantage of being supported by self love, while portraits from that motive will always be had at from the highest to the lowest prices ... there is a sort of Landscape *Portrait* Painting by which a good deal of money is got, viz: painting views of Houses etc., but where the picture will only be purchased for its intrinsic merits few will be found to command an income.[37]

The view of Heveningham Hall was engraved and published as a plate in William Watt's *Seats of the Nobility and Gentry* in 1782, and although Hearne produced only a few country house watercolours, their importance for his career in the 1780s was considerable.

The freer draughtsmanship, broader application of colour washes and small size of Hearne's second surviving Heveningham watercolour suggests that this was a study not an exhibited work (illus. 72). This is no expansive view of the Hall or its grounds, but an image of an enclosed woodland glade. An appropriately pastoral shepherd reclines on a bank, while the overarching trees disclose a distant view of the river. The woods at Heveningham, planted by Sir Joshua, had been praised by Charles Davy in a letter to a student:

You will be delighted with Sir Joshua's noble plantations of oaks, beeches, and chestnuts, etc., with which he has ornamented the whole country, and which, in half a century, as the

soil is particularly favourable to them, will be an inexhaustible treasure to the public, as well as to his family.[38]

Davy reiterated the traditional and paternalist convention, which has the morally responsible landowner enhancing the existing natural beauty of his estate by sensitive planting of woodland, for the benefit of patricians on the country-house tourist circuit, who alone were eligible for admittance, while patriotically and profitably supplying timber for the navy's ships.

There is substantial evidence for thinking that Hearne would have been sympathetic to the landowning and landscaping practices of Sir Joshua, and would have had great reservations about the conspicuous developments instituted by his son. We have seen that Hearne's illustrations to *The Vicar of Wakefield* implied a sympathy with Goldsmith's criticisms of the corrupt rich. These were restated in *The Deserted Village* (1770), which included a bitter attack on the owner of the new Brownian landscape garden, for which the village, its inhabitants and their productive land had been sacrificed:

> The man of wealth and pride
> Takes up a space that many poor supplied;
> Space for his lake, his park's extended bounds,
> Space for his horses, equipage and hounds;
> . . . the land adorned for pleasure all,
> In barren splendour feebly waits the fall.[39]

Moreover, at precisely the time Hearne was preparing the Heveningham drawings, he and Byrne issued the first prints of *Rural Sports* (December 1780), presenting a traditional, georgic view of country life, the antithesis of the Brownian garden's 'barren splendour', and set partly in Suffolk. Furthermore, three contemporary engravings for *The Antiquities of Great Britain* (published August–December 1780) advance the ideals of contemplative, religious retirement and the pursuit of moral virtue, as critiques of the 'gaudy pageantries' and 'vanity' of 'young men of fashion' (illus. 25,29,30).[40] Finally, in the letterpress of the *Antiquities* for the engraving of Leiston Abbey on the Vanneck estate, Hearne mentioned that it was purchased by 'Sir Joshua Van Neck, Baronet . . . who left it to his family, with those virtues which alone can render the possession of a large estate a blessing and an honour'.[41] It was a contemporary commonplace that such 'virtues' were not hereditary, but could be corrupted by 'luxury'.

The series of large watercolours of Downton made by Hearne for Richard Payne Knight between 1784 and 1786, reinforces this reading of his work. With a prime interest in antiquities and such objects as ancient trees, which signified antiquity and continuity in landscape, Hearne's idiosyncratic approach to estate portraiture appealed strongly to Payne Knight. It is no coincidence that the second Heveningham watercolour (illus. 72) is so close in composition and feeling to many of the Downton series. Despite his dictatorial behaviour in the public realm, Knight was reputed to be a sensitive patron. Thomas Lawrence remarked that 'when he has given a Commission to an artist, He is satisfied with what is done and is not disposed to propose alterations'.[42] The Downton watercolours make an informative contrast with those of Heveningham. They record the improvements Knight had made to his grounds from the mid- 1770s. Payne Knight had virtually designed Downton Castle himself, and later wrote that it was

ornamented with what are called Gothic towers and battlements without, with Grecian ceilings, columns and entablatures within; and though his example has not been much followed, he has every reason to congratulate himself upon the success of the experiment; he having at once, the advantage of a picturesque object, and of an elegant and convenient dwelling; though less perfect in both respects than if he had executed it at a maturer age. It has [moreover] the advantage of being capable of receiving alterations and additions in almost any direction without injury to its genuine and original character.[43]

This irregularity in design aped the buildings painted by Claude and Dughet, taken by Knight as models for mixing ancient and medieval styles and for architecture which harmonized with its surroundings. They were for Knight:

perfectly in harmony with the scenery; and so far from interrupting the chain of ideas, that they lead it on and extend it, in the pleasantest manner, through different ages and successive revolutions in tastes, arts and sciences.[44]

In Hearne's Claudean view the castle is integral to the landscape, surrounded by trees on the opposite bank of the River Teme (illus. 73).

73. *Downton Castle* 1785. Watercolour over pencil, 34 × 48.5. Private collection, D. P. H. Lennox, Esq.

In the grounds, Knight concentrated on making existing features more accessible. The principal attraction of the estate was the naturally and dramatically picturesque gorge of the Teme, and Knight had a path hewn from the rock along the bank of the brisk stream, flanked by wooded hills (illus. 68,90). A later visitor described the walks as 'the most wild, rich and solitary path I ever trod . . . the walk through the wood surpasses anything I have ever seen of the kind'.[45] The *View from below Pool's Farm* (illus. 74) shows the artificial cave cut into the rock, while *The View Upstream* (illus. 75) was taken from its mouth.

Hearne's Downton watercolours are a world away from prosaic country-house portraits, such as the first Heveningham Hall drawing (illus. 71), published from 1779 by William Watts in his *Seats of the Nobility and Gentry*. Some of the earlier works, showing distant views, conform with the landscape models associated with Claude and Dughet which were much admired by Knight (illus. 73,74). Those drawn later concentrate on the enclosed scenes formed by the well-wooded banks and sweeping bends of the Teme, and the nearby branches, foliage and rocks (illus. 68,75,76,90). Hearne's drawing of trees matured rapidly through this series. He had always been alert to their structure and linear patterns, but he now concentrated on variegated foliage at different distances from the eye, while taking an almost architectural approach in the careful arranging of trees in his compositions (illus. 68,74,75). *The Alpine Bridge on the Teme at Downton* (illus. 68) articulates pictorial space and natural form with exemplary clarity. The colouring (probably never very

93

74. *View from below Pool's Farm* 1785. Watercolour over pencil, 34.6 × 49.8. Private collection, D. P. H. Lennox, Esq.

strong) has faded, especially in the blue of the sky. Grey and sepia have been washed over the outline; colder grey tones in the distance make the sepia of the foreground trees appear just a little warmer in colour. Within this tightly restricted colour range, lively and delicate pen-work animates the drawing, while untinted paper serves for highlights on the foreground path and on the trees. The composition is structured through the interplay of forms and the interpenetration of one space by another. The overarching tree, wooden bridge and serpentine lines of the two paths integrate the image laterally, while the course of the river and the right-hand path drive through this movement into the depth of the picture space. Here the arch of the tree performs the same role in the composition as the great stone arch in Hearne's image of Lanercost Priory (illus. 29).

The size, subject and handling of *An Oak Tree* (illus. 69) are akin to the other Downton views, but the unconventional composition is not. Hearne would make other drawings of isolated trees during the next few years: *Moccas Deer Park, with a Large Oak Tree* (illus. 78) of 1788–9 was part of a series of watercolours commissioned by Sir George Cornewall, a friend of Payne Knight and a fellow Herefordshire

75. (*opposite*) *The View Upstream* 1786. Watercolour over pencil, 48.6 × 34.4. Private collection, D. P. H. Lennox, Esq.

95

landowner; *The Chestnut Tree at Little Wymondley, Hertfordshire* (illus. 77) of 1789 likewise presents a solitary ancient tree. In these watercolours Hearne stressed a monumentality enlivened with variety and intricacy that is comparable with his treatment of architecture. He appears to have been concerned to stress age and continuum as much as the conventional analogy between Gothic architecture and its evolution from tall avenues of forest trees. Charles Davy visited Queen Elizabeth's Oak at Huntingfield, Suffolk with Hearne. The tree was

a grand object . . . found to be nearly eleven yards in circumference . . . The principal arm, now bald with dry antiquity, shoots up to a great height above the leafage, and being hollow and truncated at top, with several cracks, resembling loop-holes, through which the light shines into its cavity, it gives us an idea of the winding staircase in a lofty gothic turret, which detached from the other ruins of some venerable pile, hangs tottering to its fall, and affects the mind of a beholder after the same manner by its greatness and sublimity.[46]

All Hearne's watercolours of trees from this period show a comparable mixture of decay and vigour. In 1798 the *Chestnut Tree* (illus. 77) was etched and published; the letterpress described that 'its trunk was hollow, and in part open; but its vegetation was still vigorous. On one side, its vast arms were decayed, and peeled at the extremities; on the other, the foliage was still full and hid all decay'.[47]

Artists had been attracted to the picturesque qualities of the beeches and oaks of Windsor Great Park since the early 1780s, and Paul Sandby in particular developed a series of landscapes featuring their huge, gnarled forms. Great trees had been associated with great families since the seventeenth century, as symbols of royal or aristocratic continuity and paternalist authority.[48] By the late 1780s the oak had many layers of associated meanings. For Alexander Pope in *Windsor Forest* (1713), the 'towering oaks' were 'future navies' which would carry the 'precious loads' of empire.[49] The naval association was to run throughout the century and beyond. For John Dalton in 1755, a solitary oak represented that securely rooted patriarchal tradition which denoted rural harmony:

Amid yon sunny plain, alone,
To patriarchal rev'rence grown,
An oak for many an age has stood
Himself a widely waving wood,
While men and herds, with swift decay,
Race after race, have pass'd away.
See still his central trunk sustain
Huge boughs, which round o'erhang the plain,
And hospitable shade inclose,
Where flocks and herds at ease repose![50]

This meaning is still embedded, for example, in Payne Knight's *The Landscape* of 1794, in which he exhorted the sensible landscape gardener to use the oak:

Then Britain's genius to thy aid invoke,
And spread around the rich, high-clustering oak:

76. (*opposite*) *'The Rock' Viewed from Upstream of Hay Mill Weir* 1785. Watercolour over pencil, 49.3 × 33.5. Private collection, D. P. H. Lennox, Esq.

King of the woods! whose tow'ring branches trace
Each form of majesty, and line of grace;
Whose giant arms, and high-imbower'd head,
Deep masses round of clust'ring foliage spread.[51]

All the theorists of the Picturesque admired the variety and individuality of ancient trees, William Gilpin believing that 'through age the Oak acquires its greatest beauty, which often continues increasing even to decay'.[52]

Hearne's *Moccas Deer Park, with a Large Oak Tree* (illus. 78) reflects these concerns – a young member of the Cornewall family sits under the ancient tree, emphasizing the continuity of past with present. When this watercolour was published as an etching in 1798, the war with Revolutionary France had spurred a revival of the old symbolism of oaks and naval power. The letterpress maintained that

the oak is the first in the class of deciduous trees; and it is a happiness to the lovers of the picturesque, that it is as useful as it is beautiful. Because, from the utility of the Oak, it is everywhere to be found; and surely, no one who is a lover of his country, but, in addition to the pleasure which he has in contemplating this noble plant, must feel his heart glow on reflecting, that from its produce springs the British Navy, which gives our Island so honourable a distinction among surrounding nations.[53]

An Oak Tree (illus. 69) is unusual in pictorial structure, contrasting markedly with the designs of the Moccas and Little Wymondley drawings. A great, gnarled oak in the foreground, dramatically cropped to fill the picture frame, and a diagonally opposed shattered trunk, confront the viewer. Other oak trees, in the middle and far distance, with their mass of foliage, cut off the recession and bring the attention

78. *Moccas Deer Park with a Large Oak Tree c.*1788–9. Watercolour over pencil, 34.2 × 50. Private collection.

back to the main tree. Its immense size only becomes apparent on perceiving the diminutive figure of the shepherd in the hollow of the blasted trunk.

Payne Knight had written *The Landscape* (1794), 'a didactic poem' on estate gardening addressed to Uvedale Price, ten years after commissioning the Downton watercolours from Hearne. Price was Payne Knight's neighbour in Herefordshire and a fellow landscape enthusiast; he had published his *Essay on the Picturesque* earlier in 1794. In many passages of *The Landscape* Payne Knight had reflected upon his estate as 'one dear favoured spot', a source of poetic ideas:

> One tranquil vale; where oft from care retir'd,
> He courts the muse and thinks himself inspir'd.[54]

Yet although there are descriptive passages which seem to parallel Hearne's imagery:

> Large stems of trees, and branches spreading wide,
> May oft adorn the scenes which they divide;
> For pond'rous masses, and deep shadows near,
> Will shew the distant scene more bright and clear,[55]

it seems unlikely, given Payne Knight's views on landscape painting, that he would have based this writing on the watercolours. In a note to the above lines he attributed

such pictorial arrangements to Claude and 'almost all the great landscape painters'. Elsewhere he criticized the usual topographical practice (which Hearne employed) of colouring in the studio a sketch made before the motif, arguing that this prevented contemporary landscape painters from imitating the fleeting colour effects of nature.[56] Hearne's series was nevertheless of great importance for Payne Knight as an elegant topographical record of his estate in 1784–6, enabling him to observe the slow evolution of the landscape through time, which was fundamental to the theory of Picturesque gardening he shared with Price.

Both books opposed, on the grounds of snobbery, the work of Lancelot Brown and his followers (principally Humphry Repton), which they felt pandered to the taste of the *nouveaux-riches*, whose conspicuous consumption should have no place in a paternalist British countryside. Price deplored the commercialism of

the mechanical and commonplace operation, by which Mr. Brown and his followers have gained so much credit . . . adieu to all that the painter admires . . . in a few hours the rash hand of the false taste completely demolishes what time only, and a thousand lucky accidents can mature, so as to make it become the admiration and study of a Ruysdael or a Gainsborough and reduces it to such a thing as an oilman in Thames Street may at times contract for by the yard at Islington or Mile End.[57]

Knight criticized Repton's scheme at Tatton in Cheshire, where the owner's crest was placed on the milestones close to the estate:

And all it does, is but to show combined
His wealth in land, and poverty in mind.[58]

The Brownian gardeners were cast as 'prim despots',[59] disrupting not only the social order, by provoking the poor at a time of revolution in France, but also nature itself:

[they] bade the stream 'twixt banks close shaven glide;
Banish'd the thickets of high-bow'ring wood,
Which hung, reflected, o'er the glassy flood;
Where screen'd and shelter'd from the heat of day,
Oft on the moss-grown stone repos'd I lay,
And tranquil view'd the limpid stream below,
Brown with o'erhanging shade, in circling eddies flow.[60]

Payne Knight commissioned Hearne to make two contrasting etchings of the 'unimproved' Picturesque landscape and the 'improved' landscape, based on written descriptions, and published them as illustrations to the poem. The 'improved' landscape (illus. 79) is Brownian to the point of parody – the river flowing within artificial serpentine banks, clumps of trees, a flimsy Chinese bridge and close-shaven lawns. The house is a simple Georgian block. This etching is very near the 'house-style' that William Watts used for such scenes and Payne Knight described the effects aptly:

79. *The 'Improved'*
Landscape 1794. Etching
(B. T. Pouncey).

80. *The 'Unimproved',*
Picturesque Landscape 1794.
Etching (B. T. Pouncey).

101

Oft when I've seen some lonely mansion stand,
Fresh from th'improver's desolating hand,
Midst shaven lawns, that far around it creep,
In one eternal undulating sweep.[61]

By contrast, the screen of trees, the rough and broken foreground and the rustic bridge (taken from the Alpine Bridge at Downton) of the 'unimproved' Picturesque landscape (illus. 80) suggests the Claudean landscapes of Smith of Chichester (illus. 2). The poem comments thus:

Through the rough thicket or the flow'ry mead;
Till bursting from some deep-imbower'd shade,
Some narrow valley, or some op'ning glade,
Well mix'd and blended in the scene, you shew,
The stately mansion rising to the view.
But mix'd and blended, ever let it be.
A mere component part of what you see.[62]

Here, the Jacobethan mansion acts as a symbol of conservative continuity, an irregular building that appears natural to the landscape, not imposed upon it as in the Brownian scheme.

In 1786, as Hearne completed the earlier Downton commission, he published Volume I of *The Antiquities of Great Britain*, with French as well as English texts to cater for the Continental sales he confidently expected. Hearne had now established himself as primarily a draughtsman, working for private patrons such as Beaumont and Payne Knight and also exhibiting regularly, if sparingly, at the Royal Academy. His work for the engravers now lapsed almost completely until 1796, when he began a second volume of *The Antiquities* with William Byrne. The engravings here supply evidence for reconstructing his practice between 1786–96.

Hearne spent many summers in Herefordshire and Shropshire in the late 1780s, probably staying with Payne Knight at Downton and Sir George Cornewall at Moccas Court. In 1787 or 1788 he made his first visit to Monmouthshire and the Wye Valley, and although no dated drawings have been traced he exhibited a view of *Tintern Abbey* in 1788 and *Chepstow Castle* in 1789 at the Royal Academy. In 1794 Hearne again made the Wye tour, this time with Beaumont. Their relationship remained close throughout the period, with Hearne following Beaumont's increasing interest in the great masters of landscape painting. Around 1785–6 Beaumont purchased his first Claude, the small *Landscape with Hagar and the Angel*. For a while, as he followed the enthusiasms of his mentors Richard Wilson and Sir Joshua Reynolds, he collected less contemporary art. Hearne may have lost some trade, but he shared Beaumont's admiration for earlier schools of painting, acting as his agent to bid successfully for Claude's *Landscape with Narcissus and Echo* in 1790.[63]

Few securely dated works of this period have been traced, although we know that Hearne sent a landscape of Ludlow Castle to the Royal Academy in 1792, which was also engraved for the second volume of *The Antiquities* (illus. 81). The grandeur

81. *Ludlow Castle* 1797.
Watercolour with touches
of bodycolour over pencil,
31.8 × 43.2. Private
collection.

of the scene was again emphasized and exaggerated for dramatic effect; and the
letterpress followed the conventional line, stressing the wall's fine state of repair
affording 'ample scope for contemplation upon the extensive and gloomy mansions
of our ancestors'.[64] Along with the watercolour of Ludlow, he exhibited the even
more ambitious *View of Bath from Spring Gardens* (illus. 82). This represented the
view from the newly laid out Gardens, looking over the River Avon to the terraces
of John Wood's South Parade on the left, Robert Adam's Pulteney Bridge in the
middle distance, and 'the Back of the new Buildings in Bathwick fields, Belmont,
Lansdown Place, and Camden Place, with Beacon Hill and Lansdown Hill in the
Background'. In the letterpress to the engraving of 1792 Hearne also noted that
since the 1770s in Bath,

within a very few years the Spirit of Building has encreased prodigiously, and two more
Crescents have been erected, called Lansdown Place and Camden Place, a very long wide
street and a building in the form of a lozenge called Laura Place in Bathwick Fields, and a
new Square behind The Royal Crescent.[65]

In fact by then Bath was declining as an exclusive and fashionable spa. Gainsborough
had left the city for London in 1774 because he had run out of wealthy sitters. The
revised rules of 1787 for the New Assembly Rooms stressed that sheer numbers
were now overwhelming patrician customs of politeness:

as the late great extension of the city of Bath puts it out of the power of the Master of the Ceremonies to be regularly informed of the several persons who arrive here, he hopes they will be so indulgent to him as to not charge him with want of attention.[66]

The opening of Spring Gardens was symptomatic of this same change. Anstey's *New Bath Guide* of 1790 described the recreation area which Hearne included in the lower right of his watercolour:

Just on the other side of the New Bridge, erected by William Pulteney esq; across the Avon, leading from the Market-place to Bathwick, is a public garden called Spring Gardens, very pleasantly and judiciously laid out by Mrs. Purdie, for the summer amusement and recreation of the inhabitants and company in this city, who may walk here the whole season on paying a subscription of three shillings. Those who do not subscribe, pay sixpence for admission, and receive a ticket that entitles them to anything they choose of that value. Here are publick breakfasts and publick tea, attended with horns and clarionets, during the summer, the days uncertain; and also one publick evening every week, with illuminations, fireworks and entertainments similar to the London Vauxhall.[67]

Hearne pictured typical parties of visitors descending the steps from South Parade to the shore of the Avon, then crossing the river by boat to arrive at the Gardens. The colouring of this superb watercolour is dominated by warm pinkish tones offset by cooler blue-green washes. He may have felt this lighter and simplified palette would attract attention in the crowded Academy galleries. After exhibiting two watercolours in 1793, however, Hearne did not show at the Academy again until 1806; most likely he disapproved of the hanging committee's placing of his work.

From the late 1780s Hearne regularly visited Beaumont at Dedham in Essex, and made many drawings. The *Site of the Castle at Pleshey* (illus. 83) is one of his most unusual designs of the early 1790s. The Castle, situated between Chelmsford and Great Dunmow, and described as 'a great keepmound, somewhat oval in form, rising nearly 50 feet above its surrounding moat, a brick bridge connecting it with the base court or bailey', was a site of prime significance for antiquarian enthusiasts.[68] Richard Gough felt that

the stupendous keep, amazing ditch and magnificent bridge of one brick arch, must strike the most superficial spectator. But, on closer inspection, this spot will be found to furnish some new lights for the illustration of our national antiquities . . . few places afford more ample speculation to an English antiquary than this residence of our High Constables of England for four centuries from the Conquest.[69]

Hearne depicted the north side of the keep, which Gough described thus:

the earthworks may defy the injuries of time and cultivation; but of the buildings that once adorned them remains only the magnificent bridge leading across the moat to the keep. This bridge is of brick, of one pointed arch, strongly cramped together with iron, 18 feet high and 18 feet wide.[70]

82. *A View of Bath from Spring Gardens with Pulteney Bridge* 1790. Watercolour and pen and ink over pencil, 31 × 46.3. Yale Center for British Art, Paul Mellon Collection.

83. *Site of the Castle at Pleshey, Essex* c.1793. Watercolour over pencil and grey wash, 20 × 27.3. The Trustees of the British Museum.

Pleshey also had an authentic English hero in the Duke of Gloucester, 'a stern inflexible patriot' of Richard II's reign, who opposed the King – 'an effeminate prince plunged into all the luxuries of the French court'.[71]

Hearne drew the bridge from an oblique angle to maximize the drama of the site, the sunlit medieval arch centring a composition disrupted by opposing diagonal movement. He was technically skilful in combining pencil work, individual touches of the brush and broader areas of wash in order to give a convincing image of a variable and complex terrain, containing an antiquity with very meaningful associations at a time of renewed hostilities with France. A tendency to omit detail in the outline and use washes more freely is also evident in a watercolour of Whitefriars at Aylesford (illus. 84). The receding buttresses of the thirteenth-century friary are painted in growing dissolution of detail, with the surface texture free from conflict with the strong, arched design of the trees along the side of the building. The wall of the friary is only a component part of the whole picturesque image; such partial views of antiquarian subjects were to figure more often in Volume II of *The Antiquities of Great Britain*, an indication of the growing visual sophistication of those purchasing such subjects from the mid-1790s.

Hearne would have known of Beaumont's and Sir Uvedale Price's collaboration in the years prior to the publication of *An Essay on the Picturesque*, and in 1796 Farington recorded Hearne's enthusiastic description of a tour to Somerset which shows him searching out usable subjects for the new aesthetic:

Hearne described *Wells* as abounding with picturesque buildings – gateways etc., etc., in which respect it exceeds Durham; but the situation of the town is very inferior . . . Cheddar Cliffs . . . are very high rocks, one perpendicular 300 feet, – they are very remarkable but bare and not picturesque except the *entrance* which is very picturesque.[72]

While aware of extensive prospects ('the situation of the town'), Hearne's interest was clearly in more individual features of the built and natural landscape ('gateways' and the narrow, wooded entrance to Cheddar Gorge), which accords with Price's approach. For Price, a 'good landscape' in nature is like a 'good government'; all its various parts must contribute to the energy, beauty and harmony of the whole. But with the threat to the traditional social landscape from 'improvers', he sought to direct the landowner away from extensive prospects, now associated with 'despotism' and dullness, towards viewing the landscape in close-up, focusing on particular objects. Moreover, he suggested harmonizing the newly perceived variety of forms by following nature's hints rather than imposing an external, artificial order. This is the horticultural and pictorial counterpart of the rural paternalism he also advocated, and much of Hearne's work responded to this new aesthetic from the mid-1790s.[73]

When Hearne toured the River Wye in 1794 with Beaumont, they left Cheltenham, where Sir George had been taking a spa cure, in the middle of July and hired

a boat in Ross-on-Wye to make the leisurely journey south. By now this trip was standard for any would-be picturesque tourist. William Gilpin and Thomas Gray had been among the first to do it (in 1770), and (as with the Lake District) their writings dictated responses to this terrain. In May 1771 Gray had written to his friend William Mason:

My last summer's tour was through Worcestershire, Gloucestershire, Monmouthshire, Herefordshire and Shropshire, five of the most beautiful counties in the kingdom. The very principal light and capital feature of my journey, was the river Wye, which I descended in a boat for near 40 miles from Ross to Chepstow. Its banks are a succession of nameless beauties.[74]

Gilpin attributed the varied beauty of the Wye to its 'lofty banks' and 'mazy course':

The *ornaments* of the Wye may be ranged under four heads – *ground* – *wood* – *rocks* and *buildings*. . . . Bays, castles, villages, spires, gorges, mills and bridges . . . one or other of these venerable vestiges of past, or cheerful habitations of present times, characterize almost every scene.[75]

As usual Hearne appears to have been less interested in landscape than antiquarian motifs, while maintaining a concern for atmosphere and light effects. The unconventional angle from which the Bye Street gate of Hereford is represented (illus. 85), emphasizes the effect of seeing the architectural detailing diminish against the strong light of a setting sun, the Gothic arch of the gate being just visible behind the houses and sheds built out from its walls. *Near Monmouth* (illus. 86) and *Raglan Castle, Monmouthshire* (illus. 93) were both drawn with sepia ink, though for different reasons. In the first, the warmth of the outline offsets the cool blues of the sky and river to add subtlety and variety to a drawing which captures the brightness of a fresh summer day; in the second the sepia harmonizes with and enhances the warm colours of the evening sun through the trees. The same glowing light illuminates the Castle and dapples the cottage scene in the foreground, picking out the texture of the wall on the right. In *Goodrich Castle on the Wye* (illus. 88) Hearne attempted to capture in strong, close-toned pigments, the early evening's intensity of colour.

A concern with landscape was common to a small group of private collectors and amateur artists who, from the 1790s onwards, were buying many of Hearne's best works. Dr Thomas Monro is the best known, but others included John Henderson (1764–1843), a neighbour of Monro's, another amateur draughtsman and purchaser of all Hearne's sketches from the 1794 Wye tour, and George Baker (1747–1825), a book- and print-collector, who told Farington in 1800 that he had amassed almost one hundred drawings by Hearne, who was a close personal friend.[76] Monro's father, Dr John Monro, who preceded him as physician to Bethlem Hospital, had been a considerable art connoisseur, and Hearne was well represented in his collection of watercolours. On his father's death in 1791 Monro inherited part of the collection, as well as 'an inclination for drawings', as he later told Farington.[77]

84. *A Part of the Remains of the Whitefriars at Aylesford, Kent c.*1790–3. Watercolour over pencil and grey wash, 18.4 × 25.4. The Trustees of the British Museum.

85. *Bye Street Gate, Hereford c.*1794. Watercolour over grey wash, 18.8 × 23.2. The Trustees of the British Museum.

86. (*opposite*) *Near Monmouth c.*1794. Watercolour over pen and sepia ink, 21.6 × 14.3. The Trustees of the British Museum.

108

109

He continued to buy Hearne's work as he felt him 'superior to everybody in drawing'.[78] In 1797, after Hearne returned from a visit to his mother in Wiltshire, Farington noted: 'Hearne made some beautiful sketches while in the country – Monro engages all he can'.[79] In 1810 Monro calculated that out of the £3000 he had spent on amassing his large collection of drawings by modern artists, £800 had been spent on drawings by Hearne. Since Hearne was estimated to make only £150 in a year from drawings, this was a very substantial investment.[80]

Hearne's contact with these collectors may reflect a turning away from the Royal Academy and the large commissions he had secured from landed patrons in the 1780s, to a more socially congenial circle of middle-class supporters who bought, but rarely commissioned, watercolours and drawings. Their enthusiasm for landscape and their consistent purchases may also have encouraged Hearne in his shift towards a more expressive handling of watercolour and the production of many finished pencil drawings – feeling able to evolve a freer and more personal approach, he would enhance the individuality of his style and their appreciation of it. Later in life Hearne told Farington

that which he best liked to do was to remain at home and finish up his old drawings. This he said had always been more agreeable to him than executing commissions, as when he undertook to make a drawing for any person he had a constant thought prevailing in his [mind] as to what would best please the taste of his employer. This reflection was always a check upon his mind.[81]

Goodrich Castle on the Wye (illus. 88) is a wonderful record of the picturesque appeal of the Wye tour, and Hearne's composition is close to Gilpin's enthusiastic description:

A grand view presented itself. . . . A reach of the river, forming a noble bay, is spread before the eye. The bank, on the right, is steep, and covered with wood; beyond which a bold promontory shoots out, crowned with a castle, rising among trees. This view which is one of the grandest on the river, I should not scruple to call *correctly picturesque*; which is seldom the character of a purely natural scene.[82]

Below the castle ruins Hearne included plumes of smoke, a common feature of the lower Wye:

Many of the furnaces, on the banks of the river, consume charcoal, which is manufactured on the spot; and the smoke, which is frequently seen issuing from the sides of the hills; and spreading its thin veil over a part of them, beautifully breaks their lines, and unites them with the sky.[83]

Typically, the tourist boats in the foreground are also carefully observed. Farington, on his Wye tour of 1803, had 'hired a boat to take us to Monmouth. The fare is one guinea and a half for the boat, and half a guinea to the Boatmen, three in number, one to steer and two to row'.[84]

Further downstream, about four miles before Monmouth, was the gorge of

87. *Iron Forge at Tintern, Monmouthshire*, drawn in 1794. Etching 1798 (B. T. Pouncey). Guildhall Library, London.

Symonds Yat or gate (illus. 89). Here, the touches of ochre on the distant trees and rocks combine with the gently washed blues, to arrest at certain key points the gradual recession towards the far screen of hills. For many visitors this was one of the most Sublime sections of the Wye, as the rocks which further upstream were 'entirely clothed with trees, as to be seldom visible', were now 'a primary object . . . the stream washed the base of stupendous cliffs. Among these, the most remarkable are Coldwell Rocks and Symond's Gate, forming a majestic amphitheatre'.[85] In Hearne's view attention is also given to the cottage on the left, the iron works on the right, pack horses in the foreground and activity on the river's bank. As we have already seen with *Goodrich Castle*, many places along the length of the Wye had iron forges and 'bays and harbours in miniature; where little barks lay moored, taking in Ore, and other commodities from the mountains'.[86] Ironworks had been located near Tintern Abbey since the sixteenth century, fuelled by the readily available timber (illus. 87). Gilpin noted that

the country about Tintern Abbey hath been described as a solitary, tranquil scene; but its immediate environs only are meant. Within half a mile of it are carried on great iron works, which introduce noise and bustle into these regions of tranquillity.[87]

Hearne, like Sandby before him, was able to portray this evidence of industrialism because of the examples provided by Dutch paintings. Uvedale Price admired Dutch landscape, from which he had learned to praise those fundamentally Picturesque

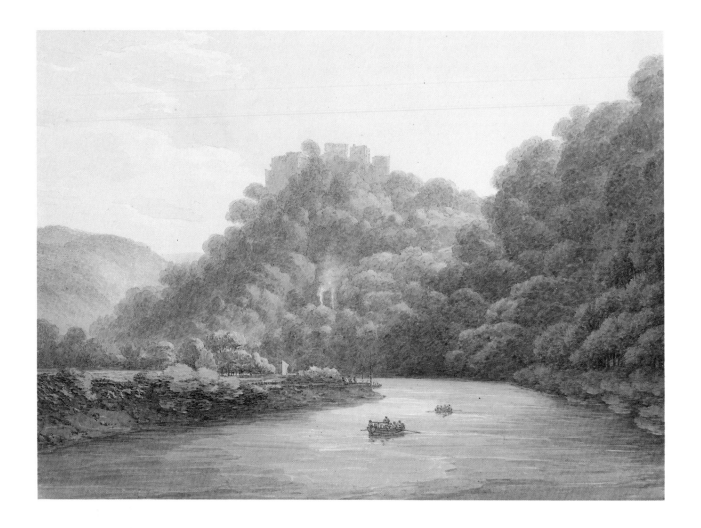

88. *Goodrich Castle on the Wye c.*1794. Watercolour over pencil, 22.5 × 31.2. Yale Center for British Art, Paul Mellon Collection.

qualities in old mills as 'the extreme intricacy of the wheels and the woodwork . . . the singular variety of form and of lights and shadows, of mosses and weather stains from the constant moisture'.[88] For Price, the critical factor was that such buildings must be old and weathered; they should have upon them the patina of time and appear as a 'natural' part of the landscape. The iron works at Tintern were of ancient origin, and in the drawing for the etched print Hearne was careful to introduce the trees enveloping the forge at the top left and a further distant view of woodland to the right, which do not appear in the original sketch but harmonize the industrial building with its surroundings. When Hearne included industrial scenes in his Wye views, he integrated these potentially disruptive human activities into the natural landscape.

Half a mile away from the iron works was Tintern Abbey, the best-known ruin along the route (illus. 91). Hearne's drawing of the west window is another essay in the Picturesque. Gilpin remarked of the interior of the Abbey, that 'Nature has

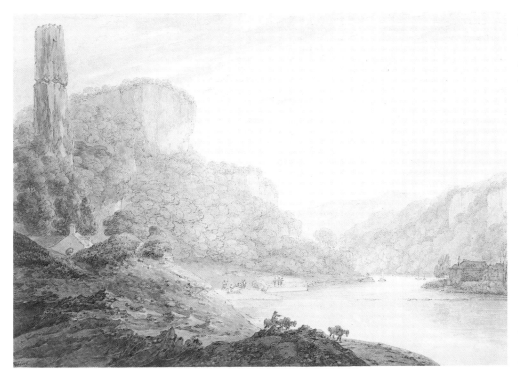

89. *Symond's Yat on the Wye, Herefordshire c.*1794. Watercolour over pencil, 24.2 × 34.6. Whitworth Art Gallery, University of Manchester.

90. (*below*) *The Gorge of the River Teme, Downton* 1785. Watercolour over pencil, 33.4 × 49.9. The Trustees of the British Museum.

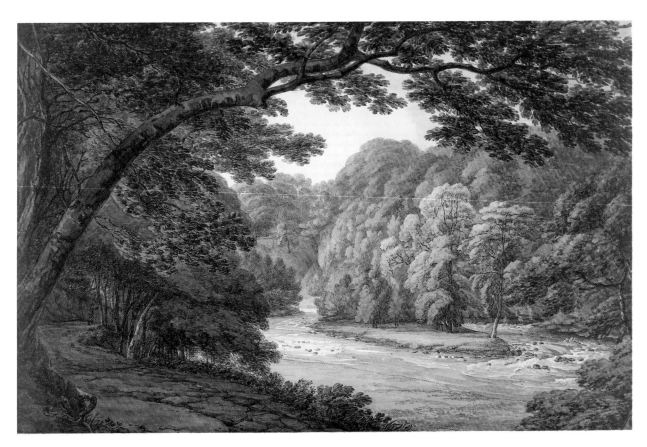

113

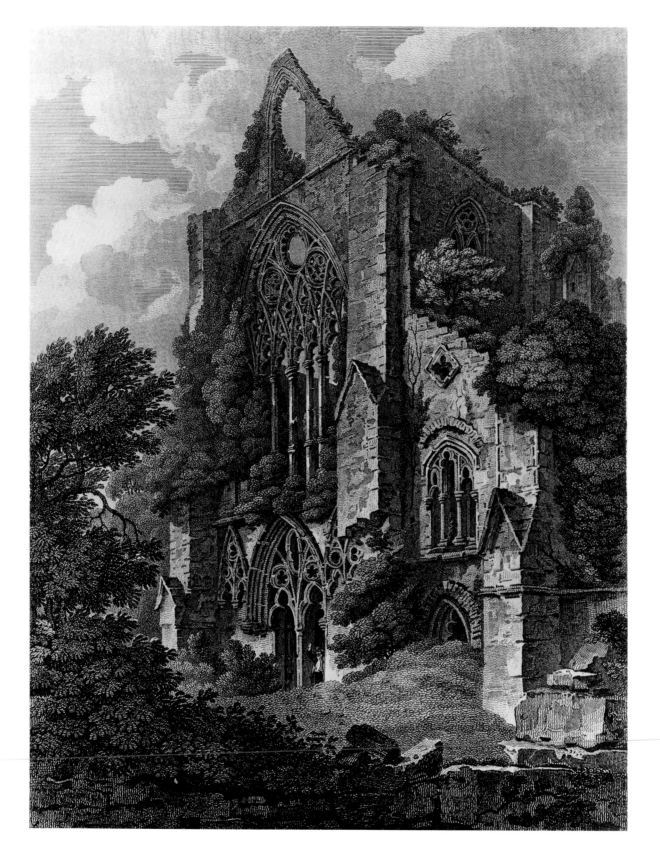

114

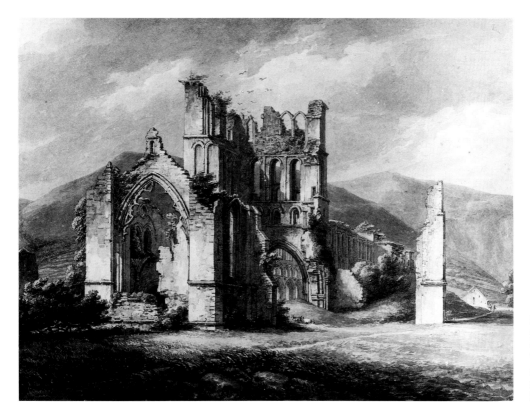

now made it her own. Time has worn off all traces of the rule; it has blunted the sharp edges of the chisel; and broken the regularity of opposing parts'. By contrast, the exterior was stubbornly intact and thus imperfectly Picturesque:

A number of gable-ends hurt the eye with their regularity; and disgust it by the vulgarity of their shape. A mallet judiciously used (but who durst use it?) might be of some service in fracturing some of them.

In contrast to the 'monkish times' evoked by Tintern Abbey and *Llanthony Priory* (illus. 92), *Raglan Castle* (illus. 93) offers a meditation upon the broken aristocratic power of a medieval estate.[89] From its beginnings in the twelfth century, Raglan was the centre of immense landed power and wealth:

The Castle had three parks of considerable extent, and the fertility of the surrounding estate enabled the owner (the first Marquis of Worcester) to maintain a garrison of no less than eight hundred persons. These parks were planted thick with oak and beech, and in former times were well stored with deer.[90]

The Castle was sacked in 1646, towards the end of the Civil War, by Sir Thomas Fairfax and the Parliamentarian army. Its ruined appearance contrasted with what someone of Hearne's views would have seen as its past glories. Before this melancholy ruin Hearne placed a simple cottage scene, recalling those in Gainsborough's pictures. This combination permitted him to elevate the simple virtue and industry

115

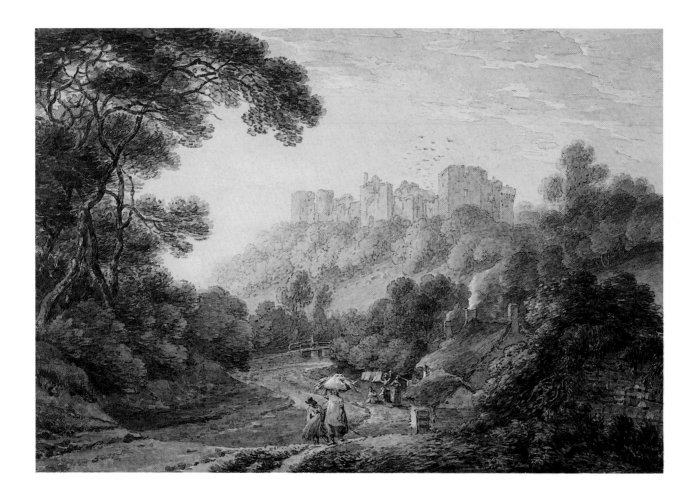

of the poor, within the context of a paternalist order connected to the remote past
by custom and established duty.

Hearne and Beaumont ended their Wye tour at Chepstow, where they both drew
the noted prospect from the Alcove in the Walk at Piersfield Park. Hearne's
Chepstow Castle from Piersfield (illus. 94) represents the scene which had attracted
Gilpin's attention:

the views on this side are not the romantic steeps of the Wye; but tho' of another species,
they are equally grand. They are chiefly distances, consisting of the vast water of the Severn,
here an arm of the sea . . . and of the town of Chepstow, its castle and abbey.[91]

With this survey of Hearne's landscape development to the mid 1790s, we are
now in a position to assess his technical qualities as a watercolour painter and
consider how these contributed to his work. His mature watercolour technique was
a significant advance on the simple washed outline of the earlier topographers. He
drew more often than not in pencil, which allowed broader, more atmospheric
effects, although he used pen and ink early in his career and later for works intended

116

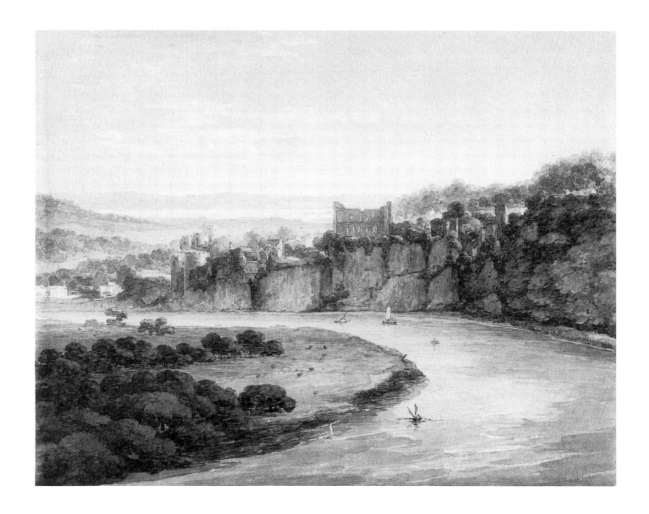

for exhibition or which needed particular effects. His twelve Downton watercolours of 1784–6 are all drawn in pencil. Conversely, *An Oak Tree* (illus. 69) and *The Alpine Bridge on the Teme at Downton* (illus. 68) are outlined in pen and ink, suggesting that they were made for exhibition at the Royal Academy. In *Raglan Castle* (illus. 93) Hearne used pen and sepia ink to harmonize with the warm tonality of the sunset, while in several later watercolours he omitted the outline in pencil or pen and instead drew with the brush point. *Elvet Bridge, Durham* (illus. 57) is a good example of this. Hearne typically used delicate grey washes in the shadows, allowing for more variety of tint than the grey underpainting favoured by Sandby or Rooker though, unlike the generation which followed Girtin and Turner, he did not abandon the practice altogether.

From the beginning Hearne had applied watercolour washes with small flake-like brushstrokes of different colour to suggest the crumbling texture of stone, or flickering sunlight on leaves and foliage. He was capable of creating a realistic impression of ancient, weathered architecture within a landscape setting, gently softening the distances with aerial perspective. He was adept at drawing the boughs

94. *Chepstow Castle from Piersfield* c.1794. Watercolour over grey wash and pencil, 18.7 × 24.4. The Trustees of the British Museum.

117

and general structure of trees, and for much of his life drew foliage as outlined areas filled with flecks of varying colour. He tended to restrict his palette to grey, blue, brown, green and ochre, sometimes with a more vibrant touch of red or yellow, and at his best rendered atmosphere and articulated space through a subtle modulation of tonal values. There is some truth in the common opinion that he adopted this restricted colour range out of consideration for the job of the engraver, but there is more to it. Hearne was joined in his preference for a limited colour range by John Robert Cozens, one of the more pictorially expressive of his contemporaries, who seldom worked with a thought for the engraver. Moreover, Hearne's young contemporary Edward Dayes was enlightening on the subject of colour in landscape drawings:

The vegetation should not be coloured too green; that is with a raw hungry colour of blue and yellow, but by uniting a red, as burnt terra de Sienna, or lake with it, to give it a more solemn or autumnal hue; as nothing can have a more common or vulgar air, than too much green. The student must distinguish between a glaring and a glowing colour, as we admire what is fine, before we can discern what is beautiful; for colour is the attire of the art, and not the patches and paint of a courtezan.[92]

It is arguable that Hearne's colouring was a discipline arrived at from a decision to subordinate distracting detail and aggressive colour to the guiding principles of balance, harmony and an ordered pictorial structure. Hearne differentiated tones, animating the whole surface of his best drawings with a sense of quiet, incipient change. Furthermore, techniques varied with the purpose of any particular drawing. The greatest doubts about this argument are raised however when Hearne's consummate professionalism is taken into account. He appears to have aimed in his watercolour drawings to avoid too gross a sensory appeal, in order to elevate his imagery as far as its Academic status allowed. It might have been for this reason that in the early and mid- 1790s Hearne was, after John Robert Cozens, the most important influence on the topographical work of the young J. M. W. Turner.

CHAPTER SIX

Later work

Gundulf's Tower, Rochester Cathedral, c. 1793–4 (illus. 96), is a fine example of Hearne's antiquarian draughtsmanship. It relates to an engraving published in Robert Bowyer's *Historic Gallery* in June 1794, but it is also typical of the 'outlines' which Hearne supplied for Dr Monro's 'Academy', an unofficial landscape school which Farington first recorded as existing in December 1794:[1]

Dr. Monro's house is like an Academy in an evening. He has young men employed in tracing outlines made by his friends etc. Henderson, Hearne, etc., lend him their outlines for this purpose.[2]

Another commentator described the practical facilities which were offered at Adelphi Terrace:

He encouraged young men to make a studio of his house . . . Desks were provided, with a candle which served for two sketchers, one sitting opposite the other.[3]

Hearne was a regular visitor (illus. 97) and, as the most senior and accomplished artist involved (Henderson, who bought Hearne's Wye drawings, was a gifted amateur), almost certainly had a leading role in planning the teaching methods. These involved drawing an outline before adding 'effects' of chiaroscuro and atmosphere, the standard topographical approach taken by Hearne himself for *The Antiquities of Great Britain* when, on several occasions he had used original sketches by other professional artists such as Farington and Edward Edwards, or amateurs such as Beaumont and the antiquarian, Sir Henry Englefield (illus. 24).[4]

Thus, at Monro's between 1794 and 1797, Thomas Girtin drew outlines while J. M. W. Turner 'washed in the effects', and presumably other students divided their labour similarly.[5]

Most of the Monro School copies are re-workings of John Robert Cozens's watercolours, but many of Hearne's drawings also provided raw material for aspiring topographical draughtsmen. Those surviving imply that drawings or prints of *The Antiquities* were most popular with the students. Girtin copied *Lanercost Priory* (illus. 29) and *Newark Castle* in watercolour.[6] Turner may have known Hearne's work as early as 1791; his early drawings began to resemble Hearne's in style and treatment of antiquarian and Picturesque subjects. Turner's *Malmesbury Abbey* (illus. 98) of c. 1792–3 (deriving from a study in the *Bristol and Malmesbury* sketchbook of 1791) is close to an earlier drawing of the subject by Hearne (illus. 99).[7] *Malmesbury Abbey*, exhibited at The Royal Academy in 1791, again shows Turner echoing another

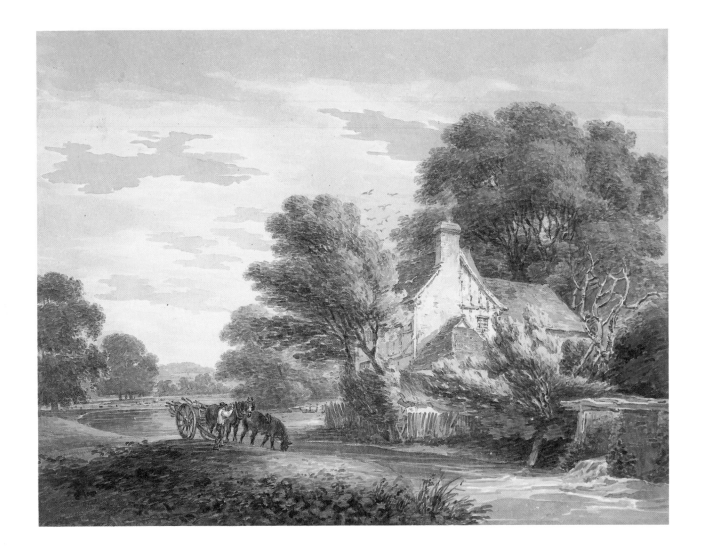

95. *Near Witham, Essex*
1793. Watercolour with
some bodycolour over grey
wash and pencil,
19.4 × 25.1. The Trustees
of the British Museum.

Hearne subject, an engraving in *The Antiquities* (illus. 30).[8] At Monro's, Turner
copied Hearne's *The Priory at Haddington* and *Edinburgh Castle*, (both engraved for
The Antiquities);[9] and in the mid- 1790s, the slanting brushstrokes, which Hearne
used for a while to delineate foliage, were sometimes adopted by Turner, while the
quiet sobriety of Hearne's picturesque colouring was mimicked in many antiquarian
watercolours, for example the *Old Welsh Bridge, Shrewsbury*, of 1794.[10]

Hearne continued to produce antiquarian and architectural work until just before
his death. As well as for the second volume of *The Antiquities* he supplied drawings
for many engraved publications, including William Byrne's *Britannia Depicta*
(1803–17) and John Britton's *The Beauties of England and Wales* (1805–14).[11] Hearne,
along with Farington, George Stubbs and George Dance, was elected to the Society
of Antiquaries in 1793, and attended meetings regularly. In December 1797 he was
one of the 143 majority voting for the election of the controversial architect, James
Wyatt.[12] The vote was carried against the determined opposition of an important

96. (*opposite*) *Gundulf's
Tower, Rochester Cathedral*
c.1793–4. Pencil,
25.5 × 18.6. Yale Center
for British Art, Paul Mellon
Collection.

120

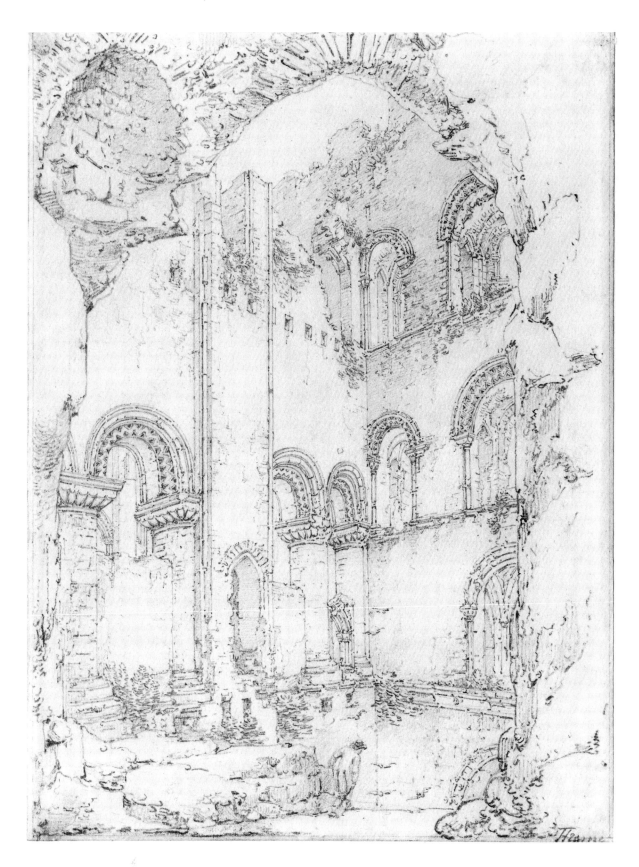

121

group of 'preservationists' (who mustered just 20 supporters) led by the director, Richard Gough, and which included the architectural draughtsman and Gothic propagandist, John Carter, and two Roman Catholic antiquaries, John Milner and Sir Henry Englefield.[13] This group detested Wyatt's series of 'improvements' to the cathedrals at Lichfield, Salisbury, Hereford and Durham. These improvements, carried out between 1787 and 1797, were felt by the preservationists to have grossly exceeded 'necessary repairs' to the existing buildings and 'doomed to destruction' many parts of the cathedrals, sacrificing them to the 'scalping knife of modern taste'. At a meeting of the Society in June 1797, the preservationists succeeded in rejecting Wyatt's first candidature by sixteen votes to eleven.[14]

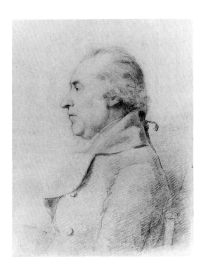

97. George Dance: *Profile Portrait of Thomas Hearne* 1795. Pencil, 22.9 × 17.8. Private collection.

Hearne published *Hereford Cathedral* in April 1797 (illus. 100) and *Salisbury Cathedral* in March 1798 in *The Antiquities*. The prints offer an intriguing commentary on Wyatt's improvements and the reactions they provoked.[15] Neither letterpress praised Wyatt's work. The Hereford text simply noted the restoration of the nave, after the collapse of 1786, had been 'completed under the direction of Mr. Wyatt'; the text for Salisbury made it clear that the print showed the Cathedral's east end before Wyatt had, among other things, instigated the destruction of the Hungerford and Beauchamp chantry chapels. Both engravings were dedicated to the respective Dean and Chapter. These engravings confirm that Hearne was unenthusiastic about Wyatt's improvements, but the question remains as to why he failed to support Gough and the preservationists in the second vote in December 1797. Hearne's divided loyalties and the crisis in the Society of Antiquaries involved contradictions between the desire to preserve medieval buildings and the modern needs of the Anglican establishment, to which Hearne was also devoted. In December 1797, Wyatt's supporters argued that the Society of Antiquaries was 'not a Court of Inquest, it has nothing to do with Deans or Chapters, or their alterations

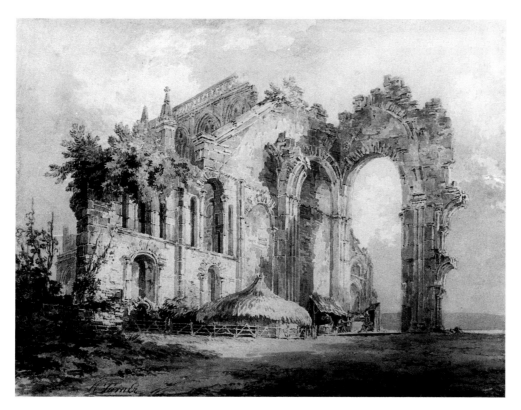

98. J. M. W. Turner:
*Malmesbury Abbey c.*1792–3.
Watercolour. Bury Art
Gallery and Museum.

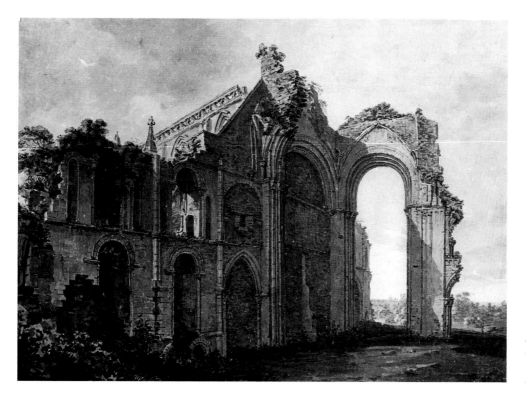

99. *Malmesbury Abbey
c.*1778–81. Watercolour
over pencil, 19.4 × 27. The
Syndics of the Fitzwilliam
Museum, Cambridge.

123

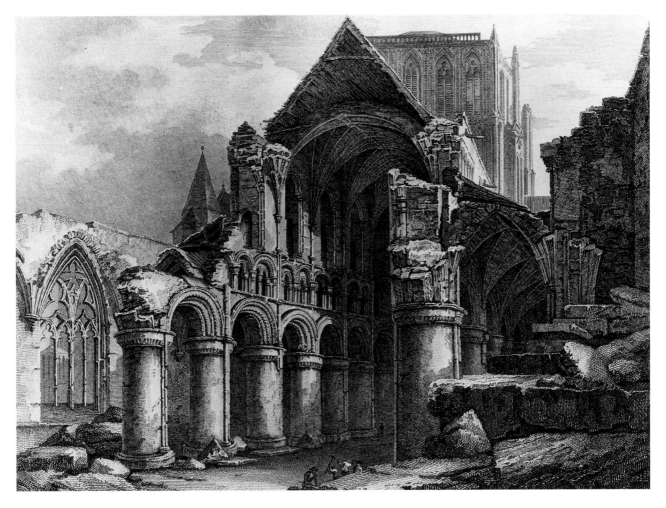

100. *Hereford Cathedral –*
The Fall of the West Front
1797. Engraving (W. Byrne
and J. Sparrow). John
Rylands University
Library, Manchester.

of buildings'. Wyatt's cause had also been linked generally to a 'zeal for the establishment and respect for Royalty'.[16] Any criticism of church hierarchy was seen as an attack on the constitution, and enthusiasts should not have influence at a time of war with revolutionary France.

Milner and Englefield's Catholicism probably also strongly swayed Hearne towards opposing the preservationists. He felt the maintenance of the Anglican establishment to be vitally important: it had always contributed to his enthusiasm for Britain's medieval architecture. In 1807 Farington recorded Hearne's 'great pleasure at the change of administration and said it was evident the late Ministers wanted to deceive the King into the Catholic measure'.[17] This referred to a bill aimed at introducing some political rights for Roman Catholics; it brought down Grenville's ministry, with George III asserting that 'He must be the Protestant King of a Protestant country, or no King'.[18] Hearne was, in the parlance of the Napoleonic War period, a 'Church and King' man. The character sketch written up in his obituary in the *Gentleman's Magazine* was accurate in saying that he had been 'on Subjects of a political nature, upon which he bestowed much attention, a

constant and strenuous Supporter of good order and established Government in opposition to Vague Theories and Innovation'.[19]

While continuing to pursue his interests in medieval architecture during the 1790s and 1800s, Hearne became increasingly preoccupied with vernacular buildings, rural life and landscape, interests first manifested in *Rural Sports*, (re-issued in 1810). A watercolour contemporary with the original issue of *Rural Sports*, the *Old Toll House*,

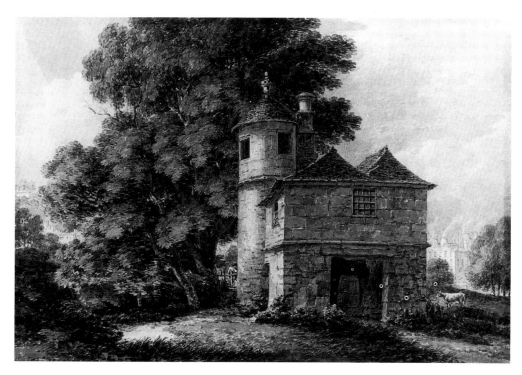

101. *The Old Toll House, Widcombe, Bath* 1784. Watercolour over pencil, 19.7 × 29.2. Victoria Art Gallery, Bath.

Widcombe, Bath (illus. 101), is an early example of Hearne depicting a vernacular building within the pictorial formula used most often for antiquarian drawings. The abandoned and crumbling toll house is shown to be only a few hundred yards from the centre of Bath – rows of modern terraces can be seen to the right and through the trees on the left. The inclusion of the cow on the right, just beneath the terrace, is a bucolic touch intended to emphasize Widcombe's essentially rural situation, a small village with its church and manor house, which stands cheek by jowl with the rapidly expanding city drawn by Hearne six years later in 1790 (illus. 82).[20]

This period saw great changes in towns, with the destruction of many older buildings in efforts to accommodate an increase in traffic caused by economic growth. Between 1782 and 1798, all six of Hereford's medieval gates were taken down, including Bye Street gate which Hearne drew in 1794 (illus. 85).[21] In the Widcombe drawing, he pictures a site which embodies the resistance of the traditional, local and rural to the modern, cosmopolitan and urban – a crucial aspect of much Picturesque theory in the 1790s. *Near Witham, Essex*, of 1793 (illus. 95),

125

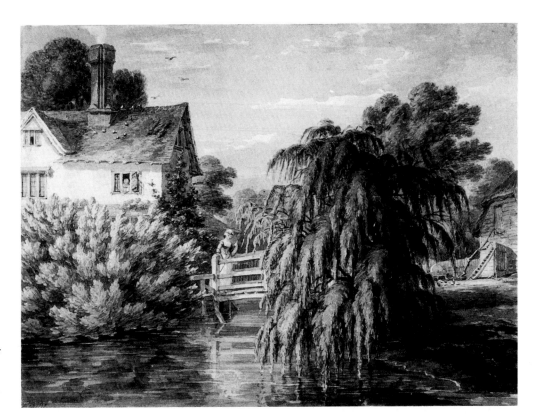

is a well-observed rural landscape, with a cottage partially concealed by trees and, on the opposite bank of the stream, a man unharnessing his horses from a wagon. Hearne captures the feel of this cold, blustery day in his treatment of the windswept trees, scudding clouds and grey-blue sky. This cool palette is offset by the warm ochre tints of the foliage in the middle-, far-distance and the foreground. The sky and colour harmony are close to another Essex subject, the *Site of the Castle at Pleshey* (illus. 83), probably drawn during the same visit to the Beaumonts at Dedham.

At Much Easton, Essex, of *c.* 1790 (illus. 102), and *A vine-clad Cottage* (illus. 103), which is dateable to the mid- 1790s, are similar in subject-matter and feeling to the domestic scenes in *Rural Sports: The Hop-Ground* (illus. 44) and *The Apiary*. Both show the type of idyllic rural cottage later promoted by Sir Uvedale Price and Richard Payne Knight. In *The Landscape* (1794), Payne Knight wrote that next to classical ruins, a castle or a ruined abbey, the greatest enhancement a rural valley could receive was

. . . the retired and antiquated cot:-
Its roof with weeds and mosses covered o'er,
While mantling vines along its walls are spread,
And clustering ivy decks the chimney's head.[22]

126

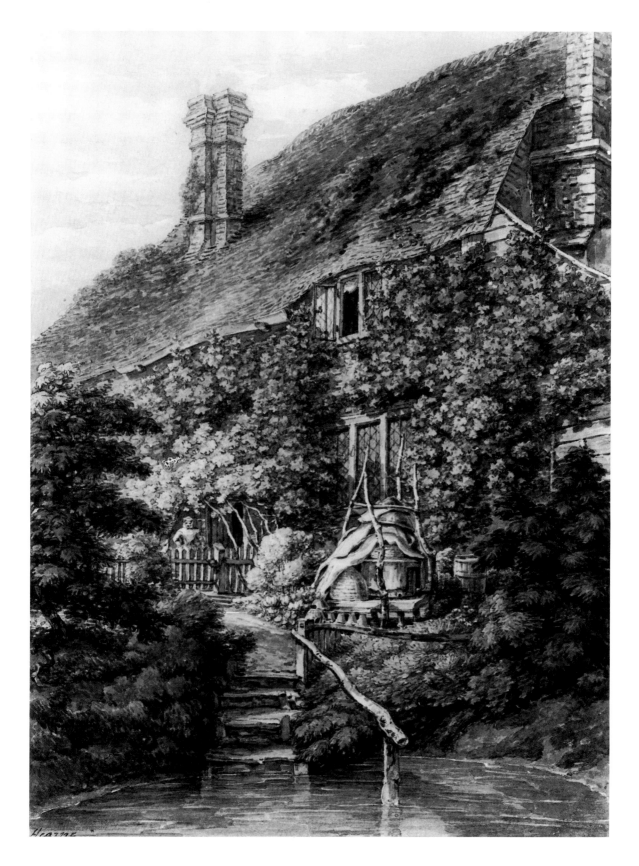

Or, as Price wrote:

A cottage of a quiet colour half concealed among trees, with its bit of garden, its pales and orchard, is one of the most tranquil and soothing of all rural objects.[23]

Hearne's interest in these subjects predated the fashion for the Picturesque, and was fed by a reverence for vernacular buildings as symbolic of a simple, honest and laborious rural life, one which contrasted favourably with urban culture and the newly-enclosed landscape. There are parallels here with Gainsborough, whose rustic landscapes and cottage scenes of the 1760s and 1770s were an escape from the toils of city life and portraiture. Hearne owned twelve drawings by Gainsborough and made at least four copies after him.[24] Shortly after Gainsborough's death in 1788, he was commemmorated by Reynolds in his 14th Discourse. Gainsborough, according to Reynolds, achieved great things,

without the assistance of an academical education, without travelling to Italy . . . The style and department of art which Gainsborough chose, and in which he so much excelled, did not require that he should go out of his own country for the objects of his study; they were everywhere about him; he found them in the streets, and in the fields, and from the models thus accidentally found, he selected with great judgement such as suited his purpose.

Of Gainsborough's fancy pictures of rustic families and children, Reynolds stressed their 'grace and elegance [such] as are more frequently found in cottages than in courts'.[25] Hearne echoed this in 1809. In pastoral subjects Hearne thought that Gainsborough

succeeded admirably. A strong sentiment always prevails. He exhibits familiar scenes, but his representations of simple life are given with such taste as to delight and never to offend. He is never coarse: His Peasant in rags has no filth; no idea of dirt and wretchedness is excited.[26]

Hearne's fastidiousness was a commonplace of the day, hence the critical reception of George Morland, who also produced many rustic subjects. One early biographer, writing in 1806, while admiring the 'truth and simplicity of character' of Morland's paintings, criticized him for displaying 'the vulgar and coarse manners of the lowest part of society'; Gainsborough, who depicted 'the virtues and happiness of rural life'[27] was far preferable. Hearne and his contemporaries, while accepting rural life as being appropriate subject-matter, wished to emphasize certain moral virtues rather than offend their customers by dwelling on the 'filth . . . dirt and wretchedness' of an increasingly impoverished countryside. Besides these conventional enough rural scenes, Hearne also turned his hand to more urban subjects, making several watercolours and drawings of the *Cheesecake House* (illus. 104), a refreshment room on the north side of the Serpentine in London's Hyde Park. This had become a favourite subject for landscape painters, who included Paul Sandby, Michael Rooker and Dominic Serres in the 1790s, as the most rural and 'least cockneyfied

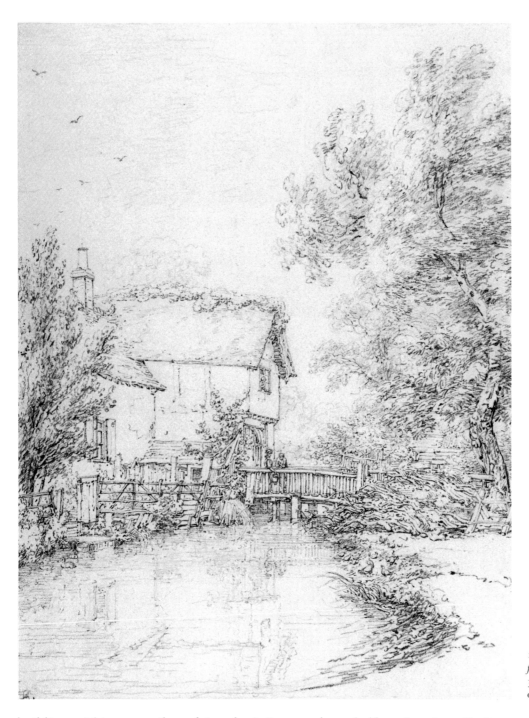

building within ten miles of London'. It was about half an hour's walk from Westminster or Charing Cross.[28] This pencil drawing, in which the rectilinear features of the house, the fencing and the bridge, contrasted with the sinuously agitated movement of the trees and surrounding vegetation, can be compared with two drawings probably made on Hearne's 1797 trip to Wiltshire. *At Bradonside, Brinkworth* (illus. 105) and *Shed and Willow* (illus. 107) are sensitive drawings, in

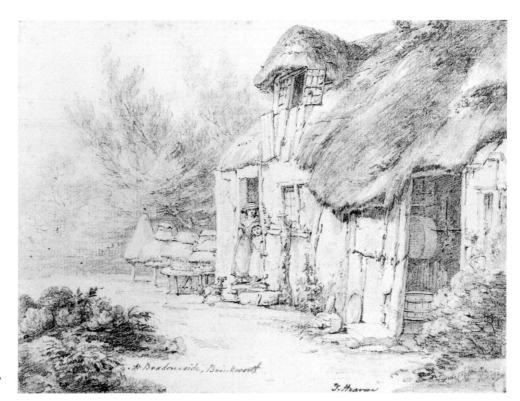

105. *At Bradonside, Brinkworth* c.1797. Pencil, 14.6 × 19.7. The Syndics of the Fitzwilliam Museum, Cambridge.

106. *Trees in Ashtead Park, Surrey* c.1795–6. Pencil, 23.7 × 30.2. Yale Center for British Art, Paul Mellon Collection.

107. (*opposite*) *Shed and Willow* c.1797. Pencil, 23.8 × 16.5. The Trustees of the British Museum.

108. (*page 132*) *Sherwood's Farm, near Bushey, Hertfordshire* c.1805–10. Watercolour over pencil, 33.6 × 27.4. The Trustees of the Victoria & Albert Museum.

130

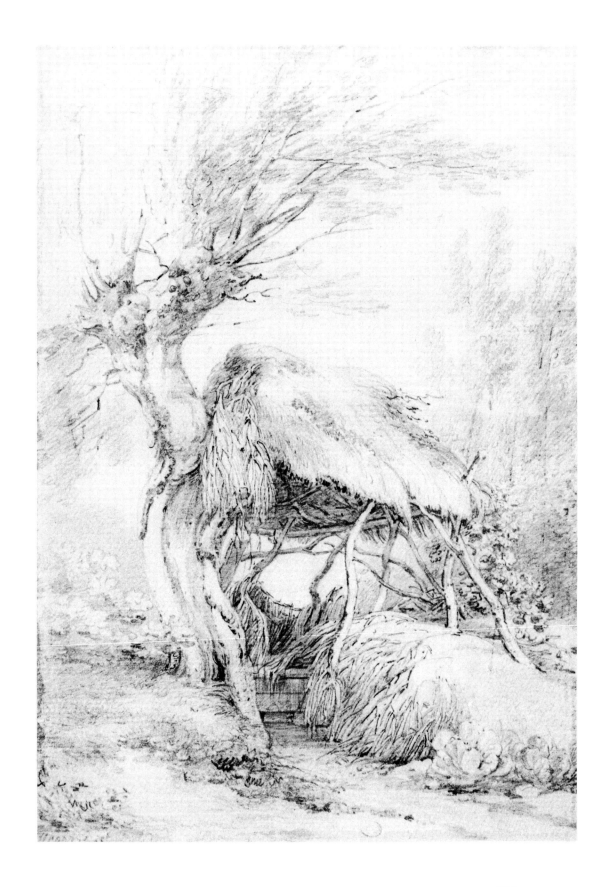

131

132

which the handling of the pollard willows recalls Gainsborough's sketches of the 1750s.[29] Uvedale Price particularly admired the unruliness of the forms of pollard willows: 'the large knots and protuberences' which 'add to the ruggedness of their twisted trunks', were preferred to the 'poor pinioned trees of a gentleman's plantation'.[30]

Drawings such as *Trees in Ashstead Park, Surrey* (illus. 106) and watercolours like *Sherwood's Farm, near Bushey, Hertfordshire* (illus. 108) were made on visits to Monro; the first when he was renting Fetcham Cottage near Leatherhead in *c.* 1795–6, the second after 1805 when he had moved to Bushey. By now a new group of young artists were being influenced by Hearne's work under Dr Monro's auspices. Henry Edridge, the portrait draughtsman, was encouraged by Hearne to take up landscape painting in a serious way, and many of Edridge's early drawings are influenced by the freer technique and stronger colours of Hearne's later works. Edridge made two watercolours of Sherwood's Farm in 1811;[31] *A House near Dunmow, Essex* (illus. 109) is a similarly informal study of a vernacular building, this time made on a visit to the Beaumonts at Dedham. In 1800 Edridge portrayed Hearne sketching in Ashstead churchyard (frontispiece), no doubt when staying with Monro at Fetcham, for the frontispiece to a volume of Hearne's drawings owned by George Baker.[32] Hearne is portrayed in a posture and setting which encapsulated his personality and interests: his hat and elegant cane are laid aside; he sits with his back against a buttress of the church, gazing intently at the subject of his sketch; in the background is a cottage in Ashstead village.

The next few years were crucial for Hearne, at a time when he was highly regarded as an antiquarian topographer. His drawings were used as models not only at Dr Monro's Academy, but also by the antiquarian publisher John Britton for training the young artists employed on the high-quality illustrations for Britton's books. By the time W. H. Bartlett joined Britton in 1823, his procedures (begun in *c.* 1803) were well developed. He would set young artists to produce drawings in

a comfortable and pleasant office in the midst of a garden . . . provided . . . with all necessary materials and also numerous books, drawings, prints and sketches for study [after the] best specimens by Hearne, Alexander, Cotman, Girtin and Turner.

Britton required sketches that were 'based on the principles of truth and daylight, and with forms and colours which were referable to the laws and effects of nature'. From the surviving sketches of this period it can be seen that Hearne's work was the most frequently imitated source. Britton's most well known protégés were Samuel Prout, Frederick Nash, and George Cattermole. Prout's drawings, made as early as *c.* 1803 when the Britton school began, reveal Hearne's influence in their use of broken-lines, a technique which became characteristic of Prout's mature work of the 1820s. Even as late as 1823 Bartlett, one of John Britton's favourite topographers, produced drawings which were clearly inspired by Hearne's anti-quarian draughtsmanship.[33]

109. (*page 133*) *A House near Dunmow, Essex c.*1795–1805. Watercolour over pencil, 24.5 × 17.2. The Trustees of the Victoria & Albert Museum.

134

A recent assessment of Britton's career maintained that 'as editor, publisher and publicist his influence on the development of the English Gothic Revival ranks with that of A. W. Pugin and John Ruskin'.[34] The style of the illustrations in Britton's publications was largely based on Hearne's *Antiquities of Great Britain.* W. H. Pyne, discussing the work of Sandby, Rooker and Hearne in 1823, felt that

Hearne, the last of this ingenious triumvirate, will be remembered as long as virtù has a charm. The elegance of his chaste pencil has raised the fame of England for this species of drawing ... [Hearne and Byrne have] contributed to spread a general love of topography ... and produced a work of British antiquity, that maintains its celebrity throughout Europe.[35]

Pyne returned to Hearne's art a year later, noting the importance of his elevation of the topographical tradition by marrying it to the principles of picturesque composition:

The mouldering walls, the remnants of carved porches; the elegant windows, with their mutilated columns, are represented in his small drawings, with a pictorial charm, that, we believe, has contributed greatly to that rage for topographical collecting, which has of late so much enriched the cabinets of our nobility and gentry, and others who have acquired a taste for such elegant pursuits.[36]

But all this was in retrospect, and came after Hearne's death. Hearne's own life after 1800 became increasingly difficult. The revolution in watercolour technique which Turner and Girtin had pioneered in the later 1790s was taken up by younger artists in the early years of the new century. What was still essentially tinted drawing in the hands of Rooker, Hearne and Dayes became fully developed watercolour painting. The practitioners of the new art formed themselves into the Society of Painters in Water-Colours in 1804 and another group set up as the New Society of Painters in Miniature and Water-Colours in 1807. Artists involved in these new ventures included such important figures (for the future) as John Varley, Robert Hills, Joshua Cristall, John Glover, John Sell Cotman, David Cox, Peter de Wint, Samuel Prout and William Westall. While the exhibitions of these new societies were at first highly successful and profitable, Hearne's personal finances declined as patronage was drawn towards younger artists. In 1795 Hearne told Farington that he did not earn more than half a guinea a day from drawing; George Baker estimated in 1800 that Hearne's annual income was around £150. By 1809 Beaumont was trying to use his influence to obtain a sinecure for Hearne – 'a place in the Hawkers and Pedlars Office or some such thing, [but a] remark was made that public money was not intended for Charity'.[37]

In addition to this, Hearne's health had begun to deteriorate, and Farington's references to his advancing age and illness suggest a lonely figure leading a frugal life as his work fell out of favour.[38] Hearne's last exhibit at the Royal Academy was *Caister Castle, Norfolk* (illus. 110) in 1806; it was also his first for thirteen years.

136

Caister Castle is a picturesque hybrid of Hearne's antiquarian topography and Gainsborough's pastoral landscapes. The blasted tree, the woodman with his bundle of sticks and the foreground log near the water's edge all occur in Gainsborough's early landscapes;[39] the Castle in the background was probably worked up from sketches Hearne made on a visit in 1792 to Norfolk with Beaumont.[40] The second volume of *The Antiquities of Great Britain* had been completed in April 1806 with the issue of four engravings, and an Academy exhibit was an appropriate mark of Hearne's achievement as well as publicity for the second volume. Farington, a close friend and an Academy Council member, asked for Hearne's watercolour to be placed advantageously in the exhibition, implying that Hearne's long absence from Academy shows signalled a response to the poor treatment which watercolours traditionally received at the hands of the hanging committee.[41]

As his livelihood declined, Hearne became savage in his criticisms of more fashionable artists. He said the sea in Turner's *Calais Pier* (exhibited in 1803) 'appeared like batter',[42] chiming in with Beaumont's description of 'veins in a marble slab',[44] made about Turner's painting the previous year. Hearne reserved particular venom for Turner, perhaps because as early as 1803, this former copyist of his work reported that he had enough commissions for twenty years.[44] His despair, fuelled also by Beaumont's increasing devotion to artists of the younger generation, became acute in 1809, just after Beaumont's unsuccessful attempt to obtain for him a government sinecure. Hearne thought the landscapes at the British Institution 'miserably bad'; Benjamin Barker's landscapes, though the best, 'were but pistacchios from Gainsborough, and mannered'; Calcott was 'overrated . . . He had done some coast scenes, imitating Turner, pretty well; He now does not look at nature'.[45] On a trip to Cassiobury to see the picture collection of Lord Essex with Edridge, Thomas Monro and Farington, Hearne launched into an attack on one of Turner's pictures: 'The sky was painted by a Mad man. Talk of Wilson retiring before him – true Wilson on seeing such a picture would soon have retired'. When looking at Turner's *Sea Piece* Hearne said 'it was raw', but of a small landscape by Gainsborough he noted 'here is something to look at in comparison'. Hearne was obviously in full flood on this visit and Farington noted as much as he could remember of the attack upon the new watercolourists:

Hearne said 'there is now an established false taste and the public mind is so vitiated that works simple and pure would not be relished: that were an Artist to produce pictures like those of Claude Lorrain they would not be admired. How could they . . . when the drawings of *Glover* and *Havil* (sic) are cried up as examples of excellence? . . . See the Public cry up Heaphy's drawings, one of which was sold for 400 guineas'.[46]

Here again Hearne agreed with Beaumont, who having been recommended by William Wordsworth to see Havell's work at the 1808 Watercolour Society, wrote indignantly that although the picture was 'one of the best there', he had been 'retrograde', while the 'general taste of the room (was) deplorable'. Beaumont feared

110. (*opposite*) *Caister Castle, Norfolk c.*1805–6. Watercolour over pencil, 59.6 × 47. The Trustees of the Victoria & Albert Museum.

137

'a manner arising in this country which if not checked in time will effectively extinguish the remaining sparks of taste which exist'.[47]

In the congenial company of Monro, Edridge and Farington, all Hearne's social insecurities were discussed. In 1806 Hearne confided to Farington that

a person who he had often met and sat with, he saw in a public room and being near to him addressed him, the other seemed not to know him even when he mentioned his name. Sometime last summer at Lord Stafford's gallery, He (Hearne) was standing with a party of distinguished Connoisseurs viz: Sir George Beaumont – Knight – C. Long etc – when this person happened to be in the room, and seeing Hearne in such company advanced the whole length of the gallery and accosted him with great familiarity and a shake of the hand. Such is the way of the world.[48]

In 1809 Hearne was in a more generally suspicious frame of mind saying that he would not 'go to any Nobleman's except with a person acquainted there, one who would be considered as a proof that there was something in the party'. Hearne criticized even Beaumont who 'desires to be supreme Dictator on works of art', and Payne Knight who had never thanked Hearne for some instruction he had given to one of Knight's protégés.[49] Hearne felt the traumas of declining patronage keenly. Much of his work had been concerned with fostering the well-being of a traditional, paternalistic order, in which he had seen himself as an artist-friend of gentlemen. Now he was the victim of a profound change in artistic expression for which he had helped to lay the foundations. Since Beaumont remained generous, Hearne was never destitute, and he eventually found a safe haven with the Ashburnham family, with Lady Ashburnham his keen pupil.[50] When Hearne died in 1817, however, it was Dr Monro who arranged and paid the expenses for his funeral and burial at Bushey Church. His tombstone can be seen there, adjacent to those of Monro and Henry Edridge.[51]

Hearne's artistic career was, in the main, similar to that of many watercolourists of the period. He began, like Rooker and Dayes, as a printmaker's apprentice. As a draughtsman, he travelled abroad in the employment of a wealthy patron, and on his return to Britain he made picturesque tours, worked extensively for engravers and executed private commissions. Despite these typical experiences, however, his work is far from 'mere topography'. His Antiguan watercolours are unique for their meticulous recording of colonial life and landscape in the Leeward Islands; *The Antiquities of Great Britain* is among the finest of such collections in the eighteenth and early nineteenth centuries, and one which played a significant role in the Gothic Revival; his superb landscape watercolours reveal an important shift, from rigorously ordered prospects and townscapes, to more informal compositions; in country-house views his work includes depictions of both the Brownian and Picturesque type of landscape garden; and these, together with his literary illustrations, rustic landscapes and studies in vernacular architecture, enrich our understanding of eighteenth-century attitudes to rural life. In many respects Hearne was one of the most subtle and accomplished architectural and landscape watercolourists of his generation.

References

CHAPTER ONE

1 – Joseph Farington's Notebooks on Artists, III, 119; typescript in British Museum Print Room; Marshfield Parish Registers and ms notes by G. Dutton in Gloucester Library. Information on Marshfield Parish Registers was generously supplied by H. W. Hayes.

2 – Algernon Graves, *The Society of Artists of Great Britain and The Free Society of Artists* (1907; facsimile edn, 1969), p.116.

3 – The three plates in *The Antiquities of Great Britain*, vol. I were as follows: *West Front of Malmesbury Abbey* (frontispiece, pubd 2 Feb 1786); *Malmesbury Abbey* (pl. 24, pubd 31 Jan 1780); *Malmesbury Abbey* (pl. 28, pubd 21 Dec 1780). *The South Porch of Malmesbury Abbey* (watercolour) is in a private collection; *Malmesbury Abbey* (watercolour) and *At Bradonside, Brinkworth* (pencil) are in the Fitzwilliam Museum, Cambridge; *Bradenstoke Priory* (watercolour), is in the National Library of Wales, Aberystwyth; *Brackenborough Church* (pencil) is in the Yale Center for British Art, New Haven (B.1975.3.1031).

4 – Farington's *Diary*, 28 July 1797.

5 – Farington's Notebooks on Artists, III, 119.

6 – Transactions of the Society of Arts, vol. II (1784), p. 128

7 – For Woollett, see Louis Fagan, *A Catalogue Raisonné of the Engraved Works of William Woollett* (London, 1885); Susan Legouix, *Original designs by William Woollett at Maidstone and a self-portrait in the British Museum* (unpublished article in Maidstone Museum).

8 – Wilson was in Italy from 1750 to *c*.1757. It was during these years that he turned seriously to landscape painting, encouraged by Francesco Zuccarelli and Claude-Joseph Vernet.

9 – David Alexander and Richard T. Godfrey, *Painters and Engraving: The Reproductive Print from Hogarth to Wilkie* (exhibition catalogue, Yale Center for British Art, New Haven, 1980), pp.22, 24.

10 – The name of the picture originated from its taking the £50 premium at the Society of Artists' first public exhibition in 1760.

11 – Farington's *Diary*, 20 April 1817.

12 – Farington's *Diary*, 12 Aug 1796.

13 – William Gilpin, *An Essay Upon Prints* (2nd ed., London, 1768), p. 51.

14 – Alexander and Godfrey, *Painters and Engraving*, pp.23, 35.

15 – The drawings were exhibited at the Free Society of Artists and the Society of Artists. Graves, *The Society of Artists*, pp. 115–16.

16 – Specific plates engraved by Woollett after these artists during 1765–71, the years of Hearne's apprenticeship, are as follows: Richard Wilson – *Celadon and Amelia* (pubd June 1766); George Stubbs – *Four Sporting Subjects* (pubd Aug 1769 – Oct 1771); George Smith of Chichester – *Two subjects to illustrate James Thomson's poem 'The Seasons'* (pubd Dec 1768 – Nov 1769); John Inigo Richards – *The Maid of the Mill* (pubd Jan 1768).

17 – Hearne is most likely to have met Banks through his association with Woollett, to whom he was apprenticed in 1765. From 1768 – July 1771 Banks accompanied Cook on a voyage to the South Seas and in December 1771 Hearne left for the West Indies with Sir Ralph Payne. This youthful portrait is unlikely to have been made after Hearne's return from the Leeward Islands in 1775, when Banks was aged thirty-two.

18 – Bruce Robertson, *The Art of Paul Sandby* (exhibition catalogue, Yale Center for British Art, New Haven, 1985); Luke Herrmann, *Paul and Thomas Sandby* (London, 1986).

19 – The most influential publication of the period was *Britannia Illustrata or Views of Several of the Queen's Palaces also of the Principal Seats of the Nobility and Gentry of Great Britain*, which had engravings by Johannes Kip (1653–1722) after Leonard Knyff (1650–1722), and in later editions after Kip's own drawings together with many by other topographers. The first volume of eighty plates was published in 1707; the second edition of 1714 had three volumes and the third edition of 1726 had four volumes.

20 – Wenceslaus Hollar (1607–77), although born in Prague was the most important topographer working in England in the seventeenth century. Samuel and Nathaniel Buck drew and engraved more than five hundred prints of urban panoramas, ruined abbeys and castles from 1711 to 1753. Their *Antiquities* were re-published in three volumes in 1774.

21 – Michael McCarthy, *The Origins of the Gothic Revival* (London, 1987), pp. 15–26, 63–91.

22 – Thomas Gray to Thomas Warton, 21 Feb 1758. Quoted in Kenneth Clark, *The Gothic Revival* (3rd edn, London, 1974), pp. 33–9.

23 – *The Correspondence of Thomas Gray*, ed. P. Toynbee and L. Whibley (Oxford, 1971), II p. 791, n.1.

24 – Richard Gough, *Anecdotes of British Topography* (London, 1768), Preface, p. xxxviii.
25 – Patrick Conner, *Michael Angelo Rooker* (London, 1984), pp. 30–1.
26 – Sir George Beaumont to Dr. Thomas Monro, 20 Dec 1816. Quoted in Martin Hardie, *Watercolour Painting in Britain*, 3 vols (London, 1966), I, p. 175.
27 – Farington's *Diary*, 5 July 1809.
28 – Revd Charles Davy, *Letters addressed chiefly to a young gentleman upon subjects of literature* (Bury St Edmunds, 1787), postscript, p. 537.
29 – For example, Adriaen van Ostade (1610–85), *The Angler* (etching). Illustrated in Irene de Groot, *Landscape etchings by the Dutch masters of the seventeenth century* (London, 1979), pl. 139. Also Hollstein 26.
30 – The second drawing, *Castle Acre Priory, Norfolk*, is in the Yale Center for British Art, New Haven (B.1975.2.578).
31 – *Antiquities*, I, *The Prior's House, Castle Acre, Norfolk* (pl. 3, pubd 1 Jan 1778).
32 – Beaumont to Monro, 20 Dec 1816 (see n.26 above).

CHAPTER TWO

1 – Janet Schaw, *Journal of a Lady of Quality, 1774–6* (3rd edn, New Haven and Oxford, 1939), p.74.
2 – In 1774 sugar made up 20% of Britain's total import bill. See Barbara L. Solow, 'Capitalism and Slavery', *Journal of Interdisciplinary History*, xvii (1987), pp. 730–40.
3 – Michael Craton, *Sinews of Empire* (London, 1974), pp. 96, 194.
4 – David B. Davis, *Slavery and Human Progress* (Oxford, 1984), p. 67.
5 – For the history of the Leeward Islands and the relationship between the sugar colonies of the West Indies and metropolitan Britain, see Vere Langford Oliver, *The history of the island of Antigua*, 3 vols (London, 1894–99); Richard Pares, *War and Trade in the West Indies 1739–63* (London, 1963); Elsa V. Goveia, *Slave Society in the British Leeward Islands at the end of the eighteenth century* (New Haven, 1965); Richard B. Sheridan, 'The Rise of a Colonial Gentry: A Case Study of Antigua 1730–75', *Economic History Review*, 2nd series, xiii (1961), pp. 342–57; Cyril Hamshere, *The British in the Caribbean* (Cambridge, Mass, 1972); Eric Williams, *Capitalism and Slavery* (London, 1944); Richard B. Sheridan, *Sugar and Slavery: An Economic History of the British West Indies 1623–1775* (Baltimore, 1974); Barbara L. Solow, 'Capitalism and Slavery' and David Richardson, 'The Slave Trade, Sugar and British Economic Growth 1748–76'. *Journal of Interdisciplinary History*, xvii (1987), pp. 730–40 and 741–69.
6 – Samuel Martin, a leading Antiguan planter, warned in 1765 that the French were 'aiming at universal dominion'. See Samuel Martin, *An Essay Upon Plantership* (4th edn, London, 1765), p.x.
7 – Richard Pares, *War and Trade*, pp.220–4. For information on the Antiguan slave plot of 1736 see Michael Craton, *Testing the Chains* (Ithaca, New York, 1982), ch. 10; David Barry Gaspar, *Bondmen and Rebels* (Baltimore, 1985).
8 – John Campbell, *Candid and Impartial Considerations on the nature of the Sugar Trade* (London, 1763), p.21.
9 – John Luffman, *A Brief Account of the Island of Antigua* (London, 1789); reprinted in Vere Langford Oliver (see n.5 above).
10 – For this and other information on Payne, see his entry in the *Dictionary of National Biography*.
11 – Lavington Sale, Jaubert, 5 July 1810. The twenty watercolours comprised ten of Antigua, four of St Kitts, one each of Montserrat, Nevis, Tortola (Virgin Islands), Crab Island, Puerto Rico, and Funchal in Madeira.
12 – In addition to the six works discussed in this chapter, a watercolour of *James Fort St John's Harbour, Antigua* (1771), is in a private collection in Antigua.
13 – Luffman, *A Brief Account* (see n.9 above).
14 – Schaw, *Journal*, p. 111; James Grainger, *The Sugar Cane* (London 1764), note to line 222.
15 – Pares, *War and Trade*.
16 – Goveia, *Slave Society*, pp.64–5.
17 – Luffman, *A Brief Account*, Letter xxii described the clothing of a field slave as a blanket to sleep upon the ground; a piece of woollen cloth or babbaw, which was worn around the waist; and a blue woollen jacket and parti-coloured cap of wool.
18 – Luffman, *A Brief Account*, Letter xxxi.
19 – Schaw, *Journal*, p. 107. Schaw came from a family of staunchly royalist gentry; she travelled to the Leeward Islands with her brother, who had been appointed searcher of customs on St Kitts.
20 – Grainger, *The Sugar Cane*, Book IV, II 582–605.
21 – For this quotation from Chesterfield, and for a full discussion of the subject, see David Dabydeen, *Hogarth's Blacks: Images of Blacks in Eighteenth Century English Art* (Kingston-upon-Thames, 1985), p.30 and pp.17–40.
22 – James Boswell, *Life of Johnson*, The World's Classics (Oxford, 1985), p.878.
23 – Johnson's review appeared in *The Critical Review* in Oct 1764.
24 – Goveia, *Slave Society*, p. 154.
25 – Luffman, *A Brief Account*, Letter v.
26 – Schaw, *Journal*, p. 94.
27 – Schaw, *Journal*, p. 114.
28 – Luffman, *A Brief Account*, Letter xiii.
29 – See n.10.
30 – Quoted in Hamshere, *The British in the Carribean*, p. 134.
31 – Schaw, *Journal*, p. 87.
32 – For examples, see Bruce Robertson, *The Art of Paul Sandby* (exhibition catalogue, Yale Center for British Art, New Haven, 1985), pp. 48–49.
33 – For Brunais, see Hans Huth, 'Agostino Brunais

Romano', *The Connoisseur* cli (Dec 1962), pp. 263–69.
34 – For Robertson, see Richard B. Sheridan, *Register of the Museum of Art*, University of Kansas, III (Winter 1967), 14ff; *Caribbeana*, I (1910), p. 187; C. F. Bell, *Walpole Society*, v (1917).
35 – William Beckford, *A Descriptive Account of the Island of Jamaica* (London, 1790), I, pp. 8–9.
36 – Revd Martin Sherlock in 1778. Quoted in Duncan Bull, *Classic Ground: British Artists and the Landscape of Italy 1740–1830* (exhibition catalogue, Yale Center for British Art, New Haven, 1981), p. 12.
37 – Copies of the engravings are in the British Museum, Prints and Drawings Department.
38 – Beckford, *A Descriptive Account*, II, p.382
39 – Oliver, *The history of the island of Antigua*, III, p. 148ff.
40 – Schaw, *Journal*, p. 92.
41 – In November 1781 the new Governor-in-Chief of the Leeward Islands, Thomas Shirley, reported that 'Parham, a small Town, on the North side of the Island, is about six miles from the Capital, and contains about fifty white families. It has a harbour and was a place of some trade before the American War'. Quoted in Oliver, *The history of . . . Antigua*, p. cxxv.
42 – Grainger, *The Sugar Cane*, II. 96–107. The poem inspired Singleton's *Description of the West Indies* (London, 1771).
43 – James Thomson, 'Summer' (first published in 1727); see *The Seasons and The Castle of Indolence*, ed. J. Sambrook (Oxford, 1972), ll. 1442–56.
44 – Martin, *An Essay upon Plantership*, pp. viii–ix, 1–3,36.
45 – Schaw, *Journal*, p. 123ff.
46 – N. A. M. Rodger, *The Wooden World* (London, 1988), caption to illus.1. Rodger also tells us that 'cattle and sheep, pigs and goats, hens and geese were carried to sea in great numbers for fresh meat . . . The fowls lived in coops, but goats roamed freely about the ship, where their habit of eating bread from the bread bags hung up by each mess made them unpopular' (pp. 70–71).
47 – Arthur Young's figures appear in Seymour Drescher, *Capitalism and Anti-Slavery: British Mobilization in Comparative Perspective* (London, 1986), p. 17.
48 – Adam Smith, *The Wealth of Nations*, Penguin Classics (London 1986), p. 489.
49 – The whole question of the antipathy of British society and law to slavery in the late eighteenth century is discussed by Drescher in *Capitalism and Anti-Slavery* (see n.47 above).
50 – Schaw, *Journal*, p. 95.
51 – Farington's *Diary*, 26 April 1817.

CHAPTER THREE

1 – Algernon Graves, *The Society of Artists of Great Britain and The Free Society of Artists* (1907, facsimile edn, 1969), pp. 115–16.

2 – John Britton, *The Autobiography of John Britton* (London, 1850), p. 424.
3 – Farington's *Diary*, 28 Dec 1795.
4 – See Margaret Aston, 'English ruins and English history: The Dissolution and the sense of the past', *Journal of the Warburg and Courtauld Institutes*, xxxvi (1973), pp. 231–55, and Stuart Piggott, *Antiquity Depicted* (London, 1978).
5 – Richard Gough, *Anecdotes of British Topography* (London, 1768), Preface, p. xlvii.
6 – Gough, *Anecdotes*, Preface, pp. xvi–xxv.
7 – Quoted in Joan Evans, *A History of the Society of Antiquaries*, (London 1956), p. 118.
8 – Gough, *Anecdotes*, Preface, p. xviii.
9 – Michael McCarthy, *The Origins of the Gothic Revival* (London, 1987), pp. 4–11.
10 – McCarthy, *Gothic Revival*, pp. 15–26; John Frew, 'Gothic is English: John Carter and the Revival of Gothic as England's National Style', *Art Bulletin*, lxiv (1982) pp. 315–19.
11 – Quoted in Thomas Cocke, 'The Wheel of Fortune: The Appreciation of Gothic since the Middle Ages', *The Age of Chivalry* (exhibition catalogue, ed. Jonathan Alexander and Paul Binski, Royal Academy, London, 1987), p. 184.
12 – Quoted in McCarthy, *Gothic Revival*, p. 13. Gwynn's remarks are taken from his *English Architecture: or the Public Buildings of London and Westminster* (1758), pp. 1–2.
13 – John Frew, 'Gothic is English', p.315.
14 – For a full discussion of these themes, see Gerald Newman, *The Rise of English Nationalism – A Cultural History 1740–1830* (London, 1987), especially ch.5.
15 – Quoted in Newman, *The Rise of English Nationalism*, p. 59.
16 – *The Correspondence of Horace Walpole*, ed. W. S. Lewis, XXIX (1955), p. 165.
17 – J. C. Brooke to Hearne, 10 Dec 1778. Bodleian Library Oxford, MS Eng. Letts. e. 98.
18 – Evans, *A History of the Society of Antiquaries*, p. 148,201.
19 – William Gilpin, *Three Essays: On Picturesque Beauty; On Picturesque Travel; and On Sketching Landscape* (London, 1792), p. 46.
20 – Letter to Richard Gough, 9 Dec 1778, quoted in John Nichols, *Illustrations to the Literary History of the Eighteenth Century* (1831), VI, p. 382.
21 – The itineraries were assembled by using dated drawings by both Hearne and Beaumont, and letterpress information in *The Antiquities of Great Britain*.
22 – Quoted in James Holloway and Lindsay Errington, *The Discovery of Scotland* (exhibition catalogue, National Gallery of Scotland, 1978), p. 63.
23 – Richard Gough, *British Topography* (1780), Preface, pp. xx–xxi.
24 – *Glasgow Cathedral*, pl. 104.
25 – Eight were of ecclesiastical sites.
26 – The antiquities were *Beauchief Abbey, Derbyshire*, pl. 28, and *Alnwick Castle*,

Northumberland, pl. 100. The landscapes were
Carlisle, pl. 83; *Durham*, pl. 89; *Roche, Yorkshire*,
pl. 97.

27 – Of the fifty-two drawings made by Hearne for
volume I of *The Antiquities*, six were based on
sketches originally made by others. Two were from
sketches by Farington, including *Furness Abbey* (pl.
16), which may have been done when Hearne and
Farington were together in the Lake District with
Beaumont in 1777. Beaumont himself supplied a
sketch of *Peel Castle* (pl. 42), made in 1781. The
antiquary, collector and patron, Sir Henry
Englefield, provided *Byland Abbey, Yorkshire*. The
other two sketches were by Sandby's follower
Edward Edwards and H. Hannan. All the thirty-two
drawings made for volume II by Hearne were based
on his own sketches.

28 – Obituary of William Byrne published 1805 in
the *Gentleman's Magazine* lxxv, pt 2 (1805). For further
information on Byrne, see J. M. Wheeler, 'The
Byrne Family and the Old Society', *Old
Water-Colour Society*, xlviii (1973), pp. 20–35.

29 – *Proposals by William Byrne for publishing A Second
Volume of the Antiquities of Great Britain*, 16 Feb
1796 (British Library, L.23.c.3 [80]).

30 – Farington's *Diary*, 28 Nov 1802.

31 – *Diary*, 23 April 1794.

32 – *Diary*, 14 Jan 1797.

33 – *Diary*, 16 March 1806.

34 – *Diary*, 28 Feb 1804.

35 – *Proposals by William Byrne* (see n.29 above).

36 – George Kearsley, *The Virtuosi's Museum*
(London, 1778), Preface.

37 – Thomas Bentley, Catalogue Introduction for
Exhibition of service at Wedgwood's new
showroom in Greek Street, London, in 1774.
Quoted in G. C. Williamson, *The Imperial Russian
Dinner Service* (London, 1909), p. 50; Alison Kelly,
'Wedgwood's Catherine Service', *Burlington
Magazine*, lxxii (1980).

38 – Gough, *British Topography* (1780), Preface, p.
xxxviii.

39 – Kearsley, *The Virtuosi's Museum*, Preface: 'At
an aera, when accumulated wealth has introduced
into Great Britain a universal taste for every species
of elegant luxury that can add to the comfort, or
increase the pleasures of social life; the direction of
this national taste to the most innocent and refined
amusements, cannot fail of meeting the approbation
and encouragement of all the liberal patrons of the
polite arts.

If intellectual delight affords greater satisfaction
to the rational mind than sensual pleasures; a plan
calculated to draw off the attention of youth from
the improper pursuit of the latter to the virtuous
gratifications of the former, will not want the aid of
a long prefatory address . . . the student, as well
as the admirer of the ingenious art of sculpture, will
be supplied with elegant engravings from the designs
of one of the first artists of the kingdom at the very
moderate price of One Shilling for each plate,
instead of the usual demand of 2s. 6d. to 5s. made
for landscapes of inferior merit'.

40 – Britton, *Autobiography*, p. 424.

41 – *Antiquities*, I (pl. 4, pubd 1 Jan 1778).

42 – Buck's *Antiquities* (1774), I pl. 98.

43 – *Antiquities* I (pl. 33, pubd 15 March 1782).

44 – Peter Hughes, 'Paul Sandby and Sir Watkin
Williams Wynn', *Burlington Magazine*, cxiv (1972),
pp. 459–66; Peter Hughes, 'Paul Sandby's Tour of
Wales with Joseph Banks', *Burlington Magazine*, cxvii
(1975), pp. 452–7.

45 – *Antiquities*, I (pl. 33).

46 – *Antiquities*, I (frontispiece).

47 – *Antiquities*, I (pl. 28, pubd 21 Dec 1780).

48 – Gough, *Anecdotes* (1768), Preface, p. xxv.

49 – Gough, *British Topography* (1780), Preface, p.
xxxviii.

50 – John M. Frew 'An aspect of the early Gothic
Revival: The Transformation of Medievalist
Research 1770–1800', *Journal of the Warburg and
Courtauld Institutes*, xlii (1980), p. 180.

51 – For Walpole and his circle of artists and
architects, see Michael McCarthy, *The Origins of the
Gothic Revival* (London, 1987).

52 – Gough, *Anecdotes* (1768), Preface, p. xxv; xxxviii.

53 – Francis Grose, *The Antiquities of England and
Wales* (London, 1773–87), supplement II (pl. II,
pubd Oct 1785).

54 – Frew, 'An aspect of the early Gothic Revival', p. 180.

55 – Grose, *The Antiquities of England and Wales*,
Introduction.

56 – John Nichols, *Illustrations to the Literary History
of the Eighteenth Century* (1831), VI, p. 382.

57 – J. C. Brooke to Hearne, 10 Dec 1778. Bodleian
Library, Oxford, MS Eng. Letts. e. 98.

58 – Nichols, *Literary History*, p. 382.

59 – Nichols, *Literary History*, p. 382.

60 – John Nichols, *Literary Anecdotes of the Eighteenth
Century* (1812–15) VIII, pp. 664–5.

61 – Gough, *Anecdotes* (1768), Preface, pp. xvi–xxv.

62 – *Antiquities*, I (pl. 16, pubd 15 April 1779).
Hearne worked up his drawing from a sketch by
Farington.

63 – Frew, 'An aspect of the early Gothic Revival',
p. 181.

64 – Quoted in Kenneth Clark, *The Gothic Revival*
(3rd edn, London, 1974), p. 37.

65 – *Antiquities*, I (pl. 25, pubd 1 Sept 1780).

66 – *Antiquities*, I (pl. 27, pubd 1 Dec 1780).

67 – *Antiquities*, I (pl. 41, pubd 2 June 1783).

68 – *Antiquities*, I (pl. 15, pubd 15 May 1779).

69 – *Antiquities*, I (pl. 20, pubd 15 Oct 1779).

70 – For these ideas, see John Barrell, *The Idea of
Landscape and the Sense of Place 1730–1840*
(Cambridge, 1972), ch.1; Barrell, *English Literature
in History 1730–80* (London, 1983); Barrell, 'The
Public Prospect and the Private View', in *Projecting
the Landscape*, ed. J. C. Eade (Canberra, 1987);
Michael Rosenthal, 'The Landscape Moralised in
mid- Eighteenth-Century Britain', *Australian Journal
of Art*, lv (1985), pp. 37–49.

71 – Gough, *Anecdotes* (1768) Preface, p. xxxvii.

72 – *Antiquities*, i (pl. 26, pubd 15 Aug 1780).

73 – *Antiquities*, i (pl. 27, pubd 1 Dec 1780).

74 – *Antiquities*, i (pl. 28, pubd 21 Dec 1780).

75 – Whitley papers, Department of Prints and Drawings, British Museum. The entry (by N.R.S.) also confirms the author of the lines of verse to be Davy.

76 – I am grateful to Michael Rosenthal for pointing out these connections with Bentley and Gainsborough. For Bentley, see R. Halsband, 'The Rococo in England: Book Illustrators, mainly Gravelot and Bentley', *Burlington Magazine*, cxxvii (1985), pp. 870–80. For Gainsborough, see John Hayes, *Gainsborough as Printmaker* (London, 1971), pp. 67–71.

77 – Revd Charles Davy, *Letters addressed chiefly to a young gentleman upon subjects of literature* (1787).

78 – Davy, *Letters*, i xxxiv, p. 218.

79 – Davy, *Letters*, i, xxvi, pp. 228–34.

80 – Davy, *Letters*, i, xxiii, p. 215.

81 – Davy, *Letters*, i, xxii.

82 – Davy, *Letters*, i xxvi, pp. 228–34.

83 – Davy, *Letters*, Miscellaneous Letter x.

84 – Quoted in William B. Willcox and Walter Arnstein, *The Age of Aristocracy 1688 to 1830* (4th edn, 1983), p. 83.

85 – For the notion of rural retirement as a moral activity in Richard Wilson's work, see David Solkin, *Richard Wilson: The Landscape of Reaction* (exhibition catalogue, Tate Gallery, London, 1982), pp. 70–6, 213.

86 – When engraved by Woollett in 1778, Wilson's *Solitude* was captioned by the following lines from James Thomson's *Seasons* (1730):

> Still let me pierce into the midnight Depth
> Of yonder Grove, of wildest largest Growth:
> That, forming high in Air a woodland Quire,
> Nods o'er the Mount beneath. At every Step,
> Solemn, and slow, the Shadows blacker fall,
> And all is awful listening Gloom around.
> THESE are the Haunts of Meditation, These
> The Scenes where antient Bards th'inspiring
> Breath,
> Extatic, felt; and from this World retir'd . . .

('Summer', II. 516–24)

87 – *Antiquities*, i (frontispiece, pubd 2 Feb 1786; pl. 24, pubd 31 Jan 1780; pl. 28 pubd 21 Dec 1780).

88 – Buck's *Antiquities* (1774), ii, pl. 316, *Malmesbury Abbey*.

89 – Gough, *Anecdotes* (1768), Preface, pp. xvi–xxv.

90 – Quoted in Hugh A. MacDougall, *Racial Myth in English History* (Montreal, 1982), pp. 81–2.

91 – Quoted in Newman, *The Rise of English Nationalism*, p. 187; see also pp. 183–89 for a general discussion of these questions.

92 – *Antiquities*, i (pl. 13, pubd 15 April 1779).

93 – *Antiquities*, i: *Donnington Castle, nr. Newbury* (pl. 2, pubd 1 Jan 1778).

94 – *Antiquities*, i (pl. 21, pubd 15 Dec 1779).

95 – *Antiquities*, i (pl. 29, pubd 30 June 1781).

96 – *Antiquities*, i (pl. 44, pubd 15 Aug 1783).

97 – Four views of Allington Castle were exhibited at the Society of Artists in 1777. See Graves, *The Society of Artists*.

98 – For *Rural Sports*, see ch.4 below.

99 – Many of these will be discussed in ch.5 below.

100 – Frew, 'An aspect of the early Gothic Revival', pp. 183–4.

101 – *Antiquities*, i (pl. 51, pubd 2 Feb 1786).

102 – Illustrated in Lawrence Gowing, *The Originality of Thomas Jones* (London, 1985), pl. 1.

103 – Gough, *British Topography* (1780), Preface, p. xiii.

104 – See Louis Hawes, *Constable's Stonehenge* (London, 1975).

CHAPTER FOUR

1 – Algernon Graves, *The Society of Artists of Great Britain and the Free Society of Artists* (1907, facsimile edn, 1969), pp. 115–16. The details of the prints are as follows: *Joseph Andrews, Book 2, Chapter 16* (pubd 1 Nov 1781; reissued 4 Nov 1784); engraved by William Byrne and Samuel Middiman, figures by Francesco Bartolozzi. *Joseph Andrews, Book 3, chapter 12* (pubd 2 Feb 1788); engraved by William Byrne and B. T. Pouncy, figures by W. Sharp.

2 – *The Vicar of Wakefield, chapter 3* (pubd 15 March 1780); engraved by William Ellis, figures by William Woollett. *The Vicar of Wakefield, chapter 24* (pubd 13 Nov 1780); engraved by Williams Ellis, figures by William Woollett.

3 – For the watercolour see Graves, *The Society of Artists of Great Britain*. Details of the engravings are as follows: *Thomson's 'Seasons' – Summer* 11. *350–70* (pubd 12 Aug 1784); engraved by William Ellis. *Thomson's 'Seasons' – Autumn 11. 230–310* (pubd 12 Aug 1784); engraved by Williams Ellis.

4 – The following novels were published in the 1740s: Samuel Richardson's *Pamela* (1740) and *Clarissa* (1747); Henry Fielding's *Joseph Andrews* (1742) and *Tom Jones* (1749); and Tobias Smollett's *Roderick Random* (1748).

5 – For general information on book illustrations, together with paintings and prints derived from literary sources, see: H. Hammelmann and T. S. R. Boase, *Book Illustrators in Eighteenth Century England* (New Haven, 1975); Richard D. Altick, *Paintings from Books: Art and Literature in Britain 1760–1900* (Ohio State UP, 1985); Catherine M. Gordon, *British Paintings of Subjects from the English Novel 1740–1870* (London, 1988).

6 – See N. McKendrick, J. Brewer and J. H. Plumb, *The Birth of a Consumer Society* (London, 1982).

7 – Gordon, *British Paintings*, p. 97.

8 – Gordon, *British Paintings*, p. 259.

9 – Gordon, *British Paintings*, p. 275, and ch.3.

10 – Six of Rooker's illustrations to Fielding are

illustrated in Patrick Conner, *Michael Angelo Rooker* (London, 1984), pp. 166–70.

11 – Henry Fielding, *Joseph Andrews*, World's Classics (Oxford, 1980), pp. 153–60.

12 – Fielding, *Joseph Andrews*, pp. 238–44, 217.

13 – Oliver Goldsmith, *The Vicar of Wakefield* (Harmondsworth, 1982), pp. 43–9.

14 – Goldsmith, *The Vicar of Wakefield*, pp. 7–24.

15 – Goldsmith, *The Deserted Village* (London, 1770), ll. 51–56.

16 – Goldsmith, *The Vicar of Wakefield*, p. 49.

17 – Goldsmith, *The Vicar of Wakefield*, p. 47.

18 – Goldsmith, *The Vicar of Wakefield*, pp. 177–96,47.

19 – Goldsmith, *The Vicar of Wakefield*, pp. 147–51.

20 – *The Cornfield* (pubd 1 Dec 1780); *The Dairy* (pubd 1 Dec 1780); *The Windmill* (pubd 15 Jan 1781); *The Hop-Ground* (pubd 15 Jan 1781); *Angling* (pubd 30 March 1781); *Shooting* (pubd 31 March 1781); *Ploughing* (pubd 16 July 1781); *Hay-making* (pubd 1 Nov 1782); *The Apiary* (pubd 1 April 1785); *The Talli-ho, or Fox Breaking Cover* (pubd 17 May 1785); *Coursing* and *Threshing* seem also to have been published between 1780 and 1785, as they are obviously part of the same series. All the prints were engraved by William Byrne. The complete series of twelve engravings was reissued by John P. Thompson in July 1810.

21 – Inscribed on the reverse of the sketch in Leeds City Art Gallery.

22 – See R. W. Brunskill, *Traditional Farm Buildings of Britain* (London, 1987), pp. 38–44,168–9.

23 – Brunskill, *Traditional Farm Buildings*, p. 100.

24 – R. W. Brunskill, *Timber Building in Britain* (London, 1985), p. 54,110 and 114.

25 – For Hearne's drawings at Heveningham, see ch.5 below; *Leiston Abbey*, in *Antiquities*, I (pl. 29, pubd 30 June 1781); *Wingfield Castle*, in *Antiquities*, I (pl. 30, 15 May 1781); *Church of St James, Dunwich*, in *Antiquities*, II (pl. 8, 15 April 1797).

26 – For information on George Lambert, see Elizabeth Einberg, *George Lambert* (exhibition catalogue, Kenwood, London, 1970). George Smith of Chichester produced a number of landscape engravings, many of which were derived from Dutch prototypes. A set of twenty-seven is in the Yale Center for British Art, New Haven (B1977.14.13082–13109). For Gainsborough, see John Hayes, *The Landscape Paintings of Thomas Gainsborough*, 2 vols (London, 1982).

27 – See Mary Webster, *Francis Wheatley* (London, 1970).

28 – John Gay, *Rural Sports* (1713), Canto I, l.38; Canto II, ll.4326–37.

29 – For the changes in the rural economy in the eighteenth century, see J. D. Chambers and G. E. Mingay, *The Agricultural Revolution 1750–1880* (London, 1966); K. D. M. Snell, *Annals of the Labouring Poor: Social Change and Agrarian England 1660–1900* (Cambridge, 1985). For the impact of these changes on landscape painting see Ann Bermingham, *Landscape and Ideology: The English Rustic Tradition 1740–1860* (London, 1987). The analysis of *Rural Sports* offered here is indebted to Ann Bermingham's work on Gainsborough's rustic landscapes.

30 – See Lawrence Stone and Jeanne C. Fawtier Stone, *An Open Elite? England 1540–1880* (Oxford, 1984).

31 – For georgic landscapes in this period, see Michael Rosenthal, *Constable: The Painter and his Landscape* (London, 1983), ch. 3.

32 – For other illustrations of Thomson's *Seasons*, see R. Cohen, *The Art of Discrimination* (London, 1964).

33 – Michael Rosenthal, *British Landscape Painting* (Oxford, 1982), p. 88.

34 – See John Barrell, *The Dark Side of the Landscape* (Cambridge, 1983), pp. 62–3. The full text of Scott's poem is as follows:

> We wish not here for Virgil's classic Swains,
> Nor dryad Nymphs light tripping o'er the plains;
> Nor yet the grinning Hobbinols of Gay,
> Nor cottage Marians in their torn array:
> The rustic life, in every varied place,
> Can boast its few of beauty and of grace;
> From these select the forms that most may please,
> And clothe with simple elegance and ease.

35 – Graves, *The Society of Artists of Great Britain*, pp. 115–16.

36 – Judy Egerton, *George Stubbs* (exhibition catalogue, Tate Gallery, London, 1984). See also McKendrick, Brewer and Plumb, *Consumer Society*, pp. 61–2, for an historical assessment of Stubbs's agricultural paintings.

37 – There were to be two more small commissions: one in 1790 to provide a landscape background for an engraving using a figure group by Giovanni Battista Cipriani and illustrating a passage from Milton's *Paradise Lost*; another from Payne Knight in 1794 to make two ilustrations for his poem, *The Landscape*. The details are as follows: G. B. Cipriani and Hearne, *Adam and Eve in Paradise*, engraved by B. T. Pouncy, F. Bartolozzi and W. Byrne (pubd 4 June 1790 by W. Byrne). A copy of the engraving is in the Yale Center for British Art, New Haven (B.1977.14.19694). For Payne Knight's poem and Hearne's illustrations see ch.5.

CHAPTER FIVE

1 – Hearne's collection of drawings, watercolours, prints and books was sold at Christie's, 11–12 June 1817.

2 – Discussions on the Lake District as a national Arcadia can be found in John Murdoch, *The Discovery of the Lake District* (exhibition catalogue, Victoria & Albert Museum, London, 1984); see also the essay by Robert Woof, 'A Matter of Fact Paradise', in *The Lake District – A Sort of National Property* (Victoria

& Albert Museum, 1984), pp. 9–27. The early, influential tours of Gilpin and Gray can be found in William Gilpin, *Observations, relative chiefly to picturesque beauty, made in the year 1772, on . . . the mountains and lakes of Cumberland and Westmoreland* (London, 1786), and Thomas Gray, *The Poems of Mr Gray To Which are prefixed Memoirs of his Life and Writings by W. Mason* (York, 1775).

3 – Thomas West, *A Guide to the Lakes* (1778). The quotation is from Richard Cumberland's 'Dedication to Mr Romney' at the beginning of the volume. West died in 1779 and so the second edition of his immensely successful book was prepared for publication by William Cockin in 1780. He included other writings about the Lake District by John Brown (see n.9 below), John Dalton (see n.14 below) and Thomas Gray (see n.2 above), in a much enlarged edition.

4 – West, *A Guide to the Lakes* (2nd edn, London, 1780), p. 1.

5 – Gilpin, *Observations* p. 186.

6 – Two typical drawings by Farington are illustrated in Woof, 'The Matter of Fact Paradise', p.19.

7 – For the background of outdoor oil sketching, see Philip Conisbee and Lawrence Gowing, *Painting from Nature* (exhibition catalogue, Arts Council, 1980). For Thomas Jones, see *Thomas Jones, (1742–1803)* (exhibition catalogue, Marble Hill House, Twickenham, 1970); Lawrence Gowing, *The Originality of Thomas Jones* (London, 1985); *Travels in Italy 1776–1783, based on the 'Memoirs' of Thomas Jones*, ed. Francis W. Hawcroft (exhibition catalogue, Whitworth Art Gallery, Manchester, 1988).

8 – Edmund Burke, *A Philosophical Enquiry into the Origin of our Ideas of the Sublime and Beautiful* (London, 1757).

9 – John Brown, *A Description of the Lake at Keswick* (1767); reprinted in West's *Guide* (2nd edn, London, 1780), p. 194–5.

10 – Brown's work first appeared in the *London Chronicle* of 24–26 April 1766 and then as a pamphlet on five separate occasions between 1767 and 1772.

11 – Brown, *Description*, quoted in West's *Guide* (2nd edn, 1780), p. 194. The 'Poussin' here is Gaspard Dughet (1615–75), the brother-in-law of Nicolas Poussin.

12 – Gilpin, *Observations*, p. 186.

13 – See G. R. Hibbard, 'The Country House Poem of the Seventeenth Century', in *Essential Articles for the study of Alexander Pope*, ed. Maynard Mack (Hamden, Connecticut, 1968), pp. 439–75.

14 – John Dalton, *A Descriptive Poem, addressed to Two Ladies, at their return from Viewing the Mines near Whitehaven* (1755), in West's *Guide* (2nd edn, 1780), 11. 288ff.

15 – Gray, *The Poems of Mr Gray*, in West's *Guide* (2nd edn, 1780), p. 203.

16 – Thomas Pennant, *A Tour in Scotland and Voyage to the Hebrides* (London, 1772), p. 40.

17 – West, *Guide* (2nd edn, 1780), p. 10, 90–95.

18 – See David Solkin, *Richard Wilson – The Landscape of Reaction* (exhibition catalogue, Tate Gallery, London, 1982), pp. 97–8,223–4, colour plate XI.

19 – See Solkin, *Richard Wilson*, pp. 94–7,225–6.

20 – Robert Southey, *Life and Correspondence*, ed. C. C. Southey (London, 1850), VI, p. 215.

21 – For panoramas see Ralph Hyde and Scott B. Wilcox, *Panoramania!* (exhibition catalogue, Barbican Art Gallery, London, 1988).

22 – Gray, *The Poems of Mr Gray*, in West's *Guide* (2nd edn, 1780), p. 207.

23 – See Murdoch, *The Discovery of the Lake District*, pp. 22–3.

24 – West's *Guide* (2nd edn, 1780), see 'Addendum on Furness'.

25 – West, *Guide* (2nd edn, 1780), see 'Addendum on Furness'.

26 – Sir Joshua Reynolds, *Discourses on Art*, Robert R. Wark, ed. (New Haven, 1975). For an examination of Reynolds's theories of art see John Barrell, *The Political Theory of Painting from Reynolds to Hazlitt* (London, 1986).

27 – Reynolds, Discourse III, p. 51.

28 – Reynolds, Discourse IV, pp. 69–70.

29 – Reynolds, Discourse III, p. 52.

30 – Beaumont had been a pupil of Cozens at Eton, and Davy referred to the artist in the preface to *A Relation of a Journey to the Glaciers in the Dutchy of Savoy*, translated by Charles and Frederick Davy from the French of M. T. Bourritt, and published in 1774.

31 – See Kim Sloan, *Alexander and John Robert Cozens* (London, 1986), pp. 49–62.

32 – The second drawing was owned by Monro's associate, John Henderson, whose son presented it to the British Museum in 1859. The elder Henderson is first known as a patron of Hearne in early 1794.

33 – Thomas Pennant, *A Tour in Scotland in 1769* (3rd edn, London, 1776), I, p. 239.

34 – *Antiquities*, I (pl. 31, pubd 1 March 1781).

35 – The fullest treatment of Payne Knight's tours in Southern Italy and Sicily is in Richard Payne Knight, *Expedition in Sicily*, ed. Claudia Stumpf (British Museum: London, 1986). See also Claudia Stumpf, 'The Expedition into Sicily', in *The Arrogant Connoisseur* (exhibition catalogue, Whitworth Art Gallery, Manchester, 1982).

36 – Christopher Hussey, *English Country Houses – Mid- Georgian* (London, 1956), pp. 165–76.

37 – Farington's *Diary*, 6 Jan 1799.

38 – Revd Charles Davy, *Letters addressed to a young gentleman upon subjects of literature* (1787), Letter XXVII, p. 239–40.

39 – Oliver Goldsmith, *The Deserted Village* (London, 1770), ll.275–86.

40 – See ch. 3 above, notes 77–84.

41 – *Antiquities*, I (pl.29, pubd 30 June 1781).

42 – Farington's *Diary*, 2 Feb 1808.

43 – Richard Payne Knight, *An Analytical Enquiry into the Principles of Taste* (London, 1805), p. 223.

44 – Payne Knight, *An Analytical Enquiry*, p. 160.

45 – *Greville Memoirs 1824–60* (1938), IV, p. 182. For information on Knight and Downton, see N. Pevsner, *Studies in Art, Architecture and Design*, I (London, 1968), and Nicholas Penny, 'Architecture and Landscape at Downton', in *The Arrogant Connoisseur*, pp. 32–49.

46 – Davy, *Letters*, XXVII, pp. 235–8.

47 – Etched by B. T. Pouncey and published 2 June 1798 as one of six *Picturesque Landscapes*.

48 – For a full discussion of English attitudes towards trees, see Keith Thomas, *Man and the Natural World: Changing Attitudes in England, 1500–1800* (Harmondsworth 1983), ch. 5.

49 – Alexander Pope, *Windsor Forest* (1713), ll.221–231.

50 – John Dalton, *A Descriptive Poem*, ll.203–12.

51 – Richard Payne Knight, *The Landscape* (London, 1794), III, ll.61–6.

52 – William Gilpin, *Remarks on Forest Scenery* (Richmond, 1973), I, p. 30.

53 – Etched by B. T. Pouncey and published 2 June 1798 as one of six *Picturesque Landscapes*.

54 – Payne Knight, *The Landscape*, I, ll.301–6.

55 – Payne Knight, *The Landscape*, II, ll.240–3.

56 – Payne Knight, *The Landscape*, II n. p.28.

57 – Uvedale Price, *Essays on the Picturesque*, I, pp. 31–2. For a valuable discussion of the issues raised here, see Ann Bermingham, *Landscape and Ideology* (1986), ch. 2, 'The Picturesque Decade'.

58 – Payne Knight, *The Landscape*, I, ll. 175–6.

59 – Payne Knight, *The Landscape*, II, l.34.

60 – Payne Knight, *The Landscape*, I, ll.292–8.

61 – Payne Knight, *The Landscape*, II, ll.1–4.

62 – Payne Knight, *The Landscape*, I, ll.214–20.

63 – See Felicity Owen and David Blayney Brown, *Collector of Genius – A Life of Sir George Beaumont* (London, 1988), p. 75.

64 – *Antiquities*, II (pl.10, pubd 31 March 1798).

65 – Engraved by William Byrne and J. Schumann and published 14 April 1792.

66 – Quoted in Christopher Anstey, *The New Bath Guide* (1790 edn), p. 25.

67 – Anstey, *The New Bath Guide*, p. 41.

68 – Victoria County History, *Essex* (1977), I, p.287.

69 – Richard Gough, *The History and Antiquities of Pleshy in the County of Essex* (London, 1803), p. 1.

70 – Gough, *Pleshy*, p. 159.

71 – Gough, *Pleshy*, Preface.

72 – Farington's *Diary*, 2 Oct 1796.

73 – Price, *Essays on the Picturesque*, 2 vols (1796–8), I, pp. 39–40. The argument employed here is related to that pursued by Nigel Everett in his unpublished dissertation, *Country Justice: The Literatures of Landscape Improvement and English Conservatism, with particular relevance to the 1790s* (Cambridge University, 1977), especially Section Two, ch. 1: 'Uvedale Price and the Politics of the Picturesque'. The essay by John Murdoch, 'Foregrounds and Focus: Changes in the Perception of Landscape

c. 1800', in *The Lake District – A Sort of National Property*, pp. 43–59, is also of central interest here.

74 – Thomas Gray, *Letter to Rev. William Mason*, 24 May 1771, quoted in William Gilpin, *Observations on the River Wye* (Richmond, 1973), p. iii.

75 – Gilpin, *Observations on the River Wye* (3rd edn, London, 1792), p. 17.

76 – Farington's *Diary*, 21 Dec 1794; 1 Jan 1800.

77 – *Diary*, 5 July 1803.

78 – *Diary*, 14 Dec 1795.

79 – *Diary*, 15 Oct 1797.

80 – *Diary*, 1 Jan 1800.

81 – *Diary*, 1 July 1811.

82 – Gilpin, *Observations on the River Wye* (3rd edn, 1792), pp. 30–2.

83 – Gilpin, *Observations on the River Wye*, p. 22.

84 – *The Wye Tour of Joseph Farington – 1803* (transcribed from the original in Hereford City Library, with notes by John Van Laun, 1988), p.7.

85 – William Coxe, *An Historical Tour through Monmouthshire* (1801), p. 347.

86 – Gilpin, *Observations on the River Wye*, p. 45.

87 – Gilpin, *Observations on the River Wye*, pp. 37–9.

88 – Price, *Essays on the Picturesque*, I, p. 55.

89 – Gilpin, *Observations on the River Wye*, p. 33, 47.

90 – *Antiquities*, II (pl.29, pubd 12 April 1806).

91 – Gilpin, *Observations on the River Wye*, p. 39.

92 – E. W. Brayley, ed., *The Works of the late Edward Dayes* (London, 1805), p. 306.

CHAPTER SIX

1 – Farington's *Diary*, 21 Dec 1794.

2 – *Diary*, 30 Dec 1794

3 – J. L. Roget, *A History of the Old Water Colour Society*, 2 vols (London, 1891), I, p. 79.

4 – See above, ch. 3, n. 27.

5 – Farington's *Diary*, 12 Nov 1798.

6 – Girtin's copy of *Lanercost Priory* is in the British Museum Print Room; his *Newark Castle* of 1795 was with Walker's Gallery in 1935.

7 – Turner's *Malmesbury Abbey* is in Bury Art Gallery. The sketch is in the *Bristol and Malmesbury* sketchbook in the Tate Gallery (Turner Bequest VI–12, 13, inscribed 'South East View of Malmesbury Abbey 1791'). The Hearne version is in the Fitzwilliam Museum, Cambridge.

8 – Turner's Royal Academy exhibit of 1792 is illustrated in Andrew Wilton, *The Life and Work of J. M. W. Turner, R.A.* (London, 1979), no. 25.

9 – Reproduced in *Turner in Scotland* (exhibition catalogue, Aberdeen Art Gallery and Museum, 1982), p. 29, and Andrew Wilton, *Turner*, nos. 73 and 74.

10 – Reproduced in Craig Hartley, *Turner Watercolours in the Whitworth Art Gallery* (1984), p. 14, repr. p. 17.

11 – Hearne's subjects for *Britannia Depicta* came from the counties of Bedfordshire, Berkshire, Cambridgeshire, Cumberland and Derbyshire;

those for *The Beauties of England and Wales* were from Herefordshire and Wiltshire.

12 – Farington's *Diary*, 7 Dec 1797.

13 – For a full account of the preservationist cause in the late eighteenth century, see John M. Frew, 'Richard Gough, James Wyatt and Late 18th-century Preservation', *Journal of the Society of Architectural Historians*, xxxviii (1979), pp. 366–74.

14 – The quotations are from Richard Gough's two letters published in the *Gentleman's Magazine* lix (1789–90), pp. 873–75 and pp. 1194–96.

15 – *Antiquities*, ii, pls 7 and 9.

16 – These passages are quoted in Frew, 'Richard Gough, James Wyatt and Late 18th-century Preservation', p. 373.

17 – Farington's *Diary*, 4 April 1807.

18 – Quoted in Ian R. Christie, *Wars and Revolutions – Britain 1760–1815* (London, 1982), pp. 279–80.

19 – *Gentleman's Magazine* (April 1817), pp. 372–73.

20 – See Charles Robertson, *Bath – An Architectural Guide*, with an Introduction by Jan Morris (London, 1975).

21 – *The Hereford Guide* (2nd edn, Hereford, 1808), pp. 27–8.

22 – *The Landscape*, ii, ll.263–67.

23 – Price, *Essays on the Picturesque* (3rd edn, London, 1810) i, p. 162.

24 – Hearne's collection of drawings, watercolours, prints and books was sold at Christie's, 11–12 June 1817.

25 – Sir Joshua Reynolds, *Discourses on Art*, ed. Robert R. Wark (New Haven, 1975), Discourse XIV, pp. 245–61.

26 – Farington's *Diary*, 5 July 1809.

27 – Quoted in John Barrell, *The Dark Side of the Landscape* (Cambridge, 1983), pp. 103–4. In ch. 2 Barrell looks in detail at the critical and public reception of George Morland's work.

28 – W. H. Pyne, *Somerset House Gazette and Literary Museum* (London, 1824), ii, p. 385.

29 – A drawing by Hearne in the British Museum is a copy after a known Gainsborough sketch of the early 1750s. The Gainsborough is reproduced in John Hayes, *The Drawings of Thomas Gainsborough*, 2 vols (London, 1970), no. 92, pl. 246.

30 – Price, *Essays on the Picturesque* (3rd edn, 1810), p. 26.

31 – One of the two watercolours is in the British Museum, the other is in the Victoria & Albert Museum.

32 – Farington's *Diary*, 17 July 1804.

33 – For the quotations and for further information on John Britton and his school of topography, see J. Mordaunt Crook, 'John Britton and the Genesis of the Gothic Revival', in *Concerning Architecture*, ed. John Summerson (London, 1968), pp. 98–119; Richard Lockett, *Samuel Prout* (London, 1985), pp. 23–27.

34 – J. Mordaunt Crook, 'John Britton and the Genesis of the Gothic Revival', p. 119.

35 – W. H. Pyne, *Wine and Walnuts* (London, 1823), i, p. 94n.

36 – Pyne, *Somerset House Gazette and Literary Museum* (1824), i, pp. 65–7.

37 – Farington's *Diary*, 22 Feb 1795; 1 Jan 1800; 26 June 1809.

38 – One report by Farington is quoted in Martin Hardie, *Watercolour Painting in Britain* (London, 1966–67), i, p. 175. Other examples are Farington's *Diary*, 15 Nov 1807; 12 Jan 1808.

39 – For example, *Wooded Landscape with Cattle at a Watering Place* (c. 1747), now in the Museu de Arte de São Paolo Assis Châteaubriand, Brazil, and reproduced (no. 79) in John Hayes, *Thomas Gainsborough* (exhibition catalogue, Tate Gallery, London, 1980).

40 – Hearne made other drawings in Norfolk in 1792: *The South Gate, Yarmouth, Norfolk* (Fitzwilliam Museum, Cambridge) and *The Castle at Castle Acre* (Williamson Art Gallery, Birkenhead) are both dated 1792.

41 – Farington's *Diary*, 6 April 1806.

42 – *Diary* 1 April 1804.

43 – *Diary*, 3 May 1803.

44 – John Gage, *J. M. W. Turner: A Wonderful Range of Mind* (London, 1987), p. 237.

45 – *Diary*, 4 July 1809.

46 – *Diary*, 5 July 1809.

47 – Quoted in Felicity Owen and David Blayney Brown, *Collector of Genius – A Life of Sir George Beaumont* (London, 1988), p. 161–2.

48 – Farington's *Diary*, 3 Dec 1806.

49 – *Diary*, 5 July 1809.

50 – Hearne probably met the Asburnham family through Beaumont; from 1812 Farington records Hearne meeting them socially.

51 – Farington's *Diary*, 17 April 1817.

Select Bibliography

This select bibliography does not include topographical works, literary texts or certain monographs already referred to in the References.

David Alexander and Richard T. Godfrey, *Painters and Engraving: The Reproductive Print from Hogarth to Wilkie*, exhibition catalogue, Yale Center for British Art, New Haven, 1980

Carl Barbier, *William Gilpin and His Theory of the Picturesque*, Oxford, 1963

John Barrell, *The Idea of Landscape and the Sense of Place 1730–1840*, Cambridge, 1972

– *The Dark Side of the Landscape*, Cambridge, 1983

– *English Literature in History 1730–80: An Equal, Wide Survey*, London, 1983

– *The Political Theory of Painting from Reynolds to Hazlitt*, London, 1986

– 'The Public Prospect and the Private View' in *Projecting the Landscape*, ed. J. C. Eade, Canberra, 1987

Sir George Beaumont of Coleorton, Leicestershire, Leicester Museum and Art Gallery, 1970.

Ann Bermingham, *Landscape and Ideology: The English Rustic Tradition 1740–1860*, London, 1987

Charles Francis Bell, 'Fresh light on some watercolour painters of the old British School, derived from the collection and papers of James Moore FSA', *Walpole Society*, v, 1915–17

Peter Bicknell, *Beauty, Horror and Immensity: Picturesque Landscape in Britain 1750–1850*, exhibition catalogue, Fitzwilliam Museum, Cambridge, 1981

Nikolaus Boulting, 'The Law's delays: conservationist legislation in the British Isles', in *The Future of the Past*, ed. Jane Fawcett, London, 1976

Edward Wedlake Brayley (ed.), *The Works of the late Edward Dayes*, London, 1805

John Britton, *Autobiography*, London, 1850

Samuel Buck and Nathaniel Buck, *Views of the Ruins of Castles and Abbeys in England and Wales*, 2 vols, London 1726–42; republished by Sayer as *Buck's Antiquities*, 1774

Duncan Bull, *Classic Ground: British Artists and the Landscape of Italy 1740–1830*, exhibition catalogue, Yale Center for British Art, New Haven, 1981

William Byrne, *Proposals by William Byrne for publishing A Second Volume of the Antiquities of Great Britain*, 16 Feb 1796 [British Library, L.23.c.3(80)]

– *Britannia Depicta*, London, 1806–18

J. D. Chambers and G. E. Mingay, *The Agricultural Revolution 1750–1880*, London, 1966

Ian R. Christie, *Wars and Revolutions – Britain 1760–1815*, London, 1982

Kenneth Clark, *The Gothic Revival*, 3rd edn, London, 1974

Michael Clarke, *The Tempting Prospect. A Social History of English Watercolours*, London, 1981

Michael Clarke and Nicholas Penny, *The Arrogant Connoisseur*, exhibition catalogue, Whitworth Art Gallery, Manchester, 1982

Thomas Cocke, 'Rediscovery of the Romanesque', in *English Romanesque Art 1066–1200*, exhibition catalogue, Hayward Gallery, London, 1984

– 'The Wheel of Fortune: The Appreciation of Gothic since the Middle Ages', in *The Age of Chivalry*, exhibition catalogue ed. Jonathan Alexander and Paul Binski, Royal Academy of Arts, London, 1987

Patrick Conner, *Michael Angelo Rooker*, London, 1984

Michael Craton, *Sinews of Empire*, London, 1974

J. Mordaunt Crook, 'John Britton and the Genesis of the Gothic Revival', in John Summerson, *Concerning Architecture*, London, 1968

David Dabydeen, *Hogarth's Blacks: Images of Blacks in Eighteenth Century English Art*, Kingston-upon-Thames, 1985

Charles Davy, *Letters addressed chiefly to a young gentleman upon subjects of literature*, 1787

Seymour Drescher, *Capitalism and Anti-Slavery: British Mobilization in Comparative Perspective*, London, 1986

Joan Evans, *A History of the Society of Antiquaries*, London, 1956

Nigel Everett, *Country Justice: The Literatures of Landscape Improvement and English Conservatism, with particular relevance to the 1790s*, unpublished Ph.D.dissertation, Cambridge University, 1977

Louis Fagan, *A Catalogue Raisonné of the engraved works of William Woollett*, London, 1885

Joseph Farington, *Diary 1793–1821*, ed. Kenneth Garlick, Angus Macintyre and Kathryn Cave, New Haven and London, 1978 et.seq.

– *The Wye Tour of Joseph Farington – 1803*, transcribed from the unpublished typescript in

Hereford City Library, with notes by John Van Laun, 1988
– *Notebooks on Artists*, typescript in British Museum Print Room
John M. Frew, 'Richard Gough, James Wyatt and Late 18th Century Preservation', *Journal of the Society of Architectural Historians*, xxxviii, 1979
– 'An aspect of the early Gothic Revival: The Transformation of Medievalist Research 1770–1800', *Journal of the Warburg and Courtauld Institutes*, xlii, 1980
– 'Gothic is English: John Carter and the Revival of Gothic as England's National Style', *Art Bulletin*, lxiv, 1982
John Gage, *J.M.W. Turner: A Wonderful Range of Mind*, New Haven and London, 1987
The Gentleman's Magazine, obituary of Thomas Hearne, April 1817
Georg A. Germann, *Gothic Revival in Europe and Britain: Sources, Influences and Ideas*, London, 1972
William Gilpin, *An Essay Upon Prints*, 2nd edn, London, 1768
– *Three Essays: on Picturesque Beauty; on Picturesque Travel; and on Sketching Landscape*, London, 1792
Lawrence Goldstein, *Ruins and Empire: Evolution of a Theme in Augustan and Romantic Literature*, Pittsburgh, 1977
Catherine M. Gordon, *British Paintings of Subjects from the English Novel 1740–1870*, New York and London, 1988
Richard Gough, *Anecdotes of British Topography*, London, 1768, 2nd expanded edition published as *British Topography*, 1780
Elsa V. Goveia, *Slave Society in the British Leeward Islands at the end of the Eighteenth Century*, New Haven, 1965
Francis Grose, *The Antiquities of England and Wales*, London, 1773–87
– the *Antiquarian Repertory*, London, 1775 et.seq.
Hans Hammelman, and T.S.R.Boase, *Book Illustrators in Eighteenth Century England*, New Haven, 1975
Martin Hardie, *Watercolour Painting in Britain*, 3 vols, London, 1966–8
John Harris, *The Artist and the Country House*, London 1979
Louis Hawes, *Constable's Stonehenge*, London, 1975
– *Presences of Nature: British Landscape 1780–1830*, exhibition catalogue, Yale Center for British Art, New Haven, 1982
John Hayes, *The Landscape Paintings of Thomas Gainsborough*, 2 vols, London, 1982
Thomas Hearne and William Byrne, *The Antiquities of Great Britain*, 2 vols, London, 1786 and 1807
Thomas Hearne, *A Catalogue of the Entire Collection of Original Drawings, of That Distinguished Artist Thomas Hearne Esq. Dec.*, Christie's, London, 11 June 1817
Luke Herrmann, *British Landscape Painting of the Eighteenth Century*, London, 1973

– *Paul and Thomas Sandby*, London, 1986
Walter Hipple, *The Beautiful, The Sublime and the Picturesque in Eighteenth Century British Aesthetic Theory*, Carbondale, 1957
James Holloway and Lindsay Errington, *The Discovery of Scotland*, exhibition catalogue, National Gallery of Scotland, Edinburgh, 1978
C.E. Hughes, *Early English Watercolours*, 1913; rev. edn by Jonathan Mayne, London, 1950
John Dixon Hunt, *The Figure in the Landscape: Poetry, Painting and Gardening in the Eighteenth Century*, Baltimore, 1975
John Dixon Hunt and Peter Willis, *The Genius of the Place: The English Landscape Garden 1620–1820*, London, 1975
Christopher Hussey, *The Picturesque*, London, 1927
F.J.G. Jefferiss, *Dr Thomas Monro and the Monro Academy*, exhibition catalogue, Victoria & Albert Museum, London, 1976
George Kearsley, *The Virtuosi's Museum*, London, 1778
Johannes Kip and Leonard Knyff, *Britannia Illustrata, or Views of Several of the Queen's Palaces, also of the Principal Seats of the Nobility and Gentry of Great Britain*, 3rd edn, 3 vols, 1726
Richard Payne Knight, *The Landscape, a Didactic Poem*, London, 1794
– *An Analytical Enquiry into the Principles of Taste*, London, 1805
– *Expedition in Sicily*, ed. Claudia Stumpf, London, 1986
Michael McCarthy, *The Origins of the Gothic Revival*, London, 1987
Hugh MacDougall, *Racial Myth in English History: Trojans, Teutons and Anglo-Saxons*, London, 1982
Neil McKendrick, John Brewer and J. H. Plumb, *The Birth of a Consumer Society*, London, 1982
Elizabeth Manwaring, *Italian Landscape in Eighteenth Century England*, New York, 1925
Samuel Martin, *An Essay Upon Plantership*, 4th edn, London, 1765
Barbara Milner, *Thomas Hearne: A Catalogue of his Watercolours and Drawings in the British Museum*, unpublished MA report, Courtauld Institute, University of London, 1983
Esther Moir, *The Discovery of Britain: The English Tourists 1540–1840*, London, 1964
William Cosmo Monkhouse, *The Earlier English Water-colour Painters*, London, 1890
Henry Monro, 'Henry Edridge and Thomas Hearne: Letters from the Papers of Dr Henry Monro', *Art Journal*, 1907
David Morris and Barbara Milner, *Thomas Hearne 1744–1817: watercolours and drawings*, exhibition catalogue, Bolton Museum and Art Gallery, 1985
John Murdoch, 'Foregrounds and Focus: Changes in the Perception of Landscape c. 1800' in *The Lake District – A Sort of National Property*, Victoria & Albert Museum, London, 1984
– *The Discovery of the Lake District*, exhibition

catalogue, Victoria & Albert Museum, London, 1984

Gerald Newman, *The Rise of English Nationalism – A Cultural History 1740–1830*, London, 1987

W. Foxley Norris, 'Dr Monro', *Old Water-Colour Society*, ii, 1924–5

Felicity Owen and David Blayney Brown, *Collector of Genius – A Life of Sir George Beaumont*, London, 1988

Leslie Parris and Conal Shields, *Landscape in Britain c. 1750–1850*, exhibition catalogue, Tate Gallery, London, 1973

Ronald Paulson, *Emblem and Expression: Meaning in English Art of the Eighteenth Century*, Cambridge, Mass, 1975

Stuart Piggott, *Ruins in a Landscape*, Edinburgh, 1976

– *Antiquity Depicted*, London, 1978

Roy Porter, *English Society in the Eighteenth Century*, Harmondsworth, 1982

Uvedale Price, *Essays on the Picturesque*, London, 1794; 3rd expanded edn, 1810

W.H. Pyne, *Wine and Walnuts*, 2 vols, London, 1823

– *Somerset House Gazette and Literary Museum*, 2 vols, 1824

Sir Joshua Reynolds, *Discourses on Art*, ed. Robert R. Wark, New Haven, 1975

Brenda D. Rix, *Pictures for the Parlour: The English Reproductive Print 1775–1900*, exhibition catalogue, Art Gallery of Ontario, Toronto, 1983

Bruce Robertson, *The Art of Paul Sandby*, exhibition catalogue, Yale Center for British Art, New Haven, 1985

J.L. Roget, *A History of the Old Water-Colour Society*, 2 vols, London, 1891

Michael Rosenthal, *British Landscape Painting*, Oxford, 1982

– *Constable: The Painter and his Landscape*, London, 1983

– 'The Landscape Moralised in mid Eighteenth-Century Britain' *Australian Journal of Art*, lv, 1985

William Ruddick, *Joseph Farington: watercolours and drawings*, exhibition catalogue, Bolton Museum and Art Gallery, 1977

Janet Schaw, *Journal of a Lady of Quality 1774–6*, 3rd edn, New Haven and Oxford, 1939

Kim Sloan, *Alexander and John Robert Cozens*, London, 1986

Hammond Smith, 'The Landscapes of Henry Edridge', *Old Water-Colour Society*, lii, 1977

Keith D.M. Snell, *Annals of the Labouring Poor: Social Change and Agrarian England 1660–1900*, Cambridge, 1985

David Solkin, *Richard Wilson – The Landscape of Reaction*, exhibition catalogue, Tate Gallery, London, 1982

Lindsay Stainton, *British Landscape Watercolours 1600–1860*, exhibition catalogue, British Museum, London, 1985

Brian Stewart, *The Smith Brothers of Chichester*, exhibition catalogue, Pallant House, Chichester, 1986

Lawrence Stone and Jeanne C. Fawtier Stone, *An Open Elite? England 1540–1880*, Oxford, 1984

Wylie Sypher, *Guinea's Captive Kings: British Anti-Slavery Literature of the Eighteenth Century*, Chapel Hill, 1942

Keith Thomas, *Man and the Natural World: Changing Attitudes in England 1500–1800*, London, 1983

David Watkin, *The Rise of Architectural History*, London, 1980

– *The English Vision: The Picturesque in Architecture, Landscape and Garden Design*, London, 1982

William Watts, *The Seats of the Nobility and Gentry*, London, 1779

J. M. Wheeler, 'The Byrne Family and the Old Society', *Old Water-Colour Society*, xlviii, 1973

Christopher White, *English Landscape 1630–1850: Drawings, Paintings and Books from the Paul Mellon Collection*, exhibition catalogue, Yale Center for British Art, New Haven, 1977

Iolo A. Williams, *Early English Watercolours*, reprinted Bath, 1970

Raymond Williams, *The Country and the City*, London, 1973

Andrew Wilton, *The Life and Work of J.M.W. Turner, R.A.*, London, 1979

– *British Watercolours 1750 to 1850*, Oxford, 1979

– *The Art of Alexander and John Robert Cozens*, exhibition catalogue, Yale Center for British Art, New Haven, 1980

Robert Woof, 'The Matter of Fact Paradise', in *The Lake District – A Sort of National Property*, Victoria & Albert Museum, London, 1984

Index

Anstey, C., *New Bath Guide*, 104
Antiquarianism: Anglo-Saxon revival, 48–50; nationalism and, 24–7, 38–9; opposition to Wyatt's cathedral restorations, 120–5; topographical draughtsmanship and, 4–6, 24–51, 78–81, 104–6
Ashburnham family, 138

Baker, G., collects work by Hearne, 107–110, 134; on Hearne's income, 135
Banks, Sir J., 4, 13, 32
Barker, B., 137
Barker, R., 75
Bartlett, W. H., 134
Beaumont, Sir G., 32, 46, 89, 102, 104, 119, 126, 134, 135, 138, 142 n27; criticism of artists, 137–8; early acquaintance with Hearne, 6–8; genealogy and antiquarianism, 27; panorama commission, 75–7; sketches landscape in oils, 70; tours: Lakes, North of England and Scotland, 28, 67–70, 75–85; River Wye, 106–16
Beckford, W., *A Descriptive Account of the Island of Jamaica*, 18–19
Bentham, J., *History of Ely Cathedral*, 41
Bentley, R., 37, 44
Borlase, Revd. P. V., 26, 38–9; *Antiquities . . . of the County of Cornwall*, 25
Bowyer, R., *Historic Gallery*, 119
Boydell, J., 2
Breadalbane, Lord, 29
British Institution, The, 137
Britton, J., antiquarian publisher, 134–5; *The Beauties of England and Wales*, 120; on Hearne and *The Antiquities*, 24, 32
Brooke, J. C., on *The Antiquities*, 38; on Hearne and Beaumont's tour in 1778, 28; letter to Hearne on Beaumont family, 27
Brown J., *Description of the Lake at Keswick*, 71
Brown, J., assistant to Woollett, 3
Brown, L. 'Capability', 90, 100–2
Brunais, A., WORKS: *A Planter and his Wife attended by a Servant*, 13; 18
Buck, S. and N., 5, 29, 33, 49; WORKS: *Buck's Antiquities 31*; 6, 32
Byrne, J., joint proprietor of *The Antiquities*, 1, 30
Byrne, W., WORKS: *Antiquities of Great Britain* (with Thomas Hearne), 24–51 passim; 5, 102, 135; *Britannia Depicta*, 120; *Joseph Andrews*, 52; *Rural Sports*, 63, 92

Cadell and Davis (publishers), buy up *The Antiquities*, 30
Calcott, A. W., 137
Carter, J., 26, 122–4
Chesterfield, Lord, 15; *Letters to his Son*, 46
Cipriani, G. B., 144 n37
Claude Lorrain, 8, 18–19, 67, 72, 78–84, 92–3, 99–100, 102
Cornewall, Sir G., 102
Cozens, A., theories of landscape painting known by Hearne, 79
Cozens, J. R., 89, 119; limited colour range shared by Hearne, 118

Dalton, J., *Descriptive Poem . . . near Whitehaven*, 73–4, 97
Dance, G., 120
Davy, Revd. C., 59, 62, 79, 89; introduces Beaumont to Woollett and Hearne at London and Henstead, 6–8; on moral purpose of the arts, 44–8; on trees, 90–1, 97
Davy, C. junior, 45, 47
Dayes, E., 79, 135, 138; on colour in landscape drawings, 118
de Loutherbourg, P., 53
Derwentwater, 3rd Earl of, 75
Downton, Herefordshire, 90–102 passim
Dughet, G., 8, 18, 67, 72, 79, 92, 93

Edridge, H., 134, 137, 138; WORKS: *Thomas Hearne in Ashtead Churchyard, Surrey, frontispiece*
Edwards, E., 19, 142 n27
Ellis, W., 52
Enclosures, and rustic landscapes, 63
Englefield, Sir H., 30, 119, 120–5
Exhibitions, annual in London, 6, 90

Farington, J., 3, 6, 29, 70, 90, 107, 110, 120, 135–7; on Hearne: Dr Monro's 'Academy', 119; early life and apprenticeship, 1; later life, 135–8 passim
Fielding, H., *Joseph Andrews*, 52–8
Free Society of Artists, 1, 52

Gainsborough, T., 44, 79, 103, 134; rustic landscapes, 62, 115, 128, 137; subverts Academic dogma, 79
Gilpin, W., 98; on ancient architecture, 28; on engravers, 3; on the Lake District, 70, 73; on the River Wye, 107, 110–16
Girtin, T., 117, 134, 135; copies Hearne's work at Dr Monro's 'Academy', 119
Goldsmith, O., *The Deserted Village*, 54, 57–8, 91; *The Vicar of Wakefield*, 52–8, 91
Gothic architecture, topographical draughtsmanship and, 24–51; trees and, 97
Gough, R., 30, 44, 68; on antiquarian draughtsmanship, 5–6, 36–9; on antiquarianism, 24–6, 29; opposes Wyatt's cathedral restorations, 120–4; *Anecdotes of British Topography*, 24–5, 36–7; *The History and Antiquities of Pleshey*, 104–6
Grainger, J., *The Sugar Cane*, 15, 21
The Grand Tour, 7, 9, 25, 54–5, 67–8, 73, 79
Gray, T., 44; as antiquary, 5, 39–41; *Journal* on the Lake District, 67–70, 74, 75; on the River Wye, 107
Grose, F., 30; *The Antiquities of England and Wales*, 37; WORKS: *Malmesbury Abbey 23*; 37
Gwynn, J., 26

Hearne, Thomas, antiquarian draughtsmanship, 6, 8, 24–51, 66, 67, 92, 104–6, 107, 112–16, 120–5, 134–5; aristocracy and gentry, 138; bridges in works, 84–5; commissions, 110; country-house and estate views: Downton, 67, 90–102; Heveningham, 89–92; Moccas, 98–9,

102; criticism of other artists, 137–8; early life and apprenticeship, 1–8; engraving, 3; landscapes, 67–118 passim; later life, 119–38; literary illustrations, 52–8, 63–6, 91; Malmesbury Abbey, significant for, 1, 24, 35–6, 46–50; at Monro's 'Academy', 119–20; rustic landscapes, 58–66, 91–2, 125–8; Sicilian watercolours, 85–9; technique, 6, 33, 42, 67–118 passim; tours: Lakes, North of England and Scotland, 28–9, 42–4, 67–85; River Wye, 102, 106–16; trees, 92–100, 129–34; vernacular buildings, 58–63, 125–34; in the West Indies, 9–23. WORKS: *Adam and Eve in Paradise*, 144 n37; *The Sepulchre at Agrigentum, Sicily* 70; 89; *Allington Castle, near Maidstone, Kent 18*; 51; *Court House and Guard House in the town of St John's, Antigua 8*; 12–13, 15–17; *The English Barracks and St John's Church, Antigua, from the Hospital 7*; 13–15; *The Front of the English Barracks, St John's Antigua, from the Parsonage 10*; 13, 20; *Negroes on mules, Antigua 12*; 17–18; *Parham Hill House and Sugar Plantation, Antigua 9*; 19–22; *The Antiquities of Great Britain* (with William Byrne), 1, 8, 24–51, 52, 66, 67, 72, 92, 102, 106, 119, 120, 135, 137, 138; *Appleby 59*; 78, 81, 84–5; *Trees in Ashtead Park, Surrey 107*; 134; *Autumn 50*; 52, 63–4; *Part of the remains of the Whitefriars at Aylesford, Kent 84*; 106; *Joseph Banks 3*; 4; *Barnard Castle 66*; 78, 84–5; *View of Bath from Spring Gardens with Pulteney Bridge 82*; 103–4; *Sir George Beaumont and Joseph Farington sketching a waterfall 52*; 70; *Sir George Beaumont and Joseph Farington sketching in oils 53*; 70; *Beverstone Castle, Gloucestershire 17*; 32–3, 51; *At Bradenside, Brinkworth 105*; 1, 129; *Sherwood's Farm, near Bushey 108*; 134; *Caister Castle, Norfolk 110*; 135–7; *Carlisle Castle*, 67; *The Prior's House, Castle Acre, Norfolk 6*; 8; *The Cheesecake House from the West 104*; 128–9; *Chepstow Castle*, 102; *Chepstow Castle from Piersfield 94*; 116; *A view of the interior of Cockermouth Castle, Cumberland 54*; 67; *A vine-clad cottage 103*; 126–8; *Dacre Castle*, 67; *A scene on board HMS Deal Castle on a voyage from the West Indies 1775 15*; 22; *Derwentwater from Brandelhow Woods 55*; 75–8; *Panorama of Derwentwater from Crow Park 60*; 75–8; *Downton views*: 90–102 passim; *The Alpine Bridge on the Teme at Downton 68*; 93–4, 117; *Downton Castle 73*; 92; *Gorge of the River Teme, Downton 90*; 93; *An Oak Tree 69*; 94, 99, 117; *View from below Pool's Farm 74*; 93; *'The Rock' viewed from upstream of Hay Mill Weir 76*; 93; *The View Upstream 75*; 93; *A House near Dunmow, Essex 109*; 134; *Durham Cathedral from the opposite bank of the Wear 62*; 38, 78, 84; *Elvet Bridge, Durham* (Ashmolean) *58*; 78, 81–5; *Elvet Bridge, Durham* (British Museum) *57*; 78, 81–5, 117; *North-east view of Durham* (Leeds) *61*; 78, 84–5; *North-east view of Durham* (Norwich) *63*; 84–5; *Edinburgh Castle*, 38, 120; *Edinburgh from Arthur's Seat* (Tate) *64*; 78, 85; *Edinburgh from Arthur's Seat* (Yale) *65*; 85; *St Anthony's Chapel, Edinburgh 28*; 42–4; *Egremont Castle*, 67; *Cathedral Church of Ely*, 41–2; *North aspect of*

Hearne, Thomas – *cont.*
 Furness Abbey 24; 37, 67; *Cathedral Church of Glasgow*, 50; *Goodrich Castle on the Wye* 88; 107, 110, 111; *Greystoke Castle*, 67; *The Priory at Haddington*, 120; *A Bridge at Henstead, Suffolk* 5; 7, 62; *Bye Street Gate, Hereford* 85; 107, 125; *Hereford Cathedral – the fall of the West Front* 100; 122; *Heveningham Hall, Suffolk* 71; 89–90, 93; *In the park of Sir Gerard Vanneck at Heveningham, Suffolk* 72; 90–2; *Joseph Andrews and his friends Parson Adams and Fanny* 33; 52–8 *passim*; 'Joseph Andrews': *Fanny Goodwill rescued from the Captain* 34; 35, 52–3, 54–7; *The Monastery, Kelso* 25; 38, 41; *The 'Improved' Landscape* 79; 100–2; *The 'Unimproved', Picturesque Landscape* 80; 100–2; *Lanercost Priory* 29; 38, 44–8, 67, 92, 94, 119; *Leiston Abbey*, 50, 92; *The Chestnut Tree at Little Wymondley, Hertfordshire* 77; 97; *North-east view of Llanthony Priory* 92; 115; *Ludlow Castle* 81; 102–3; *Lumley Castle*, 38; *Malmesbury Abbey* 99; 1, 119; *The South Porch of Malmesbury Abbey* 22; 1, 36–9; *The South-west angle of Malmesbury Abbey* 30; 1, 36–9, 44, 92, 120; *The West front of Malmesbury Abbey* 21; 1, 35–9, 48; *The Transept of Melrose Abbey* 26; 38, 41, 44–8, 50, 92; *Moccas Deer Park with a Large Oak Tree* 78; 94–7, 98; *Near Monmouth* 86; 107; *At Much Easton, Essex* 102; 126–8; *Naworth Castle*, 67; *Newark Castle*, 119; *Penrith Castle*, 67; *Site of the Castle at Pleshey, Essex* 83; 104–6, 126; *Raglan Castle, Monmouthshire* 93; 107, 115, 117; *Gundulf's Tower, Rochester Cathedral* 96; 119; *Rural Sports* 38–47; 51, 58–66 *passim*, 92, 125; *Angling* 46; 58–63; *The Apiary* 45; 58–63, 126; *The Cornfield* 40; 58–63; *The Dairy* 43; 58–63; *Hay-making* 39; 58–53; *The Hop-Ground* 44; 58–63, 126; *Ploughing* 38; 58–63; *Shooting* 47; 58–63; *Threshing* 41; 58–63; *The Windmill* 42; 58–63; *Salisbury Cathedral*, 122; *Shed and Willow* 107; 129–34; *View from Skiddaw over Derwentwater* 51; 70–8; *Stirling Castle* 27; 42; *The Windings of the Forth from Stirling Castle* 67; 85; *Stonehenge* 16; 51; *A View in Suffolk* 48; 59–66; *Summertime* 49; 52, 63–4; *Symond's Yat on the Wye* 89; 110–11; *Tintern Abbey*, 102; *Iron Forge at Tintern* 87; 111–12; *West Window and Entrance of the Church of Tintern Abbey* 91; 112–15; *'The Vicar of Wakefield': Mr Burchell rescuing Sophia Primrose* 36; 52–3, 57–8; *'The Vicar of Wakefield': The Breakfast on the Honeysuckle Bank* 37; 52–3, 57–8; *The Hermitage at Warkworth*, 38; *Wetheral Priory*, 67; *Old Toll House, Widcombe, Bath* 101; 125; *Hospital of St Cross, near Winchester*, 38; *Windsor Castle – the South Front* 4; 4; *Near Witham, Essex* 95; 125–6; *William Woollett* 1; 1; *Micklegate Bar and the Hospital of St Thomas, York* 19; 33–5
Henderson, J., collects work by Hearne, 145 n32, 107–10
Hogg, A., *Antiquities of England and Wales*, 37
Hulme, O., 49–50
Hume, D., 49

Johnson, Dr S., 15
Jones, T., 70; WORKS: *The Bard*, 51

Kearsley, G., 29, 32
Kip, J., WORKS: *Britannia Illustrata*, 139 n19
Knight, R. P., Hearne's Downton drawings for, 67, 90, 92–102; Hearne's Sicilian drawings after Hackert and Gore, 89; *The Landscape*, 97–8, 99–102, 126; as a patron, 32, 92, 138; tour to Sicily, 85–9
Knyff, L., WORKS: *Britannia Illustrata*, 139 n19

Lake District; Hearne's tours to, 28, 67–78; as native Arcadia, 67–70, 77–8
Lambert, G., 58, 62
Langley, B., *Ancient Architecture Restored and Improved*, 25–6
Lawrence, T., 92
Lowthers (of Whitehaven), 73–4
Luffman, J., 12, 14, 16

Malmesbury Abbey, 1, 24, 79; Anglo-Saxon origins, 48–50
Mansfield, Lord, 15
Martin, S., 140 n6; *Essay upon Plantership*, 21
Mason, W., 5, 27, 39–41, 107
Milner, J., 121–5
Moccas Court, 98, 102
Monro, Dr J., collects works by Hearne, 32, 107
Monro, Dr T., 6, 8, 137, 138; collects works by Hearne, 107–10; his landscape 'Academy', 119,134
Morland, G., 53, 128
Muntz, J. H., 37

New Society of Painters in Miniature and Water-Colours, 135
Nugent, Lady, 17

Payne, Sir R., 9–23 *passim*
Pennant, T., 28–9, 74, 85
Percy, T., 38
Picturesque, the, 18–19, 62–3, 78–81, 98–102, 106–7, 110–16, 125–34
Picturesque touring, 27–9, 67–71, 106–7, 110–16
Pope, A., *Of the Use of Riches*, 74; *Windsor Forest*, 97
Pouncey, B., 7
Price, Sir U., *Essays on the Picturesque*, 99–100, 106, 111–112, 125–8, 134
Prospect landscapes, 42–4, 62–3
Prout, S., 134–5
Pyne, W. H., on Hearne, 135

Reynolds, Sir J., 102; *Discourses*, 78, 128
Richards, J. I., 4
Robertson, G., WORKS: *View in the Island of Jamaica* 14; 18–19
Rooker, M., 6, 36, 79, 117, 128, 135, 138; WORKS: *Frontispiece to the 'History of Tom Jones'* 32; 53–4
Royal Academy, 32, 78; and engravers, 3–4; exhibitions, 6, 52; Hearne's exhibits, 84, 90, 102, 104, 117, 135–7

Sandby, P., 5, 17, 30, 79, 111, 117; topographical work, 4, 28–42 *passim*, 97, 128, 135; WORKS: *View of the Town through the Gateway from the Castle Hill, Windsor* 20; 13, 33
Sandby, T., WORKS: *A View of Diest from the Camp at Meldart*, 12–14

Sayer, R., 32
Schaw, J., 9, 14–15, 16, 17, 20, 21–2, 23
Scott, J., 64
Serres, D., 128
Sherlock, Revd M., 19
Slavery, 9–23 *passim*; and sugar cane production, 9–12, 19–22
Smith, A., *The Wealth of Nations*, 22
Smith (of Chichester), G., 4, 58, 62, 79; WORKS: *First Premium Landscape* 2; 3, 102
Smith, J., 7
Smith (of Derby), T., 6; WORKS: *Derwentwater from Crow Park*, 75
Society for the Encouragement of Arts, Manufactures and Commerce, 1, 59
Society of Antiquaries, 24, 27, 36–7, 39, 51, 120–5; *Archaeologia*, 39; *Vetusta Monumenta*, 36–7
Society of Artists, 24, 29, 52, 64, 90
Society of Dilettanti, 89
Society of Painters in Water-Colours, 135
Southey, R., 75
Stothard, T., 53
Strawberry Hill, 5, 26, 37
Stubbs, G., 3, 4, 120; WORKS: *Haymakers*, 64; *Reapers*, 64
Stukeley, Dr W., 51

Tatton Park, 100
Taylor, Sir R., 89–90
Thomson, J., *Autumn*, 64–6; *The Seasons*, 143 n86, 52, 53, 63–6; *Summer*, 21, 64–6
Tinney, J., 2
Tudway, C., 19–20
Turner, J. M. W., 51, 63, 117, 118, 119, 134, 135; copies Hearne's works at Dr Monro's 'Academy', 119–20; WORKS: *Calais Pier*, 137; *Malmesbury Abbey*, 119; *Old Welsh Bridge, Shrewsbury*, 120

Van Neck, Sir J., 50, 89, 90–1
Vanneck, Sir G., 89–91
Vernet, C.-J., 2
Virtuosi's Museum, The, 29–32

Walpole, H., 5, 26–7, 37
Warburton, W., 26
Watts, W., *Seats of the Nobility and Gentry*, 90, 93, 100
Wedgwood, J., 32
Wells, 106
West, T., *Guide to the Lakes*, 67–8, 74, 77–8
West Indies, 9–23; Antigua and Leeward Islands, 8, 9–23, 138; black slavery in, 9–23
Westminster Abbey, 26, 45
Wheatley, F., 63, 66
Wilson, R., 4, 70, 79, 84, 102, 137; WORKS: *Cader Idris, Llyn-y-Cau*, 75; *Destruction of the Children of Niobe*, 2; *Snowdon from Llyn Nantlle* 56; 75; *Solitude*, 48
Woollett, W., 23, 30, 44, 48, 52, 53, 75; Hearne's apprenticeship to, 1–8, 9, 13, 29
Wyatt, J., and cathedral restorations, 120–5
Wye Valley, Hearne's tours to, 102, 106–16

Young, A., 22
Young, Sir W., 18